It's All That Glitters

Portraits of Burlesque Performers in Their Homes

Brian C. Janes

Schiffer Publishing Ltd

4880 Lower Valley Road · Atglen, PA 19310

Other Schiffer Books on Related Subjects:
Burlesque Exotic Dancers of the 50s & 60s. Judson Rosebush. ISBN: 9780764336676.
 $24.99
The Queens of Burlesque: Vintage Photographs from the 1940s and 1950s. Len Rothe.
 ISBN: 0764304496. $19.99

Library of Congress Control Number: 2011945599

Designed by John P. Cheek
Cover design by Bruce Waters
Type set in Fontdinerdotcom/University Roman Bd BT/News Goth BT

ISBN: 978-0-7643-3998-1
Printed in China

Schiffer Books are available at special discounts for bulk purchases for sales promotions
or premiums. Special editions, including personalized covers, corporate imprints, and
excerpts can be created in large quantities for special needs. For more information contact
the publisher:

Published by Schiffer Publishing Ltd.
4880 Lower Valley Road
Atglen, PA 19310
Phone: (610) 593-1777; Fax: (610) 593-2002
E-mail: Info@schifferbooks.com

For the largest selection of fine reference books on this and related subjects, please visit
our website at **www.schifferbooks.com**
We are always looking for people to write books on new and related subjects. If you have
an idea for a book, please contact us at
proposals@schifferbooks.com

This book may be purchased from the publisher.
Include $5.00 for shipping.
Please try your bookstore first.
You may write for a free catalog.

In Europe, Schiffer books are distributed by
Bushwood Books
6 Marksbury Ave.
Kew Gardens
Surrey TW9 4JF England
Phone: 44 (0) 20 8392 8585; Fax: 44 (0) 20 8392 9876
E-mail: info@bushwoodbooks.co.uk
Website: www.bushwoodbooks.co.uk

 To my loving, talented, and
beautiful wife, Alison Janes.

Foreword

I met Brian in 2004 while we were both working on technology projects at a company in Chicago. Both of us moved on and embarked on separate paths, developing our creative capacities. In the last year, I have completed a Masters Degree in the Humanities and Brian has completed a cross-country photography project. During the respective processes we have had many conversations on creative expression and art as reflection of culture.

Photography is about light. It is a record of light caught on a film plane or on digital media. Light has many characteristics. One of its most mesmerizing features is the fact that it can be reflected. Depending on the angle of reflection, light will bounce back to its source or on to another point, perhaps into the gaze and imagination of an audience member in the thrall of a burlesque performer. The reflection of light, life, and culture is the basis for *It's All That Glitters*.

It's All That Glitters is a photographic essay on the contemporary world of burlesque. Just as light reflects off of many surfaces, this project is about illuminating and recording the theatrical characters of burlesque performers within their homes. No longer onstage, what light do they reflect sitting in their abode? This book offers prismatic perspectives of the performers who are involved in the contemporary burlesque scene throughout the United States. The photographs in this book are records of "all that glitters" in the lives of these performers. Although some of the performers make a living in burlesque, the majority of performers make their livings through other means; these are librarians, marketing executives, graphic designers, actors, bartenders, psychologists, dance instructors, artists, musicians, and more. Burlesque provides these performers with a means to express the erotic, irreverent, and subversive aspects of their personalities within theater.

Burlesque has its origins in ancient Greece. During the festivals of Dionysius one day of Satyr plays followed the three days of Tragedies. The Satyr plays are the origins of burlesque. They were send-ups of the culture. They were bawdy. They were sexual. They gave the populous an opportunity to satirize the politics of the day.

Today's burlesque scene continues the Satyr play tradition. In the pages of this book, you will find the "at home" stories of the performers who vivify this ancient tradition. There are many reasons that the performers who you see illuminated, reflected, and recorded participate in burlesque. They seek to "play" in the realm of Dionysus, in voyeurism, titillation, brazen sexual expression, and gender politics. These are courageous women and men, whether they are taking it off to tease or taking it off to tilt the power structure of gender, each has a unique story for the stage and a unique life at home. Enjoy meeting the women and men who have generously allowed Brian to capture their various, beautiful, challenging, and sumptuous reflections, to discover, *all that glitters*.

Paul Conley

The time spent setting up lighting, photography, and video gear for a portrait session in someone's home provides ample opportunity for conversation. One of the questions I heard most often was, "What inspired you to do this project?" It's a question for which there are multiple answers.

Throughout my photography career I have followed various blogs and web sites pertaining to photography, be it photographers posting their own work and talking about their projects, or sites dedicated to tips and tricks on how to take better pictures. One such photographer who stood out to me was Kyle Cassidy. Aside from being a phenomenal photographer, Kyle has the keen ability to encourage and inspire creativity in others through his own projects.

In 2007 Kyle released a book called *Armed America: Portraits of Gun Owners in Their Homes* in which he photographed gun owners in their homes and asked them one question, "Why do you own guns?" I was deeply inspired by this project because, not only did I desire the ability to create and tell stories through such moving and technically advanced portraits, but I craved the adventure that traveling across the country and meeting new people would bring.

By early 2009, having photographed burlesque performers on and off stages throughout Chicago for over four years, I was friends with many of them and was inspired to embark on a project that would highlight their creativity while capturing a historical document of burlesque in this day and age.

Around that same time I was party to conversations with various folks in the burlesque scene that made me realize what burlesque means to one person is not necessarily what it means to another. And it got me thinking: What is burlesque, really? I figured the best people to ask would be the people who are at the heart of burlesque—the performers. Thus, I decided to ask them, "What does burlesque mean to you?"

The name of the project, *It's All That Glitters*, is derived from two key sources of inspiration.

The first is glitter. Glitter, along with sequins and rhinestones, is a fundamental ornament in burlesque. Many burlesque performers, especially dancers, strive to be the most glittery, shimmery performers onstage. And once glitter is used as a decoration, it becomes omnipresent, sometimes appearing days and weeks later in some of the most obscene and unusual places. Just as an atom is the basic unit of matter, so glitter is the basic unit of burlesque.

The second is a play on the saying, "All that glitters is not gold." It seems fair to say that the stage can be considered a fantasy while the individual's home is reality. Is the glitz, glamour, and glitter that we see onstage a true representation of the performer? Or will we have a different understanding of the individual if they are pictured in the context of their own home?

Burlesque is commonly associated with glamour. Furthermore, most performers in any medium are typically in complete control of their time onstage as they present a performance that has presumably been rehearsed and refined. So what if someone were to run up onstage during a performance, grab the performer, place them in their home, and take a picture?

The resulting photographs are a visual study of the contrast between the public view of each performer as represented by her or his stage persona and private life as represented by his or her home.

And finally, for purely selfish reasons, I wanted to immerse myself in a project that would challenge my skill set in the world of multimedia production. This included honing my lighting and photography skills, which would be further challenged by diverse environments and lighting conditions in each performer's home, as well as expanding into video production. Although this book does not include the video interviews, the text of the book is derived from the performers' responses during the video interviews.

Given the similarities of this concept to Kyle's book, I emailed Kyle to share with him my idea and inspirations. He responded with a message of blessings and encouragement. And so, in June 2009, I embarked on this wonderful journey that took me over 14,000 miles across the United States and into more than 100 homes.

Brian C. Janes

Acknowledgments

This project would not have been possible without the kind support of many people. I will attempt to name as many of them here as possible. To those whom I have neglected to name: Thank you.

Thank you to my wife, Alison Janes, for providing endless mental, emotional, and creative support, for joining me on the road, and for occasionally holding and carrying the light stand bag.

My trek across the country would not have been possible without the warm hospitality of the people in each city who opened their homes and guest rooms to me.

And of course, thank you to all of the performers who allowed me into their homes to photograph and interview them. More often than not I was entering someone's home as a stranger and leaving as a friend.

Special thanks to:

Amanda Amico; Katie Baltensperger; Dave Beil; John Blum; Lara Bullock; Natalie Bunton-Pagel; Michael Burke; Esy Casey; Kyle Cassidy; Matthew Chaboud; Jenn Chaboud; Paul Conley; Candice Lee Conner; Meagan Evanoff; Daniel Inouye; Jackie Inouye; Stephen Janes; Rhonda Janes; Evan Kane; Frank Kearl; Chelsea Laumen; Cindy Lee; Lindsey Marks; Rachel McCauley; Jeremy McElroy; Tanya Moody; Emily Napolitano; Nick Novelli; Dave Pagel; Megan Pedersen; Lauren Petre; Megan Piret; Natanya Rubin; Trillian Stars; Katheryn Sullivan; Nina Weiss; Devon Yost

What is burlesque? Who better to ask than burlesque performers themselves? Of course, there is the dictionary's definition of burlesque, but this book was born out of the theory that today's collective response is quite different from the printed definition.

Merriam-Webster defines **burlesque** as follows:

1 a literary or dramatic work that seeks to ridicule by means of grotesque exaggeration or comic imitation

2 mockery usually by caricature

3 theatrical entertainment of a broadly humorous often earthy character consisting of short turns, comic skits, and sometimes striptease acts

And so, I traveled over 14,000 miles to visit with burlesque performers across the United States, photograph them in their homes, and ask them the question: What does burlesque mean to you?

The text of the book is derived from video interviews I conducted with each performer.

When animals or other people appear in a photo with a performer, I have included their names in order from left to right.

7

Paris Green

Burlesque Dancer and Producer

CHICAGO, ILLINOIS

Burlesque to me is an opportunity to have fun onstage. It's empowering, of course, but for me, I just like to be able to go out and to be silly and sexy and to entertain people. That's what burlesque is to me—it's an opportunity to do all those things in front of people who appreciate me for what I can do and what I bring to them.

When I say it's empowering I think that burlesque performers have an opportunity to do something that shows people that every body type is sexy. Every way of taking your clothes off can be sexy or silly or fun. But I think when I say that it's empowering it gives women an opportunity to define what sexy and sexuality is on their own terms and that is a really empowering feeling as a performer.

You know, you can be a very skinny woman, a very voluptuous woman like myself, you can go onstage and do something really silly or something really seductive, but it's your own terms. You get to dictate what it is that is sexy to you.

One of the things that I really love about burlesque, and it doesn't necessarily get talked about a lot, is that it's really kind of a kick-back to old-time showbiz. It's really the kind of environment, at least that I find, that I think used to exist in the days of vaudeville in the original days of burlesque. Everybody pitches in—at least with my group it's very much like a second family. We're kind of old souls with young hearts. And that is something that, as an actress, as a comedienne, I haven't found really. But as a burlesque performer, it's something really unique and I think it's something that, because it goes on behind the scenes and it's backstage and the audience doesn't get to see it, it is something that I wish more people knew about.

If you do things right, if you're producing a show and do things right, they shouldn't see what's behind the scenes. But, I think as a community, the way that we promote ourselves and interact with one another, that supportive part of the community—that's something that people can see. That's something that when you go to another person's show, if you go to another producer's show or another group show, just by the being there, being the supportive person, that's really important. And I think if audiences see that we as performers support one another, we help out one another when, you know, there's a pastie emergency, or a music malfunction, or ... that's the kind of, I think, feeling and environment that used to exist. The show must go on, you know, and I think that's something really cool that we do, that other art forms don't necessarily fall into as much.

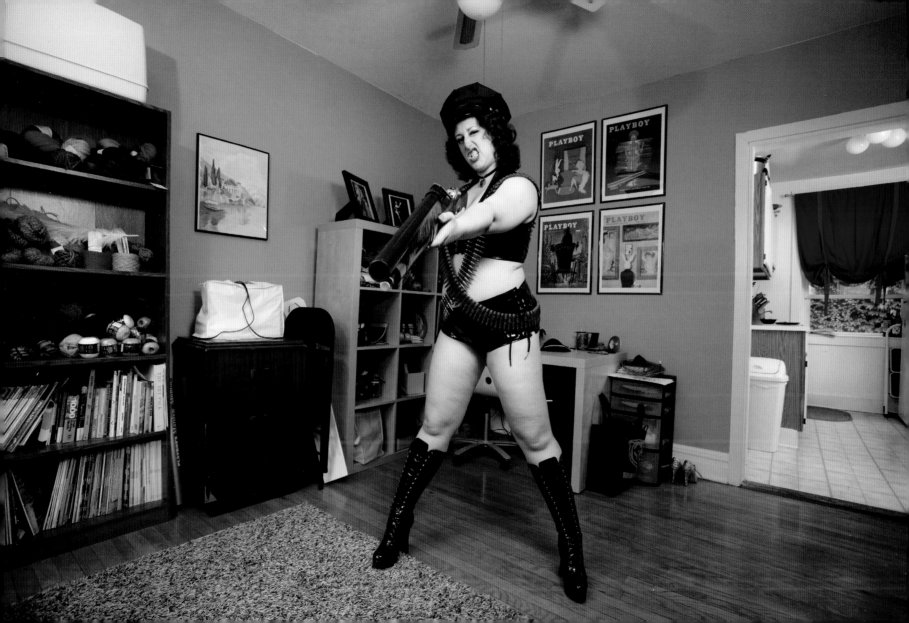

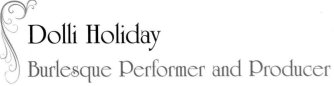

Dolli Holiday
Burlesque Performer and Producer
RICHMOND, VIRGINIA

Burlesque for me is kind of an escape from the doldrums of every day life. It's my time where I can put on something sexy or something glamorous and feel like a star. It's also about celebrating the female form and, you know, loving your body and being comfortable in your own skin. And for me this has really taken me to that level where I feel far more confident in what I do and that reflects, not only onstage, but also upon my everyday life. It's made me love my curves and just, you know, know that I don't have to be model-thin. There's not a particular mold that I have to fit into because it's just about being comfortable. The audience loves you no matter how you look. So, it's been a big confidence boost for me, I guess.

I think gaining confidence is definitely a happy side effect of burlesque, but I also was kind of looking for it when I went into it. When I first decided I was gonna do burlesque I made a life change. It was like a life decision. I wanted to be healthier and a better person and feel comfortable with who I was. And so I started making changes in my life that helped pave the way to burlesque. And I set it as a goal, like, I'm gonna do this and then I'm gonna take this next step. So, it was both. I was looking for it, but then it also ended up being just a really great result from doing all of this.

I feel like burlesque is also about community and sisterhood and brotherhood. I've met so many wonderful people doing what I do, and it's so interesting because you meet people from so many different walks of life. And we all share this common goal and common passion. And even some of the audience members I've met have just been really wonderful people and I think right now all of my friends do burlesque. Well, most of my friends are burlesque performers and if they're not burlesque performers, they're burlesque supporters, so, it's kind of a fun thing that we all share. And everybody loves it and it's great to have this wonderful community and this wonderful open and accepting family. So, it's a little bit of everything. It's great to have that community.

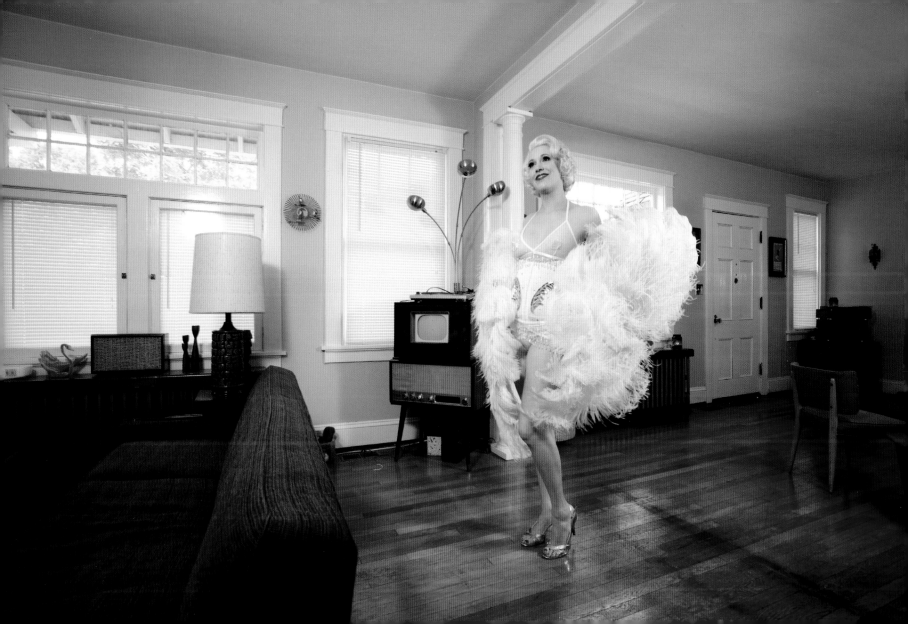

Tigger!
Burlesque Stripperformance Artist
NEW YORK, NEW YORK

Burlesque means sex plus humor plus self-expression. Those three things are absolutely fundamental and everything else is up to the individual performer/number that night. I started doing it coming out of a variety of inspirations and a frustration with work that I really enjoyed in downtown theater. And what drove me to create stuff that people later called burlesque was the freedom, the option, the wide-open opportunity to involve theater and dance and performance art and circus and drag and Grand Guignol crazy-ass puppetry and glitter. I don't like too many definitions. I don't care about the props, the costumes, the budget spent, what your particular sense of humor is. But I feel it's really crucial that it plays with sex, because in this horrifically puritanical country we've gotta play with sex all the time so everyone can eventually be a little bit more liberated. Play with humor, because, again, we're puritanical and those are two things the Puritans famously sucked at, sex and humor. And if you put them together that is the most important step towards liberating everyone. Performers, audience, all of us together. And doing it together is the way to do it. And self-expression, more and more because there's a million of us. And I'm less interested … I have great respect for craft, but I'm not interested in seeing just how well you've mastered a craft. The thing that lets me be still excited after all these years and thousands and thousands of titties twirling and fans flying and gloves peeling, is self-expression. Show me who the hell you are and that is the thing that no one else can take from you.

That is what burlesque is. An important part of what burlesque is, is this whole mission of liberation for all of us together. People in a public space together recognizing the glamour, the beauty, the titillation, and the absolute absurdity and hilarity of sex and of all of our human bodies is, I think, a fundamental way to be freer, happier, less oppressable people. I also think a big part of what we're doing is exploding gender stereotypes. Women aren't presenting everyday women. It's not defining who women are. And likewise, I don't feel like it's at all my job to define who men are. What we are doing is giving cartoons … crazy exaggerations, because all of gender is a drag. Everyone is doing a drag show every damn day of their lives, it's just that most people's drag is boring. So, we're just giving a heightened presentation of whatever-the-hell gender we wanna do in that number, that moment, that part of that number, to sort of explode all these limitations that people feel stuck in. To give them a little more freedom … to give all of us, especially us, more freedom to move between gender roles as they suit us.

Okay, that's all … for now.

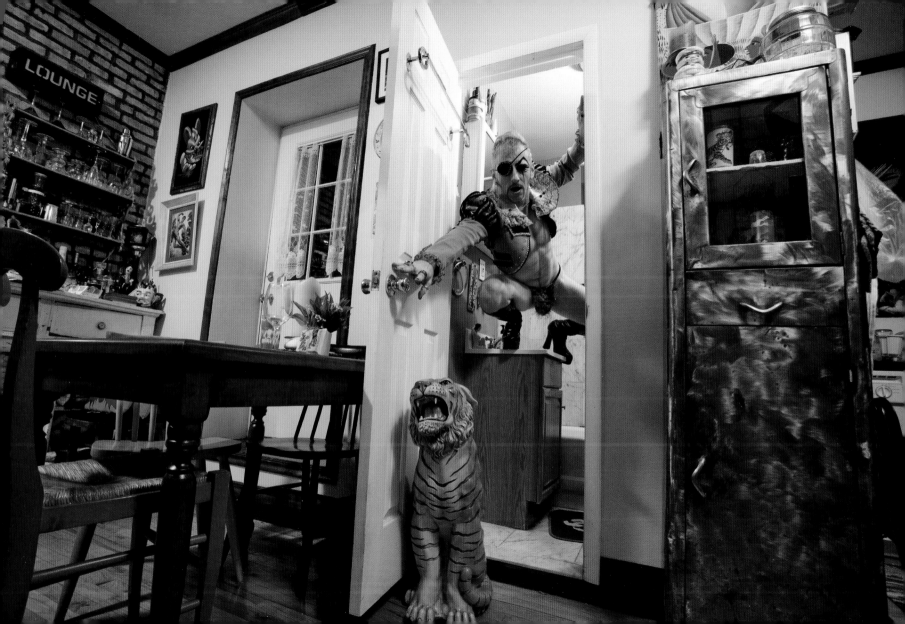

Fuchsia FoXXX

Belly Dancer for the Burlesque Stage

SEATTLE, WASHINGTON

Burlesque to me is like a hodgepodge of a lot of different kinds of art forms. I would say today in contemporary burlesque it's lots of things that are sort of geared towards mainly entertaining an audience. That audience is sort of like the average American, so not like an audience for the theater or opera or modern dance or anything specific. I wouldn't say it's lowbrow, well, yeah ... maybe it's lowbrow. But, some of the productions today, you wouldn't call them that because they're so amazing.

There's so many kinds of skill sets that come into the burlesque world from juggling to trapeze to belly dancing and modern dance and drag and lip sync and opera and ballet, and pretty much any skills can be incorporated into a burlesque routine. I think that the main objective of the burlesque performer is to entertain the audience. And it's not really to shoot so high that no one's understanding what's happening. It's also not playing to the lowest common denominator, either. You're sort of finding a middle ground to where you can satisfy your own artistic energy. You put your own vision out there. But, at the same time, you're conscious of who's out there. The people know nothing about whatever I'm really obsessed about; they don't care, they don't know. And so, the point is that they wanna have fun and that's why they're coming to a burlesque show.

So, burlesque for me is definitely a group of artists that have found this particular art form that is very accessible to the audience. There's a very quick turnover from your idea as a dancer, as an artist, to creating the thing and then putting it out in the world for just anybody to see. That quick process is very different, say, from coming from the visual arts world, where I'll make a painting and then maybe one day it'll be in a show, and then the only people that are going to look at it are people that go to a gallery or people that are painters themselves that maybe you were in college with that had your same studio class. So, burlesque is really magical in this way that anybody can just sort of traipse through a bar in downtown Seattle, or who knows where, some place in Phoenix, and just see some really amazing thing. They may not really know what it is, but they're gonna enjoy themselves because it's really geared towards that instant satisfaction and putting it out there. It's like a one-liner sometimes, one act really just has that one sort of point to it. Maybe you're naked at the end or maybe you're not. But, it's pretty simple. It's digestible for the average Joe.

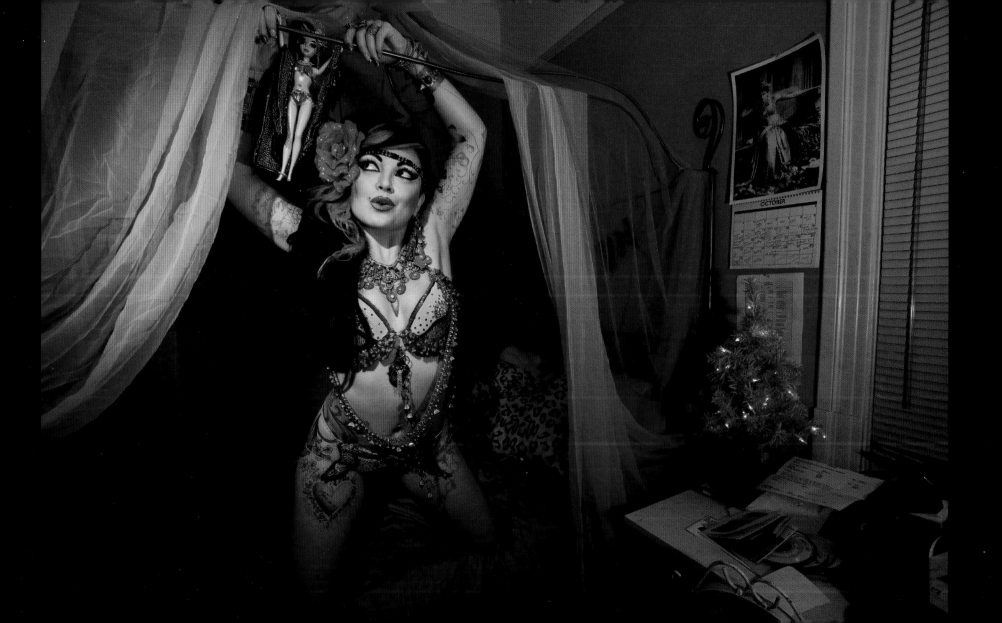

Moxie Rhodes

Burlesque Dancer

MADISON, WISCONSIN

Basically, burlesque to me is a wonderful thing that I'm allowed to participate in. I get to be myself and recreate myself regularly. The ability to have an alter ego is certainly something I value. I love meeting the women involved. Some men that are involved are good too, but I would say primarily it's a feminist movement and certainly more of a modern feminist movement where burning your bra isn't something we're into. We're about showing our bras and making people smile and making people laugh and ... showing off.

The people are pretty much the main part. Getting to travel, getting to go on tour, picking out even the most inane details to what you're going to be wearing that evening, how you're gonna be doing your makeup, it's all part of this glorious seduction that is burlesque, and I'm very proud to be a part of.

To me feminism in burlesque would be the celebration of the female body for all its parts, sizes, and shapes. Anybody is beautiful and everybody is beautiful. And celebrating your body is a good thing. And not being afraid of your body is a good thing. And sexual education is a good thing. And being proud of your temple is a good thing.

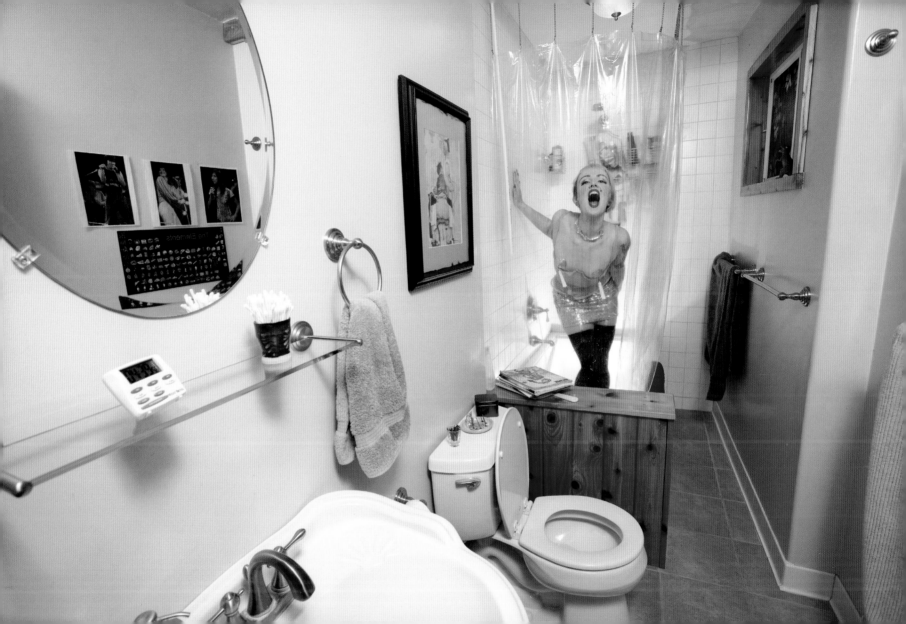

Lola van Ella

Burlesque Performer, Producer, and Instructor

ST. LOUIS, MISSOURI

What does burlesque mean to me? Burlesque is definitely creating a fantasy. It is my passion. It is my drive. It is my full-time business and profession. I love burlesque because, besides the fact that it's glittery and fabulous and covered in rhinestones and exciting and intoxicating, it has a really strong sense of community behind it. I love working with other really strong, fantastic, sexy women. I love being surrounded by women like that. And also there are great guys, too, but of course usually it's more women-oriented for me. I really enjoy the creation. I can't imagine not creating something, a performance of any kind—and not just burlesque, but singing and dancing and acting and all of those things. I find a lot of joy in creating something new, in taking a twist on the old and making it something newer and more strange or different or sexy or whatever, it's fun.

And I know a lot of people use the word "empowering." Sure, burlesque is empowering. A lot of women say it's empowering to do burlesque. But, for me there is an empowerment in just creating. It's not so much about taking my clothes off or whatever, because I enjoy being naked and, frankly, if you just gave me a pair of stockings and some glitter I could stand onstage for ten minutes, probably, and, I would hope, be entertaining in some way. But, for me that's really not what it is. Yes, I like to be an exhibitionist and be onstage and in various stages of undress, but that isn't why I feel empowered when I do it. I feel the empowerment comes from the creation and the performance aspects. And I love being able to give that to people. I think that everyone feels that they are trying to find their place in the world or their contribution. And I feel like my contribution is bringing entertainment and laughter and joy and the feeling of being allowed to enjoy something sexy.

It's okay to watch. It's okay to get titillated and excited and if I can take people away from their humdrum whatever, the nine to five or whatever it is that they're doing, and have them escape from that a little bit, I think that's really fabulous and I hope it's a lovely little contribution. And can I just say that I simply like rhinestones? Is there something so wrong with that? I just … like sparkly things. The end. That's good. Yeah. Okay.

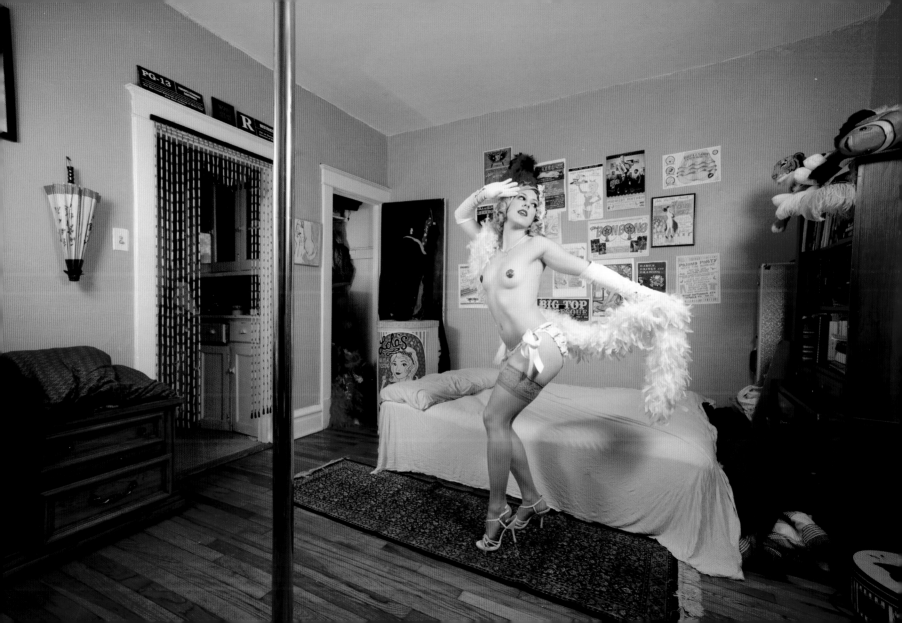

Coo d'Twat with NumieMuffinCooCooButter

Burlesque Dancer

CHICAGO, ILLINOIS

It's hard to pin down what burlesque means for me. Burlesque is so many things. Burlesque is a chance to take on a character, to be someone else for a while. It's a chance to act out something sexy. It's a chance to be silly … in a way that you can't do off stage.

In some ways I feel like it's an extension of being twelve years old and dressing up in your friend's basement and dancing around, only we're just going a little further.

Burlesque for me is a chance to act out a character and to take a moment onstage to explore things about my personality, about my views, and what I would like to convey to other people. It's a chance to take something from the past and relive it.

I love the opportunity to use vaudeville, to use dance, to use song, to use costuming to bring together one act that says something—or that does not even necessarily say something—but still brings a moment of joy. And I get to be silly and take my top off.

I'm naturally very silly and sort of over-the-top and an exhibitionist and I don't get a lot of chance to do that in my real life. And so as Coo d'Twat I get to do all of the things that are sort of shunned in day-to-day life. I get to take a moment to just be as ridiculous, as silly, and fun, and fluffy, and naughty, and sexy, and dumb, and ditsy as I want, and really live it up to life's fullest. And I think that's what burlesque means to me.

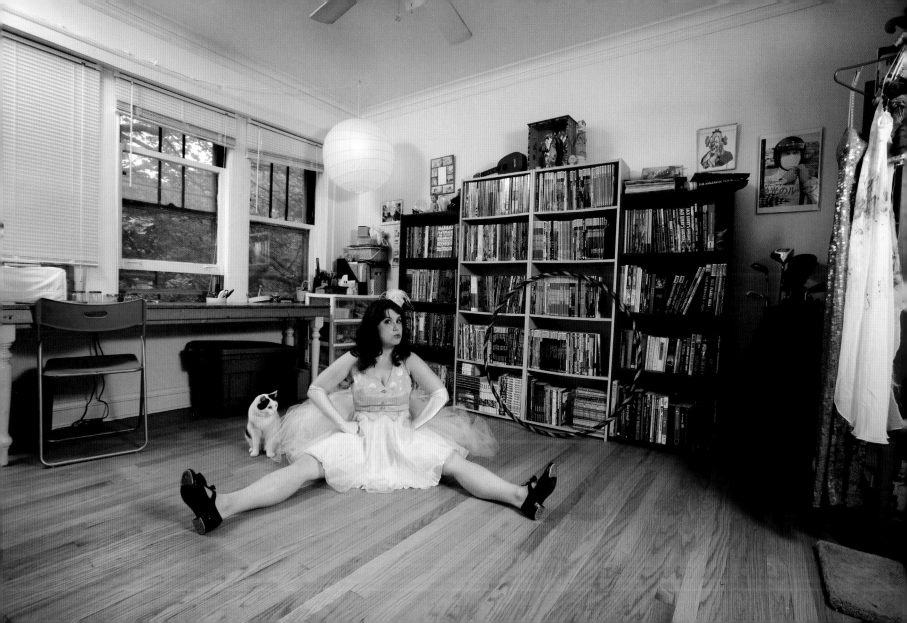

Ava von Sweets

Burlesque Dancer

MILWAUKEE, WISCONSIN

I would say that burlesque is any type of entertainment—singing, dancing, comedy, acting, acrobatics—anything of the sort. And it would probably involve removal of some sort of clothing. It can be one glove or your whole outfit. And you know maybe add a little tease in there as well.

For me personally, when I do burlesque, I like it to be funny. I'm just looking to entertain everyone—guy, girl, gay, straight—anyone in the audience. I just want to entertain them and I want them to think, "Oh, that was funny" or, "That was cute." I'm not going up there to try to be sexy. I'm not ever trying to do much of the tease and I'm not really trying to tantalize or anything like that. I'm just trying to do stuff that's funny, lighthearted, a little more unexpected. And I work with more scenarios and just try to portray a character. And I really just want people to say, "Oh, that was cute." I'm not up there to be lusted after. That's not what I'm in it for.

When I do go down to pasties, it's usually only for the last two seconds of the song. And then I run off. Whereas some people are a little more comfortable and they'll maybe perform in pasties for the last thirty seconds of the song or they'll walk off through the crowd in their pasties. I'm just not comfortable with that. So, I like it to be a little more entertaining for all kinds of people and I just want people to think, "Oh that was clever, that was funny, that was cute."

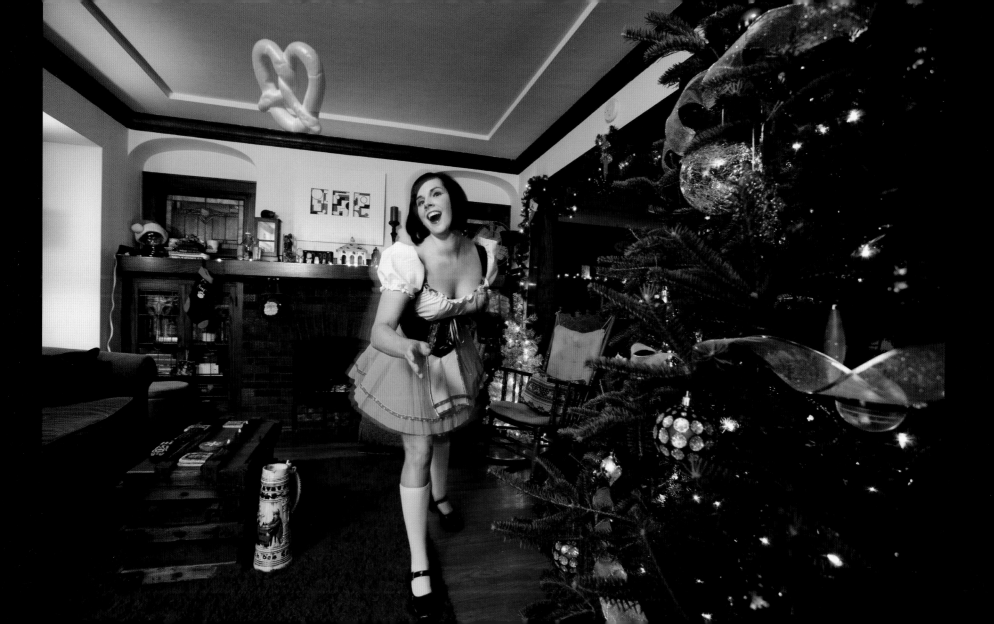

Charlotte Treuse
Burlesque Performer

PORTLAND, OREGON

Burlesque means a lot of different things to me. Right now what I'm most excited about is the fact that I get to be one of the lucky people that keeps a true American art form alive. I really enjoy the connection to the past. I love the fact that a lot of the legends are still here, accessible, and so willing to share their knowledge. And I think it's just a very incredible, fascinating, magical thing to be able to talk with these performers from the '30s and '40s and learn from them.

I come from a very extensive theater background and an extensive dance background as well. And when I was younger I did a lot of ballet and in my teenage and early adult years I was in a Middle Eastern dance troupe. With both ballet and belly dance it was very structured. And, you know, you didn't screw up and you did your very ... *very* structured dance. And with burlesque I just enjoyed that I was able to choose my music, make my costume, do exactly what I wanted to do onstage and, really, produce myself. It has been a really enlightening journey learning who I am. When I originally started and

was wanting to do this real sideshow thing, which ended up evolving into this very classic glove and gown routine—a boa dance, fan dance, sometimes ... girl—it was a real journey of self-discovery for me that, oh my goodness, here I am girly. I'm kind of a girly-girl. I didn't realize that until a few years ago. So, that's been very fun. I think that's what it means.

The community, actually, is really one of the things that I've most enjoyed about getting to become a burlesque performer. I've really enjoyed getting to meet all the people from different states. I like to do Exotic World and do festivals when I can; the sense of community's amazing. These women from all across the nation are just friends and our community's still so small. It's growing, but we're still so small and so fierce that we all know each other, which is really kind of an amazing thing. You can, you know, connect with somebody in Chicago or New Orleans or wherever and say, "Hey, I'm doing this, what are you doing?" And they're open and willing to show you their tricks and wanna learn tricks from you, and, it's just really cool.

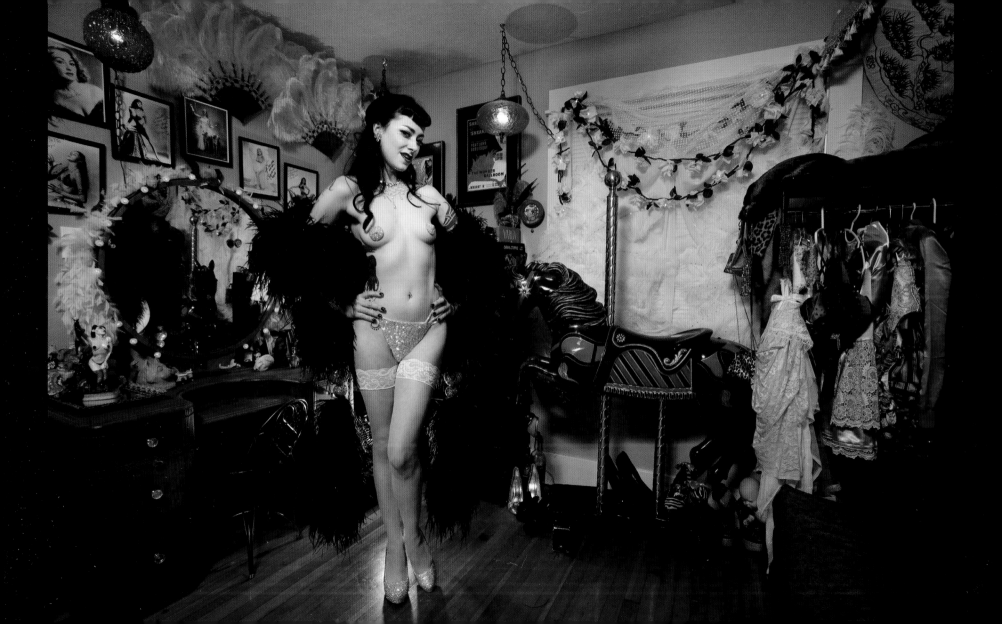

Inga Ingenue
Burlesque Artist
SEATTLE, WASHINGTON

What does burlesque mean to me? Well, the Academy of Burlesque where I work, which is run by Miss Indigo Blue, along with many schools of burlesque, all kind of agree that the basic textbook, technical definition of burlesque is "the art of tease as put forth through performance and theatrics onstage." But that's of course like calling painting the art of putting some paint on canvas. You know, that's like the simplest, most basic definition. Thank God it's a wide art form that can encompass so much. I believe Tigger! from New York City defines burlesque as "sex plus personal style," and I think that's a really good definition because it's so broad, and it doesn't use "tease" in it, which I think is interesting because technically, burlesque is supposed to involve tease, but I think if you just think of it as sex plus personal style it's a little bit more all encompassing. Though, if any young student came to me and asked me what is burlesque, I would tell them it's about tease because I think that's a good building block for you to build the rest of your "sex plus personal style" on top of.

I think when most audiences see burlesque, the things that stand out about it are usually women performing in really sparkly costumes, there's some kind of vintage aspect to it, and obviously there's nudity. So I think that's what stands out for audiences. So, when they think burlesque, that's what they see. But there is actually so much more to it. It also depends on where you are. Like in Seattle, the vintage aesthetic isn't the most popular aesthetic, whereas if you go to other parts of the country the vintage aesthetic is much more popular and sort of the whole pinup girl look. The way people do their makeup and the way they do their hair and everything is much more widespread. But here in Seattle we're more about drag queens and things being really big and boisterous and over the top. And we like thinking of burlesque as this explosion of femininity, but not femininity as it actually is, but femininity as like a thing that you put on and what that means. Like what does it mean that I'm a girl, a female bodied girl putting on femininity in this way that is so theatrical that it almost makes me seem not feminine? But at the same time it's beguiling in a feminine sort of way and people who are usually attracted to feminine types are really interested in what I do onstage. And then people who aren't attracted to feminine types are interested in it because what I'm doing is so feminine it's not feminine anymore. It's … different. I don't know. It's like you just asked me to define art. I can't do it—I can't!

I think that burlesque for me, personally, obviously is a form of expression. Or at least, it started out as a form of expression, but it's gone past that. Now it's my art form. It's what I do. It's like waking up in the morning and breathing. Burlesque I think is an amazing place for performance artists who have done other things like theater and dance and all those other forms of performance, an amazing place for them to go because it gives them the freedom to do almost whatever they want. In fact, they do pretty much whatever they want. Like, you want to pull a boa out of your body? Do it! We will applaud you as you do it and there'll be glitter thrown on you and you'll have backup dancers. It'll be great! Burlesque really gives performers the freedom to express themselves in any crazy way that they want to because burlesque is usually so sparkly and so beautiful.

I think people need to remember that burlesque is stripping. You know, even I can sometimes get on this platform of it's art, it's art, it's art! Still, being stripping doesn't make it less of an art form. And there's absolutely nothing wrong with it being stripping. In fact I would prefer, honestly, that people call me a stripper. I'm a very fancy stripper, I'm a theatrical stripper, but that doesn't make me less of a stripper. I go onstage and I take my clothes off for money so that an audience can watch it. There's nothing wrong with that. There is absolutely nothing wrong with someone going onstage and taking their clothes off. And there's nothing wrong with putting a plot around it; we put some sparkle on it. That's essentially what it is. Sex plus personality. Thanks, Tigger! I think that the only thing I would add to my definition of burlesque is that it's stripping and that's okay. Deal with it people. That's it.

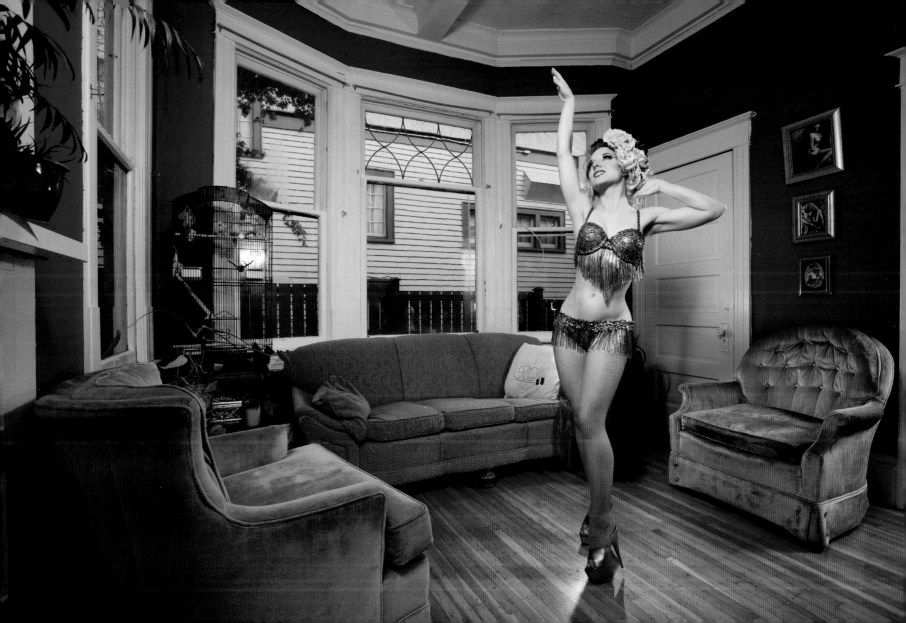

Mimi Le Yu with Betsy

Burlesque Dancer

ST. LOUIS, MISSOURI

Oh … Burlesque means lots of things. Burlesque means girl time. I had never been a girly-girl and when I started doing burlesque I still wasn't a girly-girl, or even had that many girl friends. So, when I became a burlesque dancer and got more into the scene, I grew in my relationships with women and met all these wonderful girls and kind of became this girly individual that I'd always been, I guess, maybe, longing to be. So, it's about girliness and empowerment and fun. I mean it's definitely kind of an alter ego of myself, you know, this character that I play and we have a great time with the audience. We play and we flirt and we tease and they laugh at us and it's a great time. It's a lot of fun. I wouldn't do it if it wasn't fun.

It is empowering because it takes a lot to be quote unquote naked in front of an audience, but there's a certain amount of confidence that takes place. You really have to be a confident person in yourself and who you are. Whether you're skinny or you're large or big-boobed, or big-butted, or small-boobed or small-butted, you know, you have to be comfortable with yourself to be able to get up there and be like, "You know what? I might be curvy, I might be thin. I might be whatever. But I am a sexy girl and here I am and I'm gonna make you laugh or I'm gonna, you know, tickle your fancy, whatever it is. I'm gonna show you how talented I am and how much fun that being confident can be." In St. Louis, our biggest demographic is women. Like, single women, from their twenties to their forties. They come out in droves to see us, especially the bachelorette parties. They love us because there's something empowering about seeing women take charge of their sexuality to say, "Hey! I love myself, you know, cellulite and all and I'm gonna take off my clothes and I'm gonna make you laugh and we're gonna have a great time!" I'm like, "Ah! I wanna be like that!"

I've discovered a love of costuming that I had no idea lived within me. I mean, I'm an actor so I love costumes anyway. Halloween's definitely my favorite time of the year. But I now have a sewing room. I know how to bedazzle all kinds of crap. Sequins and ribbons are my best friends. And it's fun. It's fun making your own costumes and seeing what you can create and how you can rip up your clothes and make them into snap off items. I mean that's been kind of a new hobby. I ask myself, "Oh what can I create? What can I make? How can I tell this story, not only through how I shake and how I shimmy but also how I take off my clothes and what my clothes mean?" The costumes are as much about the story telling as the dancing. So, yeah, that's about it.

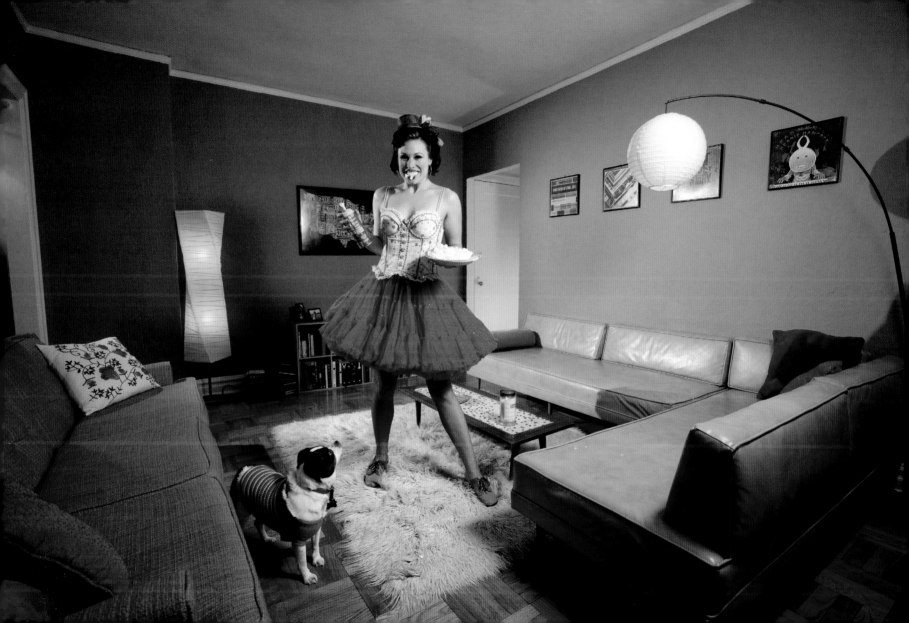

Hellena Honeypot with Beaux

Burlesque Performer

New Orleans, Louisiana

Oh boy. It means a lot. I'm sure everyone says that, but, to me, it means a few things.

Number one to me would be camaraderie. Because there are so few of us here in New Orleans, it seems that it's kind of an extended family. And I wouldn't know a lot about myself or about life without the women ... not necessarily *just* women ... magicians, emcees, or producers here. But it means performance and it means performance with family. It's slightly carnival, a little bit. But the thing that makes me happy most is to make other people happy through being entertained with the people who are closest to me.

It means getting to always be around new and interesting people and things. Always being exposed to new ideas, new performance, and new music, which is really awesome. There's lots of weird, strange, obscure things that I'd never even begun to have heard of that I now get to play with all the time. It means learning to make costumes, props, meeting Mardi Gras crews, costume makers who make costumes for kings and queens of secret societies and ... I guess more than anything else ... it means exploration. I get to explore. My job is to explore how to entertain people. And it means so much. It really does.

I don't know what else I can say about it. I could say a ton. But it's what I wanna do for as long as I can do it and it'll keep me in shape and keep me exploring. It'll keep me deep in the thick of friends, that's for sure. And it'll probably keep me drinking bourbon well into my old age. God bless that.

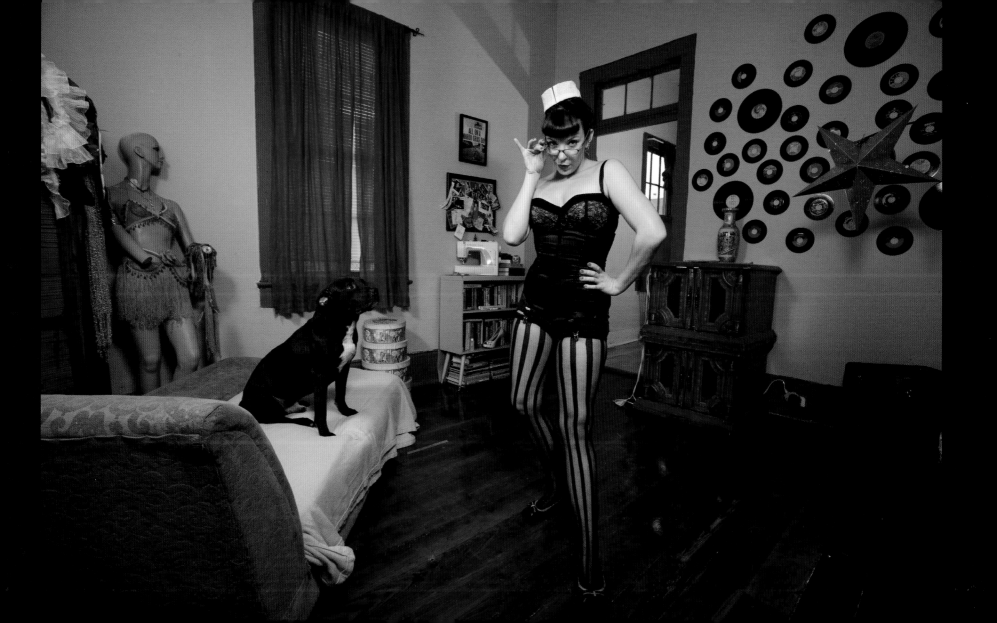

Ms. Behavin' with her son Beast
Burlesque Performer and Producer
MADISON, WISCONSIN

Burlesque to me is a conglomeration of many women's talents—and men's. You can do anything from striptease to singing to dancing to skits. It's a way of taking a slice of society and putting your own spin on it. And that's what we do.

For us in particular, for my group, we believe in empowerment of women. It's one of the main reasons why we do burlesque. We like to make fun of ourselves. We like to make fun of people. We like to make fun of society's norms and what people think that women should be. And we like to represent all different body types, body styles. We like to have different races so that, again, you get a slice of what the actual Midwest is like.

I think it gives women another option. It gives women a different alternative of how to view their sexuality—that you don't have to be the person with the button-up shirt. You can be conservative and still love your body. You can be wild and still understand that there are lines that you feel comfortable with. We have women in our show that go down to pasties; we have women that don't. And we're okay with whatever expression the women choose to do because it is about their expression and their empowerment.

For me burlesque is about showing people that you don't have to be the most talented, you don't have to be the skinniest, you don't have to be this beautiful, exotic woman. You can just be like me, a mom who likes to sing and dance and likes to show people that it's okay to be who you are, whatever it is that you are; it's okay.

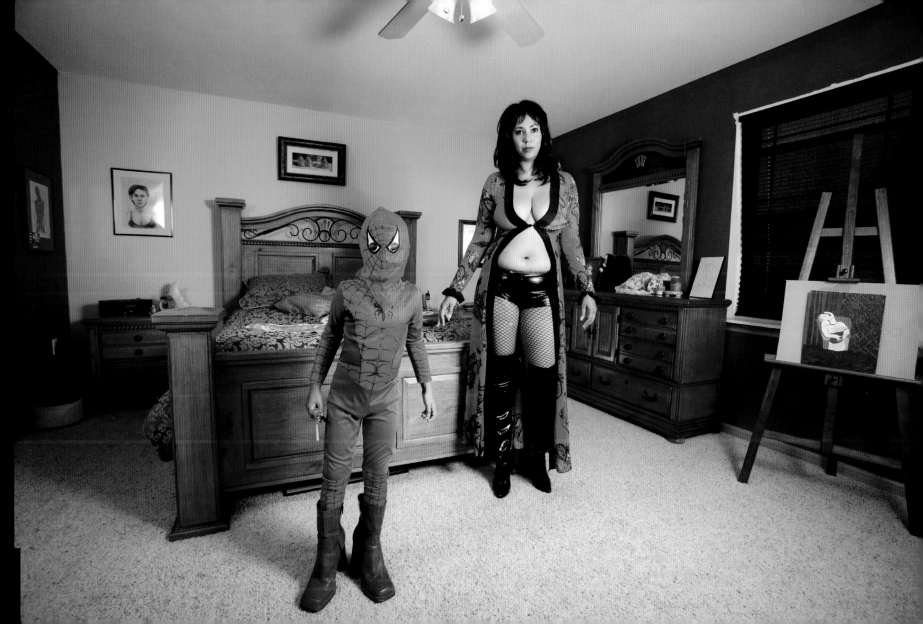

Sue Nami Sake

Burlesque Performer

LAS VEGAS, NEVADA

Well, I'm from Baltimore, and there we have Trixie Little and the Evil Hate Monkey, and they do kind of acrobatic and comedic burlesque, so that's a lot of what I was exposed to initially. I moved to Las Vegas and became a performer with the Babes in Sin troupe. We're very vintage-inspired, sort of calling on the old style of burlesque. And with all the burlesque that I have seen recently in the Burlesque Hall of Fame, I see so many different dance styles and techniques that can be incorporated into an act. So, I have a belly dance background and a flamenco background and I incorporated some of that into my acts. I also like to do funny stuff. You know, I've done rock lobster, and I think that may be inspired a little bit more from the Baltimore background. I just think that you can use so many different techniques between the comedic, the vintage, different types of dance, different types of costumes and reveals in this style of dance that you don't see in a lot of other dance, and you can be sexy in just so many different ways. So, it's different creativity to express your sexuality in performance. And it's just a lot of fun, too.

Burlesque also, to me, is a form of empowerment, because you get to perform on a stage and I love to perform, and you sort of hold everyone's attention at that time and you can show everybody what you're about and express yourself. So, for me, I'm normally a very quiet individual, which sounds odd because I teach, but, I'm pretty quiet. But then, I love to perform and that's how I express myself so I can show myself that way. I think that's how a lot of people learn about me since I'm not very talkative or outgoing normally.

I mean, I just love the idea of being able to express and be sexy in any way I feel comfortable to, or however I'm inspired to. You see so many different acts out there nowadays that incorporate sideshow stuff like fire and contortion and different forms of dance, like Latin dancing, and then acrobatics and then people that could easily be comedians in real life, too, because they're so funny. And the creativity behind the costume-making is always amazing to me. There's no over-the-top in burlesque. In other dance forms they'd be like, alright, you have to calm it down ... all of the fringe and sequins on that costume. With burlesque it's all out. You want to glitter and shine as much as possible. It's like limitless creativity, I feel, in burlesque.

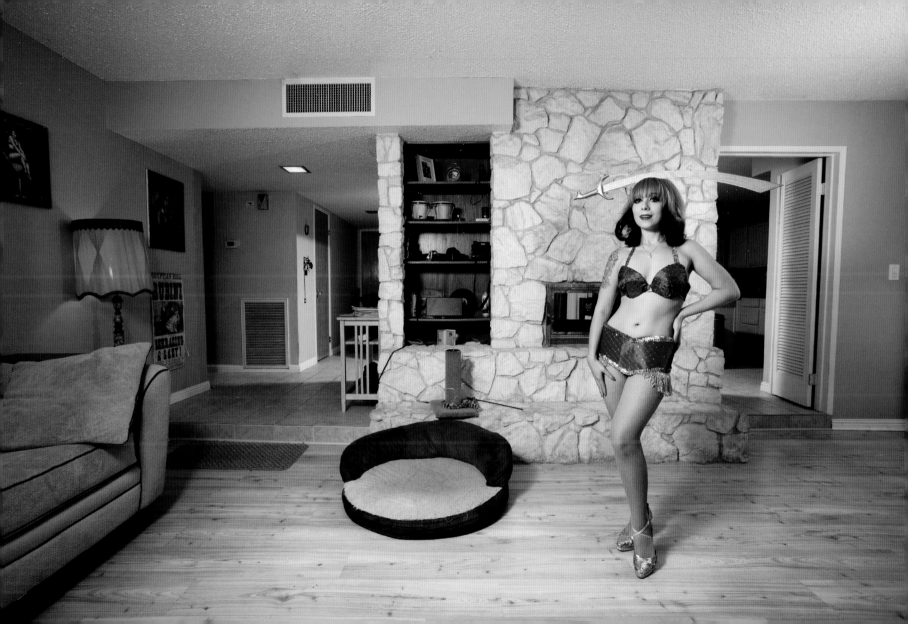

Miss Mina Murray
Burlesque Performer
BOSTON, MASSACHUSETTS

Burlesque to me means a combination of dance, theater, glamour, costumes, a little bit of special effects and, for me, a little bit of circus arts all sort of rolled together into one spectacular package.

My background is in theater with a little bit of dance thrown in. And lately I've been performing circus arts. And the fact that burlesque allows me to put all of these arts together while wearing fabulous costumes, and I get to take my clothes off in public. What could be more wonderful than that?

Burlesque means so many different things to different performers. I love the openness of it and the opportunity to make it whatever I want it to be, as long as it has those certain elements of, say, striptease, humor, and theatricality. I think those are essential to burlesque.

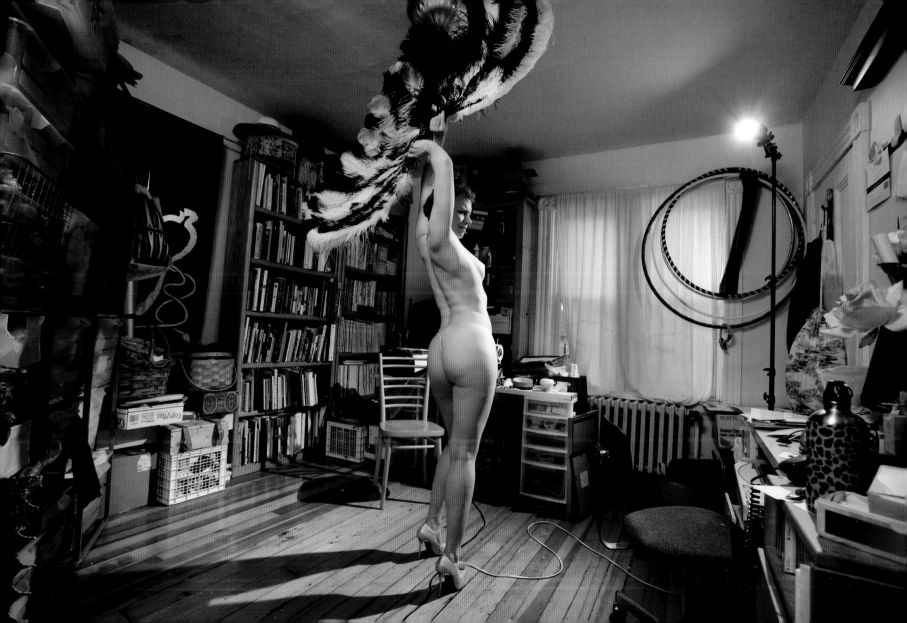

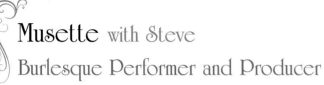

Musette with Steve

Burlesque Performer and Producer

MINNEAPOLIS, MINNESOTA

Burlesque means to me an opportunity to get onstage and live life glamorously. I guess I feel like it's do-it-yourself. It allows people without any dance background or theatrical background to be able to develop their talents, kind of like street performers, which, I think, originally, you know, the whole theatrical business comes from. You have this talent, you can do it? Why don't you do it in front of people? You can do it in front of people and they like it? Why don't you do it onstage? And I like that, I like how you see people be able to develop things that they didn't know they could ever do, and it's really awesome. So, thank you burlesque, 'cause now I get to be onstage.

For me, I'm very opinionated about the way I feel about it because it was never to emulate the old school 1950s people. It was more just a way for me to climb and crawl onstage and be able to have people look at me, because I always wanted to be onstage and I always wanted to be a dancer. I can't touch my toe to the back of my head or call an eight count in a split second, so there's just kind of a do-it-yourself element that allowed me to do it and it means a lot to me. And I think it's great that people that are ambitious and wanna do it can try it and some might go a long ways with it and some people don't; but, it's just a great experience to give it a whirl.

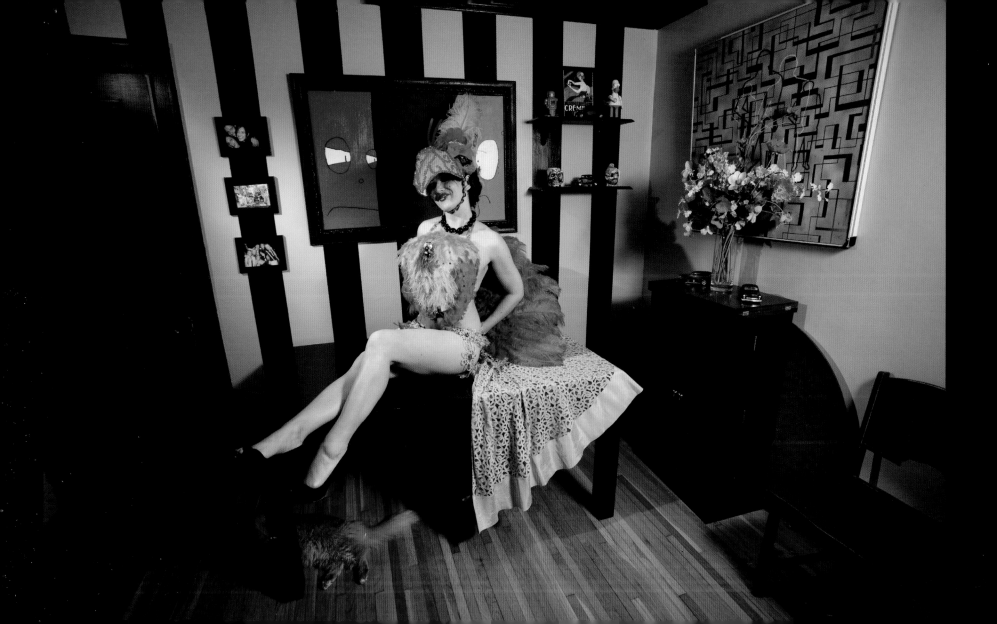

Penny Starr, Jr.

Burlesque Performer, Producer, Instructor, and Filmmaker

LOS ANGELES, CALIFORNIA

Burlesque means to me something overtly theatrical. Definitely something funny. It has the ability to be sexy, although that's specific to every audience member what is sexy and what isn't. And most importantly, it has to be entertaining.

What I love best about burlesque is it's open to everyone. I couldn't be a traditional Broadway dancer. I'm not even five foot, and I'm a 36-26-36—not traditional dancer qualities. And I haven't been dancing since I was twelve. And that world was cut off to me until I found burlesque, and I realized, oh, burlesque is whatever you bring with you. I knew I could make a costume when I started. I knew I couldn't necessarily dance but I could mimic a lot of MGM musicals. And I could make a good costume and I had boobs. And that's actually what gave me the confidence to get into burlesque, I knew I could get all of that, and I figured the rest would just come along the way. And since then I've been studying dance, but, I like to see a performer's personality onstage. And there're some beautiful performers, and I swear to God you never see their soul. And that's important to me, I need to see the performer's soul for me to really be engaged with what they're doing.

Burlesque also has brought dance back as a form of entertainment. That hasn't existed in decades, where you can actually go to a theater and see people dancing. And not like a dance concert, 'cause that's a really specific audience. I don't know that people go to dance concerts if they're not studying that particular brand of dance, or they have a friend in it. It doesn't have mass appeal. And I honestly feel that this burlesque movement that's been going since '95, is kind of why we can have shows like *So You Think You Can Dance* and *Dancing with the Stars*. Ballroom dancing has existed forever, but that never became a thing anyone wanted to see on TV. But I feel like burlesque has kind of laid the groundwork for people to enjoy dance in a way that doesn't feel stuffy to them.

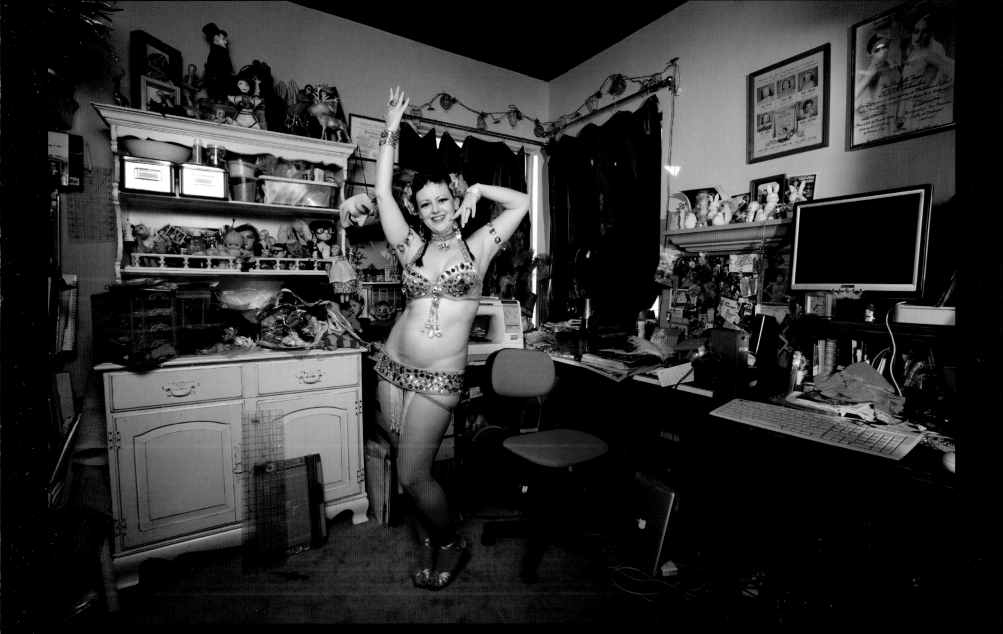

Miss Indigo Blue with The Little Man

Burlesque Performer, Producer, and Headmistress of the Academy of Burlesque

SEATTLE, WASHINGTON

Well, what does burlesque mean to me? Burlesque by a dictionary definition, I'm sure you've received that already … but, I perceive burlesque to be a theatrical art form in which there is a combination of sex, theatricality, comedy, and personality in the short form of three to five minutes of a routine, and in the long form of up to twenty minutes.

However, burlesque is more than just a dictionary definition and is more than a historical accounting of what this theatrical art form is. Contemporary burlesque is actually now a vast and wide burgeoning social scene and performance community with, of course, the shows at the center of it. But, there is so much more included and involved. The folks who are at the forefront of the neo-burlesque movement, who are performing in the late nineties and early 2000s, are folks who all know each other at this point. And now we travel around to different cities and perform together at the same festivals. There's now a performance circuit, which was unimaginable just a few years ago. So, the scene itself has expanded, exploded, mushroomed … however you wanna describe it. But more than just the shows, which are at the center of the burlesque movement, there are the people and the relationships and the community that makes contemporary burlesque what it is.

What burlesque means to me personally is that, what started for me as a form of expression, and also a perfect storm of my own personal character assets—theatricality, comic timing, exhibitionism, a love of dance, and being a ham—has turned into a full-time career and lifelong passion. When I was in my pre-burlesque days, I didn't know what I was. And then I discovered that I was a performer. And then I discovered that I was an entertainer. And that has been a magical discovery process. And now I spend my life trying to share my experience with audiences and new up-and-coming students. It's the joy of my life.

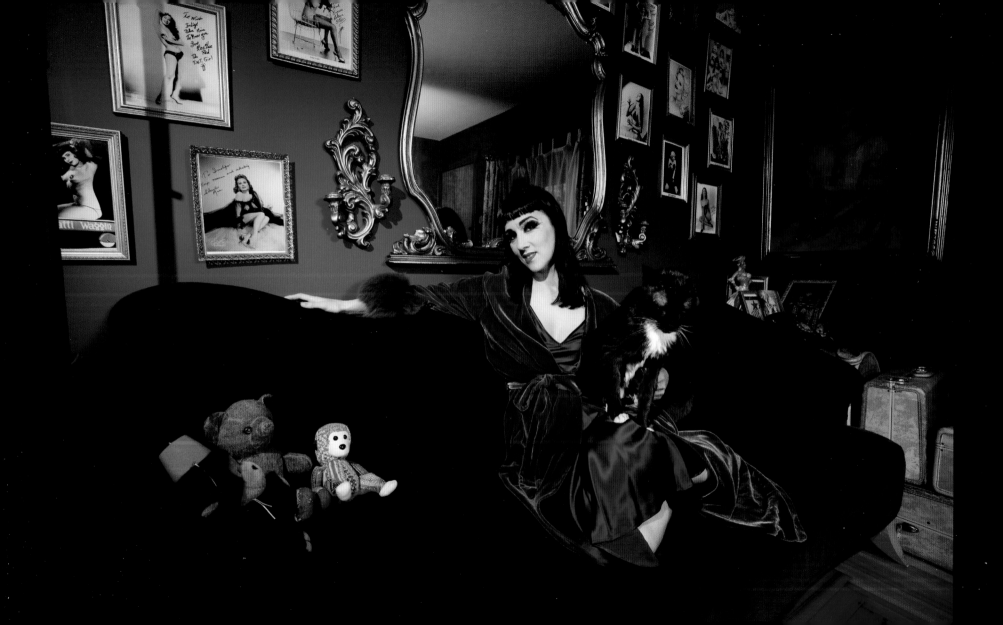

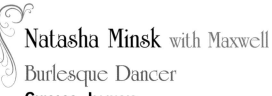

Natasha Minsk with Maxwell
Burlesque Dancer
CHICAGO, ILLINOIS

Burlesque for me is a means of expressing myself with complete creative control over my product. I am a trained opera singer. I have my Masters Degree in Opera and, as much as I love opera, it definitely doesn't give me that opportunity. And with burlesque I am able to create a routine from the ground up. I do the costuming, the choreography, and create the theatrical impetus behind the routine; it's all me. Even if I get outside help creating it, everything is my idea.

Having full creative control is really a source of pride for me. It is thrilling to perform something onstage that I created in its entirety and that gets a great reaction from an audience. That is incredibly satisfying.

The intent of burlesque, in my opinion, is to impart a theatrical experience. You're telling a story. It's not about objectifying the performer or any other participant in the show. You know, when burlesque first started it was more about objectification and pleasing a specific subset of society, and now it's more about entertaining them theatrically and being an empowering force through your performance.

Burlesque allows you to be an empowering force because you are, again, in full creative control. You put yourself out there 100% and created this theatrical presence, and you are confident in doing it. You are secure in your sexuality and who you are, and people in the audience, both men and women, find that very empowering.

The audience members find it empowering because they are seeing a woman who is confident and secure in her sexuality and being, and they realize that they, too, can be that person.

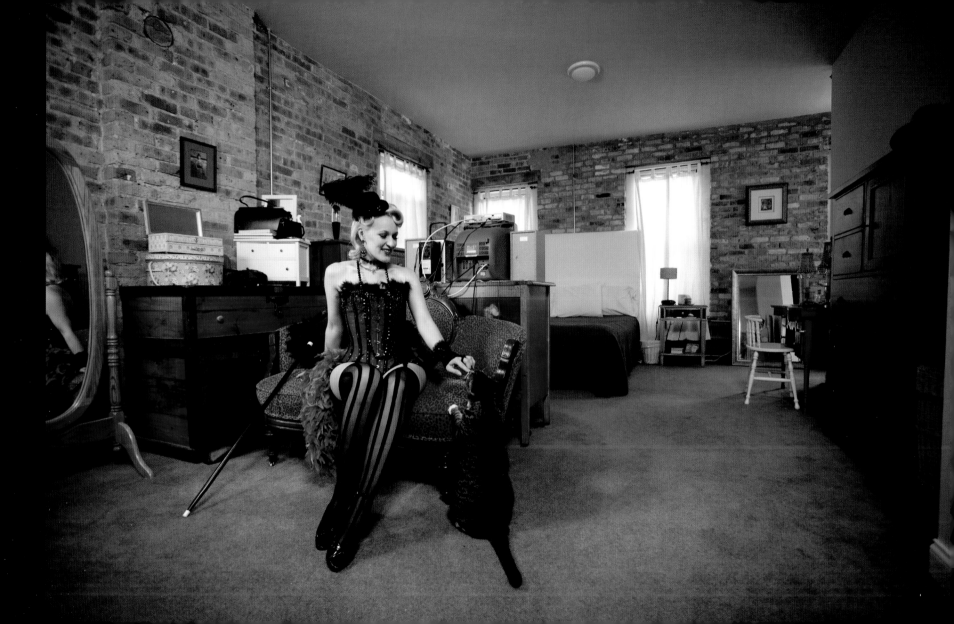

The Lady Ms. Vagina Jenkins

Burlesque Performer

ATLANTA, GEORGIA

Burlesque to me is about striptease, about being fantastic and someone's fantasy. Burlesque is ladies lovin' their bodies, hopefully, and teaching other ladies how to love their bodies. And fun. Yeah.

My thing is about having body-positivity and showing that to folks and wanting other ladies to love their bodies in the same way. I lead by example, being a person of size onstage that's not the butt of a joke, that is graceful and elegant and sexual and takes up space without all the sort of negative connotations of being a fat person in America. I lead people to believe, or lead women to believe, that their bodies can be beautiful and dynamic and useful and amazing. I think. I'm pretty sure.

Burlesque to me, or, to The Lady Ms. Vagina Jenkins, is about being a loud, obnoxious, visual exclamation point, about taking up space and about commanding and demanding the visual gaze. And the lady gays.

46

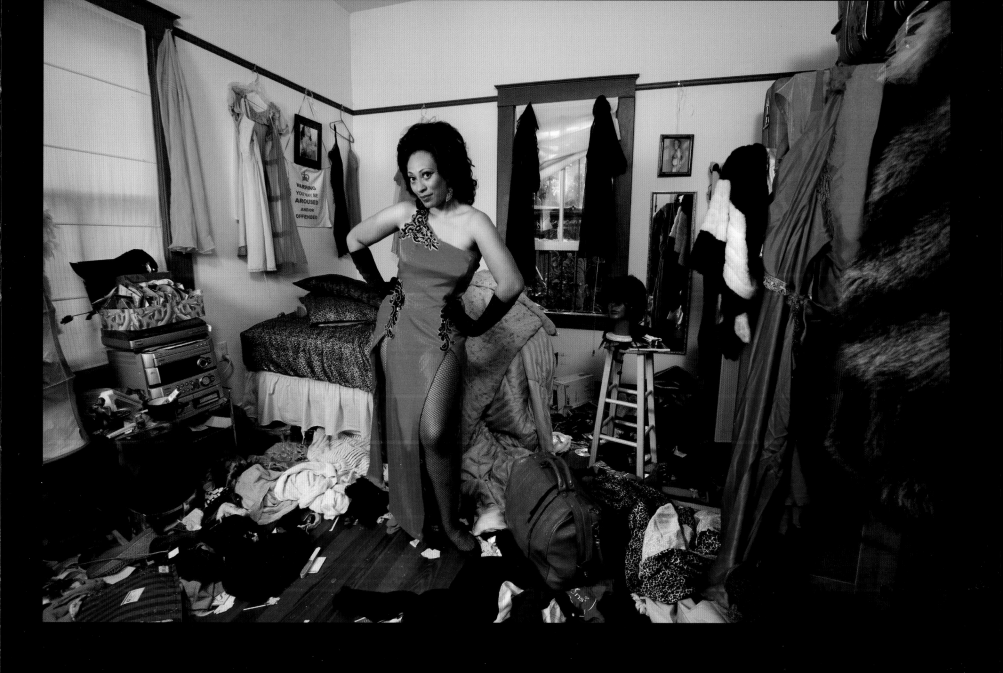

Backdoor Aly

Burlesque Dancer and Producer

CHICAGO, ILLINOIS

What burlesque means to me ... well, I've got quite a few answers for that. One thing it means for me is a helluva good time. I love having that audience—I've been chasing an audience since I was a little kid and I just love feeding off of that. I'm a person that really needs that or I go slump deep into a depression, *so pay attention to me!*

What it means to me is a good time. It means empowerment—female empowerment. You can have any body you want; you just need the confidence and the lack of insecurity and I love that. I was born an Aries. I'm the oldest girl in the family. I just really am an independent. So, burlesque for me is a way to showcase my independence, like, to the hilt, to remain creative. And we have a good community, so all my friends are in it; it's a nice family to belong to.

Also burlesque means to me unrefinement. I'm not a Vegas showgirl, which are typically the same size, the same weight, the same facial type, you know, cookie cutter. But with burlesque you can have the unrefined bump and grind. You can just go out as you and make everybody love you for you, and just have that edge or have comedy based behind you or be a little bloated. It's cool; it's fine. And that's the beauty and freedom of burlesque, which I love so much.

The empowerment really came about because I've always been this way. I've always been an exhibitionist and I've always been a leader and a boss. I'm shovin' it down your throat, be it comedy, be it music, you know, whatever. So now with burlesque, I never really thought about the empowerment because I live empowerment all the time, that's just me, my make up. But I never really thought about the empowerment issue until people started coming to the shows and it was women after the shows that would come up and they're like, "This show is so empowering to me because I'm watching you and you're not flawless and you can do it and you make anybody think they can be a part of it and do it because you have that confidence and it's contagious." So, I never really thought about the empowerment until I started getting that feedback and I like it! I really like that, for somebody who's very pro-female. I really like that feedback.

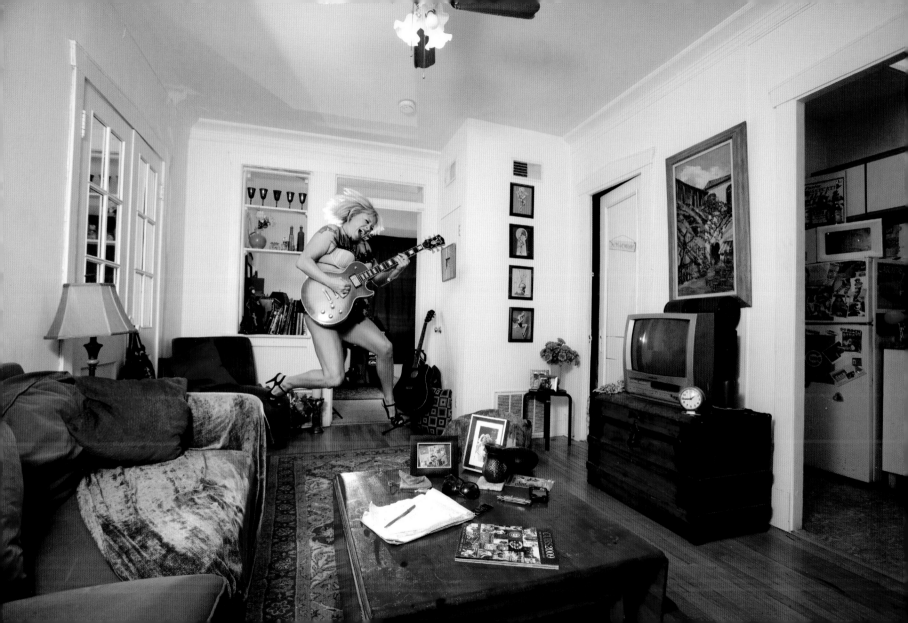

Cha Cha Velour

Burlesque Performer, Producer, and Instructor

Las Vegas, Nevada

This is actually a question that I've thought about a lot. Especially living in Las Vegas, with the reflection of what I feel Las Vegas thinks burlesque is and how that influences my definition of burlesque.

What burlesque means to me ... I mean ... I don't know if I have an actual word definition. I know what the dictionary definition is, that it's a literary or theatrical work that is humorous in nature, and is grotesque exaggeration and I'm inspired by that. It is like the theatrical part of it.

To me it is more than just stripping. I'm not just stripping. I'm performing. I have this song and I want to share something with my audience through my performance. You conceptualize the colors of your costume, and the costume, and the choreography, and how that all goes together. So it's more than just a woman or a man taking their clothes off onstage. It's a performance, obviously very adult. It's not for the kids. So, it is adult entertainment, but it's something a little bit more than just a girl on a pole. Even though you can be on a pole and still definitely be performing a burlesque routine.

Living in Vegas, I feel burlesque is a performance, but also sort of a way of celebrating individuality in the spectrum of burlesque. You can be a perfect 10 body, thin, have everything ever done to you under the sun cosmetic-wise, or just look that way naturally. Or you could be a large woman; you can be gay, straight, man, woman. I mean, there's even little people that perform burlesque and big, tall people, and young people and old people. That's all within the neo-burlesque community. That's all celebrated. Really it's not so much about who's hotter than who; it's really about who's more entertaining and who can give a better performance, or a more entertaining performance.

So, I'm thirty. I started doing burlesque when I was twenty-seven. And, I don't know if it's just because I'm getting older that I'm more comfortable with myself, or did burlesque do that for me? I think burlesque has done that for me. With my body image, with feeling that I can accomplish things, especially since I started producing and teaching and influencing things a little bit in this city. I feel really good about myself. And I know burlesque has given that to me. I feel pretty. I feel like it's fun to get dressed up, as opposed to just wearing jeans and t-shirts every day. I'm kind of a jeans and t-shirt person outside of this. So I get to have this too and it's made me feel really good.

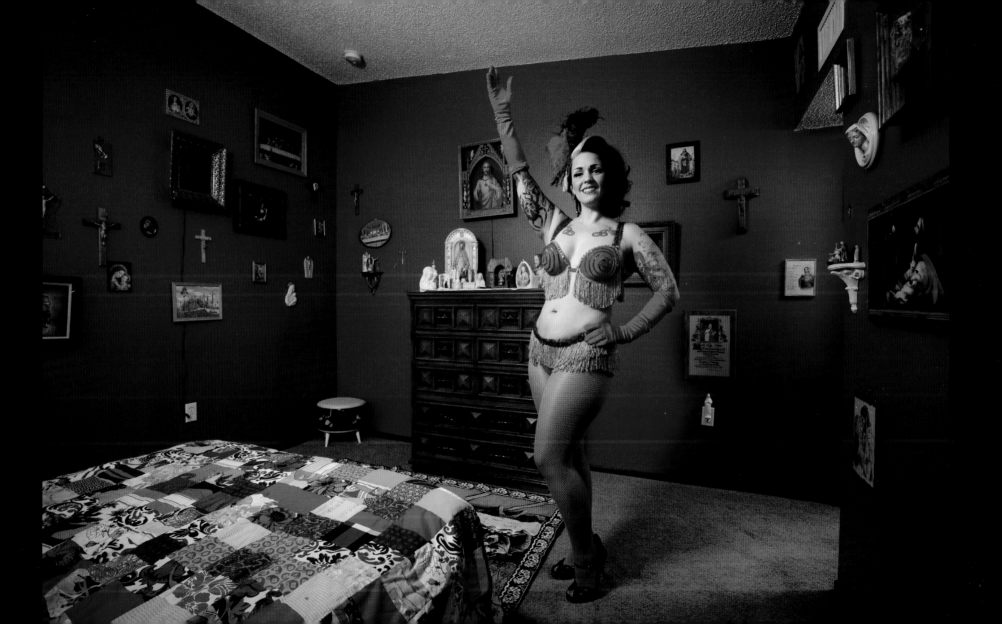

Hai Fleisch
Burlesque Performer
PORTLAND, OREGON

Burlesque means so many different things it's hard for me to start in one spot. For me burlesque means a lot of creative freedom. I think the format is really unique in that your numbers are usually under ten minutes, usually under five minutes. And basically, since the beginning, the base of burlesque has been comedy and naked ladies. And really you can go so many different directions from there. It can be comedic, it can be serious, it can be more performance art and you could make a political statement but usually that's in a joke sort of form. I think it's really just beauty for the sake of beauty and entertainment just to entertain and doesn't have to be anything bigger than that.

I like that it's very playful and there's almost sort of an innocence to it. Sort of like children playing dress up. I like that you get to bring this character to the stage that is part of you. Hai Fleisch is a part of me. It's not an alter ego that I invented. It's a side of me that doesn't get to come out and play in normal day-to-day life. Not because I'm ashamed of her, but because I can't live in fringe and rhinestones and feathers all the time.

And you get to bring these little parts of your creative mind onto the stage and they don't have to be beginning-to-end narrative stories. They don't even have to make sense. It's just play and it's fun.

I also like that I feel, when you start doing burlesque, you're joining a greater community of people and you're joining a history and I've gotten to meet some of the women who have been performing and they're in their seventies and eighties now. I've met lots of performers from all across the country. You enter into this bigger family of people that tend to have a lot in common, like being very boisterous, being very unashamed of taking off their clothing in front of other people, being very theatrical and very warm, and being very welcoming. And that's been really exciting. I feel like you're stepping into a continuing history when you start doing burlesque, and I like that part about it.

One of the things that I really appreciate about burlesque, or specific performers, is when people make their own sets and costumes. I think burlesque is theatrical, but it's different from seeing a play because a play is all these different people in different departments coming together for one product. And when you see burlesque, usually it's choreographed by the burlesque performer, the concept is theirs, the costume is usually made by them, and all of the props that they make as well, and then they perform it. So you're really seeing just a labor of love onstage by that person.

I tend to approach burlesque more as performance art than a classic striptease. I do appreciate the striptease also, and I think that is an interesting art form. But, I kind of revel in just being able to get up onstage for three minutes and do what I want. But I do kind of between performance art and classic because I am very inspired by the old costumes, especially Ziegfeld. And I like to come out with the big headdresses and really, sort of, showcase that kind of thing. But, I also like getting up there and doing things that are probably considered pretty unattractive—making weird faces or using my body in ways that are kind of grotesque. I think that I like the reaction that gets from the audience when I come out all done up in makeup with my chest out and contorting around, you know. So, I like to go between the different styles of burlesque. And I actually feel like I have more fun at shows where there is a variety between all those different styles, personally. I appreciate them all.

I think everybody who performs burlesque enjoys the glamour aspect. The Dolly Parton over-the-top glamour of rhinestones and feathers and boas and glitter. In my daily life I'm usually in a ripped-up t-shirt and jeans on a bicycle. I like both. I like being able to get really girly. I like being able to be backstage with a bunch of other girls throwing on glitter and fishnets and getting really silly and girly. And the backstage part of it is probably just as much fun as performing for me. But, I feel like on a daily basis I'm probably more comfortable as sort of a tomboy. But, I like to be able to be a showgirl in front of an audience and really it's sort of like being a super hero, because it's this exaggeration of a person. I mean, nobody really dresses up this hard when they go out to go dancing or something. And I really like the sort of almost drag queen aspect of it. I really like drag queens, so that makes sense. I get mistaken for a drag queen. Surprise, surprise. Yeah, I like the boldness.

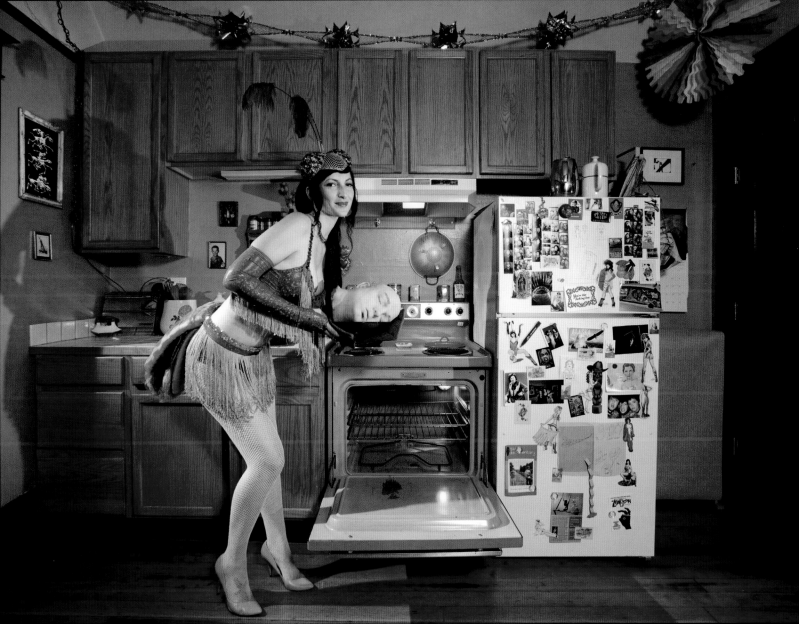

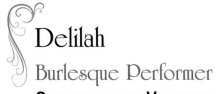

Delilah
Burlesque Performer

ORIGINALLY FROM VANCOUVER, CANADA, AND LIVING IN SAN FRANCISCO, CALIFORNIA

To me burlesque means an opportunity to engage with an audience, to tell stories, to make them laugh, to teach them something about the world as I see it, and hopefully share a moment that's entertaining for both of us. It's about communicating, more or less. I mean, occasionally the process of storytelling brings you to a place where it's political or it's edgy or it's potentially uncomfortable, but I always want to kind of bring it back into a narrative kind of story situation where you're still on the stage to entertain the person and to sort of have a moment of exchange without getting too heavy. I mean I guess I have a couple acts that sort of expose a part of myself that isn't apparent. At first, I'm just a burlesque performer or I'm just a stripper or whatever, but then they learn a little bit of something about me that's deeper than that. So if they learn a lesson, that's exciting. But, yeah, I still think my primary goal is to make people smile and make people laugh and make people forget about all of the things that are going on outside of the club.

Yeah, I mean, if you wanna see what burlesque means to me, come see me in a show. It's all going to be onstage, right there onstage for ya.

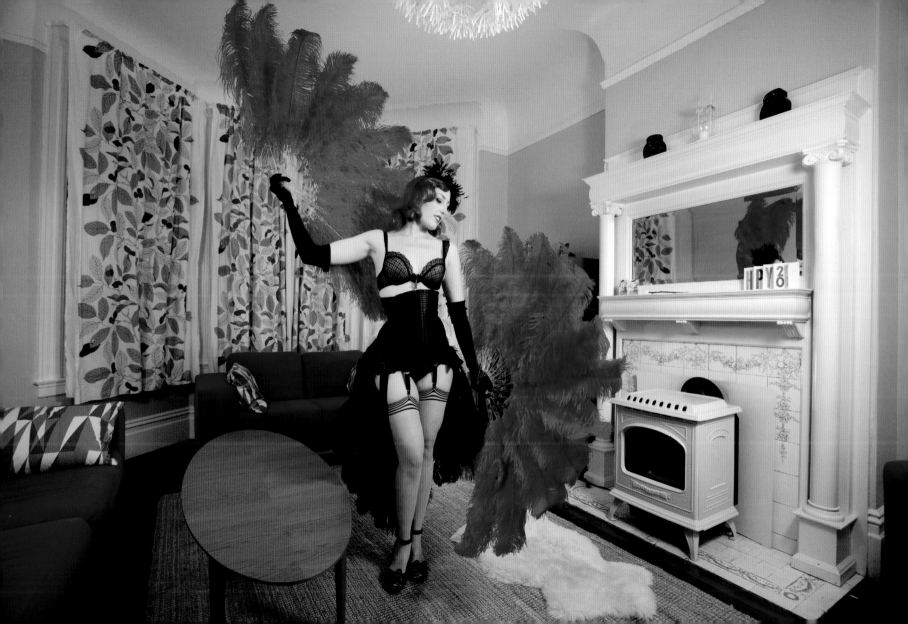

Kalani Kokonuts

Burlesque Performer

Las Vegas, Nevada

What does burlesque mean to me? Burlesque is a way that I get to express a hyper-feminized idea of myself. It's the place that I get to go to wear feathers and rhinestones and also get paid. And, you know, there's a sense of legitimacy with burlesque, as opposed to stripping. Stripping and burlesque are both legal, but the reaction you get when you say you're a stripper, as opposed to the reaction you get when you say you're a burlesque performer, are very, very different. So, when I say I'm a burlesque performer, there is a sense of legitimacy, like, oh, okay, well she's a real performer, she's a real dancer. As opposed to saying, hey I'm a stripper and I dance for dollars and, so, yeah, it's still very taboo. Stripping is very, very taboo and, you know, there's this whole sense of, oh, you know, Daddy didn't love me, kind of a thing with stripping.

Definitely burlesque is more creative. You can't go to a strip club and get onstage in drag and do whatever it is you're doing and expect the audience to be receptive because, chances are they're not gonna be.

A lot of everyday people don't even know what burlesque is. And neither do we. So, as far as stripping is concerned, yeah, yeah, you're stripping. So if you're taking something off, you're stripping. So, you know, there's a point where I could say, yeah, if you wanna be, kind of, really, really technical about it, you could say, well, stripping is maybe more vulgar, and burlesque is a lot more seductive. But, stripping can be seductive. So, it just depends on your perspective, I guess.

I do have words of wisdom for the hobbyist housewives. Spend that money elsewhere. It's just a labor of love and ultimately you'll go broke. I mean, unless you're very, very successful, which is rare, you know, it's a tough road. It really, really is. But, if it is a hobby and something that you actually have to do because, if you don't, you're going to die, well, it's none of *my* business to stop you.

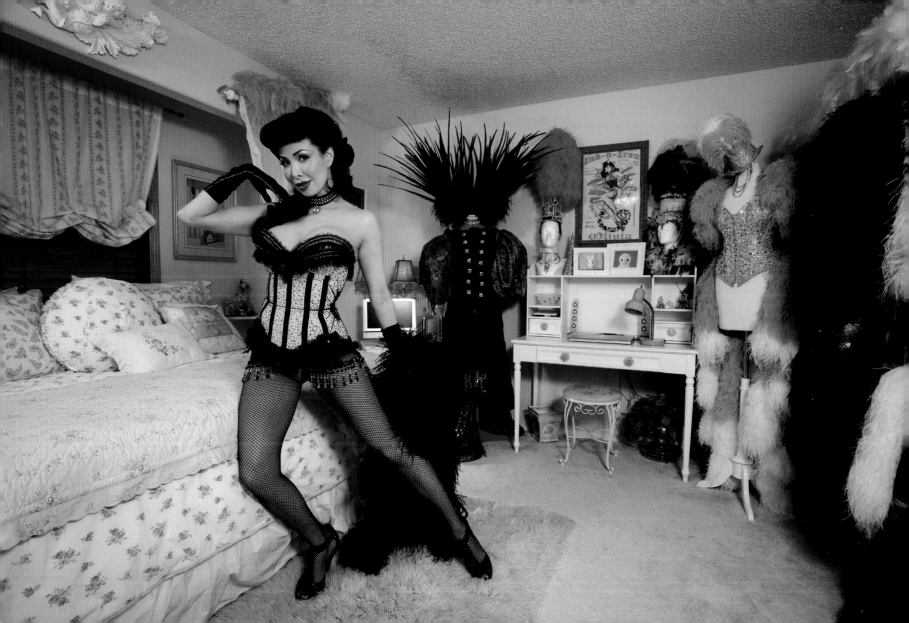

Original Cin with her son Mike
Burlesque Dancer
GRAND RAPIDS, MICHIGAN

What does burlesque mean to me? I think burlesque is parody and comedy and self-expression. I think that it's glitz and glam, the old-time glamour. The freedom to do what you feel is right for you. The freedom to express yourself through song, dance, through the movement. Telling a story through the movement. Over-exaggeration through the movement to make it comical.

I performed belly dance for eight years before I went into burlesque. And I just think that burlesque is very feminine and very empowering, actually, to women. I think it makes a woman feel strong and in control. In a way you are in control, you feed off the audience for your energy and they give it back to you and you give it back to them. So, I think it has a lot to do with that.

It's just the freedom of expressing your feelings, your movement. You work hard on a routine to show it to everybody, to an audience, and I think there's something empowering about that, about working hard, and then the fruits of your labor coming to terms onstage. Yeah. I think that's a lot of it. The glitz and the glam definitely help, though. All women are magpies.

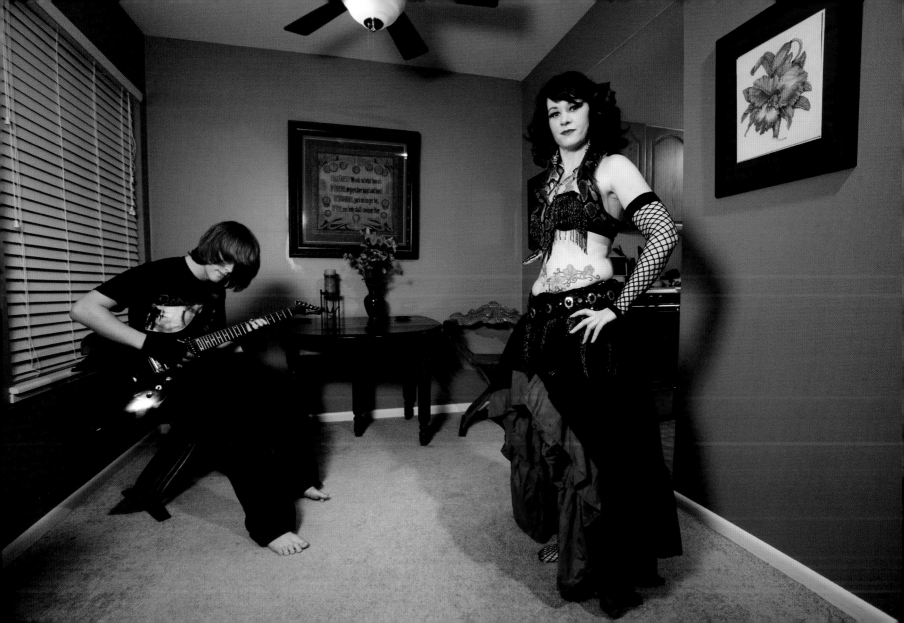

Lili VonSchtupp

Burlesque Performer, Producer, Enthusiast, Instructor, and Podcaster

HOLLYWOOD, CALIFORNIA

What does burlesque mean to me? It's a great question. Burlesque means I never have to say, "Would you like fries with that?" Burlesque is my life and I'm fortunate enough to be able to make a living at it. And it's an amazing experience. I get to work with my friends. I get to leave behind the reality of working a nine-to-five job doing something I absolutely hate. I get to be all of the things I wanted to be as a child. I got to grow up and be a princess. I got to grow up and be a fireman. I got to grow up and be a cowboy and an Indian. I get to experience life the way that most people who sit at home after a long day wish they could. Instead, they go, "I guess I have to get up again tomorrow 'cause we have a mortgage and two kids." Burlesque lets me bring every creative thing I've ever experienced in my life and put it on a stage and share it with the world. It's one of the most awesome feelings you'll ever have in your life and I highly recommend it to everybody to try once.

And the thing that's amazing about burlesque is that it's not limited to stripping. The history of burlesque goes back to parody, to mocking your government, to making exaggerations on society. In today's burlesque we still have that opportunity. We also have the opportunity to take all of the variety arts and put them into burlesque. So our strippers are our jugglers. Our strippers are our hula-hoop artists. And, to me, that's what makes burlesque so amazing for people. You get to go onstage and show highlights of talents or thoughts or experiences that you have. You get to say, not only am I this woman in this body with, you know, these boobs and this ass, which may not be exactly what you like, but I also have something to say.

And burlesque allows you to do that. For me, it's the only way to live. Every Monday night I get to go to a venue here in L.A. and I get to sit down with my friends and put a show on. It's incredible. Burlesque is amazing. I'm gonna cry. Sorry.

You have an opportunity in burlesque to show off who you are inside. It allows you to say, "I don't like the president right now and I have something to say about that." And I can say it using my sexuality, I can say it using a mask, I can say it by juggling in a weird way. I can tell my story through burlesque. It encompasses strippers and it encompasses every variety of art out there.

Burlesque is more than just a body. I think that's what I'm trying to say. From every body style out there, from every point of view out there, you can take it onstage, you can put it in a show and hopefully entertain people, as well as maybe inform them or show them that you're forty-four years old and you're a housewife, or you're thirty-seven but you won't be defined as being a lawyer. You are also this creative entity. And you get to put that out there.

Burlesque is an amazing art form for women because it allows us to be more than what the contemporary issue of *Vogue* magazine says is the perfect woman. Burlesque encompasses every weight, every sex, every color, every race, every religion. It doesn't discriminate that way. Burlesque is a very open, loving community. Burlesque looks at all of those things and says that's not what makes a woman a woman. When you're stripping in burlesque, you are allowing your inner beauty out.

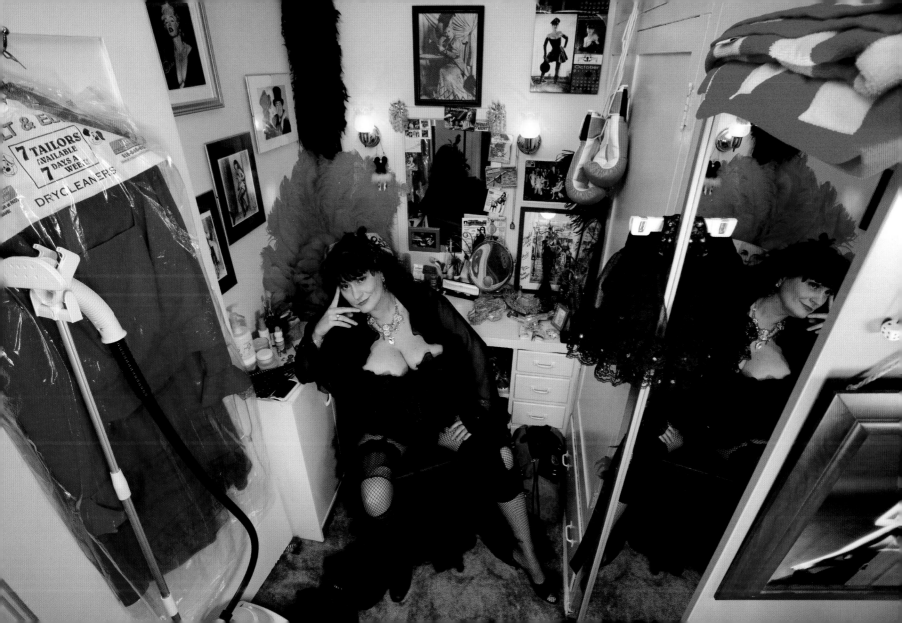

Lady Jack with Tybalt
Burlesque Dancer and Producer
CHICAGO, ILLINOIS

I think saying "this is what burlesque is" is kind of difficult at this point. It started out really referring to a show as a whole, which incorporated elements of the striptease, but really more so focused on satire and on parody and on comedy and skits. And I think that striptease was added sort of as an additional element—it wasn't the core element to begin with, but it became the most popular element. And it was the striptease portion of burlesque that continued throughout the years until now. There's recently been a huge revival of burlesque.

My preference is more towards the theatrical side of burlesque, towards creating a character, or even if it's not a character, a very theatrical persona. And, you know, a lot of my pieces have a story element—not necessarily always. I'm really more interested in communicating a concept to the audience, really communicating, even if it is just straightforward striptease.

This is my thought on sensuality. The line of a piece of music, if it's getting more and more and more and more intense, how does that kind of correlate to the idea of seduction or sensuality so that the audience, no matter what their sexual preference or experience of sex is can be like, "Oh, I know that. I know what you're talking about there. I connect with that."

And so there's enjoyment there beyond just the act of showing your figure to an audience. To me, I really feel like burlesque affords an opportunity to put something psychological out there for the audience to enjoy as well. And I think the most successful pieces encourage that in the audience because I don't know how exciting it is to see my forearm just for my forearm itself. So if I remove a glove, I don't think it's going to be exciting unless there's some kind of a communication with the audience. There has to be some kind of a connection with the music that makes it interesting.

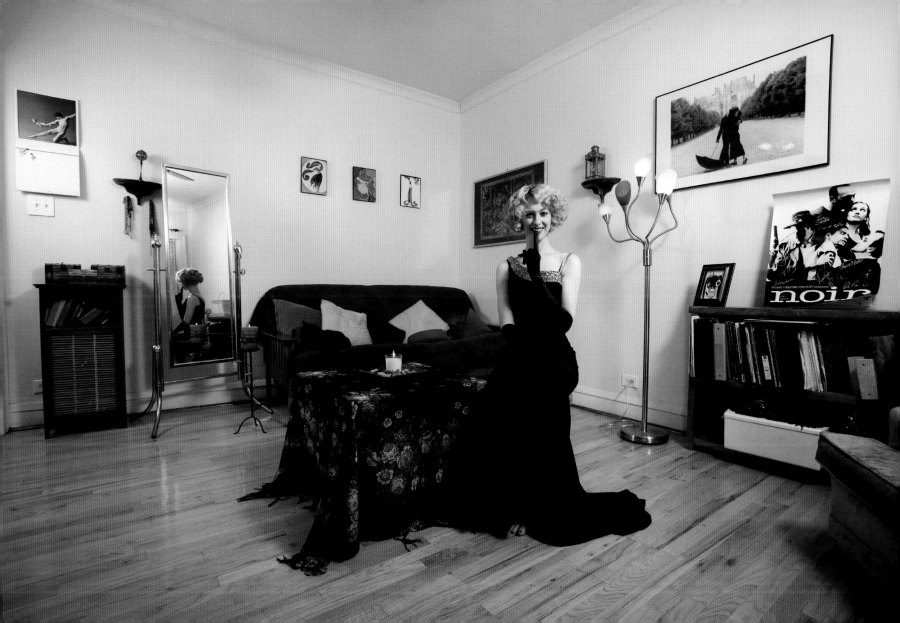

Sweet LillyBee

Burlesque Dancer

MINNEAPOLIS, MINNESOTA

What does burlesque mean to me? The first thing that comes to mind when I think about it is freedom. I've been kind of pondering it. I can't think of anything that captures it better for me. There's a freedom of expression, a freedom to create in so many ways. I'm a very creative person. I paint and I write and I sing and I dance and I love to make things. And so, all of those things come together in burlesque. The other piece that's really strong for me is a piece about empowerment. I think I spent probably the first half of my life feeling disempowered and unsure of myself. I didn't believe in myself as a person. I sort of walked around with my head down. I didn't think people liked me. I didn't put a lot of attention into my appearance. I was pretty punk rock, and so most of my expression in the world was pretty angry. You know, I was always kind of looking for a fight or people were always looking at me like I was a freak and so I kind of took on that persona, which serves me now. But, I've seen this other piece of myself that I never saw before, which is that I'm also a beautiful woman. And I can show that in the world in a way that I was never able to before.

I started doing burlesque because I was doing carnival arts, sideshow arts, and it was a natural progression for me to want to do burlesque and to explore that. Once I started to explore burlesque, that's when I really started to uncover my feminine side. I was much more masculine in my earlier years and this feels like I'm in a renaissance, my life is in a renaissance.

The other thing about burlesque is community. I don't want to sound cliché, but I love connecting with other burlesque performers and meeting people from all over the world. We have this shared culture. Even though we all do different things or think different ways about burlesque, there's sort of this baseline of understanding and acceptance that happens … it's an embrace. We all embrace life as a celebration. Life is something to be celebrated and enjoyed with as much glamour and glitter and pizzazz as possible. Yeah.

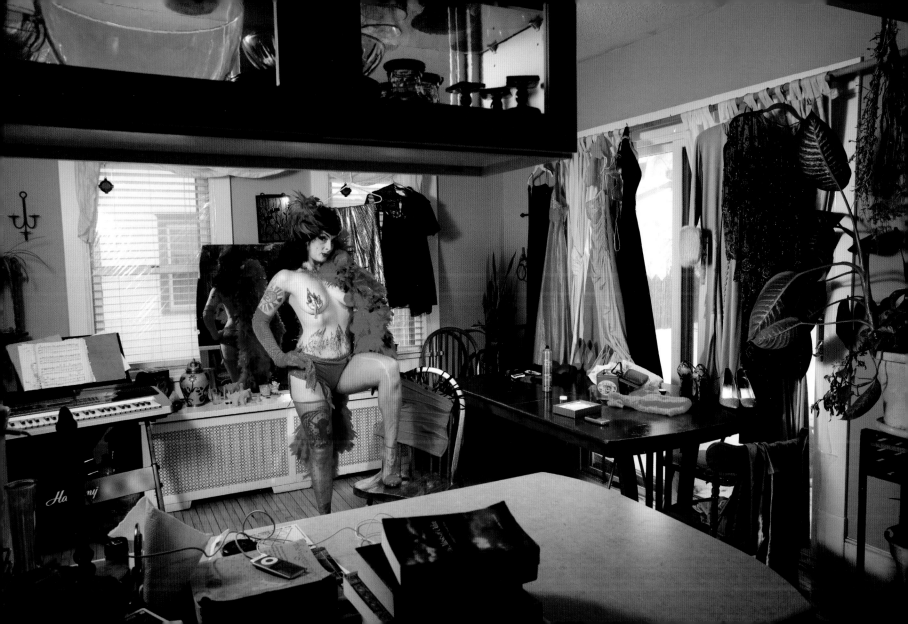

Dizzy von Damn! with Rabbi Julius

Burlesque Performer, Producer, and Enthusiast

LOS ANGELES, CALIFORNIA

Burlesque to me is about a million things, the most important of which I guess is fun. The best definition of burlesque that I ever heard, and I swear to God if I could remember who said it I would be a much better person than I apparently am, but what this person said was that burlesque at its best ridicules the elevated and elevates the ridiculous. And I thought that was brilliant and everything about it made perfect sense to me. I believe that burlesque should be at its heart a little bit funny, or a lot funny, but at least a little. Even if it's just as simple as the Ricky Cortez tapping of the unmentionables. For someone who onstage is as without limits as I am, I get a little bit tongue-tied about certain things offstage.

Burlesque should be a little bit dirty, a little bit funny, a little bit smart. It's about presenting yourself in a certain way, and that can be your best possible way, or it can be in a character's best possible way—or worst possible way if that's what your going for. It's about commitment. It's about entertainment, because if your audience is not entertained or provoked or thinking at the end of your act then you did something wrong. There should be some sort of change. The audience should feel different after you have done what you have done, so burlesque to me is a catalyst, I guess. It's something that changes your experience and the audience members' experiences, hopefully for the better.

Burlesque to me is about evolution. When I first started doing burlesque I was very committed to the high concept whack-a-do sort of funny, crazy, over-the-top thing. When I took the burlesque class that I took they told us in your debut number you should go simple because things are going to go wrong, and you should be prepared for that, and don't worry too much about it. But go simple so that way if things go wrong you don't panic because there's only a glove and a boa and how wrong can that really go? I didn't follow that advice. I had lights in my bra, an LED bite plate, and, like crazy ... I mean, crazy ridiculous things happening. And of course things went wrong, but still to this day that's one of my most popular acts that people always remember me for.

But as I've evolved, like a burlesque act, changing, peeling away the layers of what I do, I find more and more I'm challenged by, and really take joy in, doing something a little bit more classic because it's harder for me. And I like to make myself do things that I don't want to do. That's actually part of why I got involved in burlesque. The idea of people seeing me in a state of undress was perhaps the worst thing that could ever happen to me, and I don't like feeling limited. So I decided I was going to do it. If I don't want people to look at me in a bathing suit, I'm going to have them look at me naked instead. Perfect! Sounds like a plan. I'm all about efficiency. It seemed like the most efficient way to get over that fear. So, what I'm doing now I do because I don't feel comfortable with the sexier parts of burlesque, the more traditionally sexy parts of burlesque, because I can do the funny sexy. That's my default. I like to focus a little harder on the more traditional parts, the sexy glove peels, the stocking peels, things like that.

The evolution of burlesque is really important. I think it's wonderful that burlesque has been able to encompass people of both genders and people who identify as somewhere in between even. That's one of the most powerful things about burlesque for me. You can be whoever you want to be. If during the day you are a nurse, you can be something completely different at night. If during the day you're a man, you could be a woman at night. If during the day you're a woman, you could be a man at night. Who knows? And who cares, really? Because, you have created this amazing character, an illusion, and a world for other people to experience. Burlesque at its best is an experience.

I always regret when people talk about burlesque as if it's a female only activity because it's not and it shouldn't be. And there are so many valuable members of the community who are either not biological women, or who identify only as women for the stage, or identify only as men for the stage.

I love that burlesque has been so welcoming to people of all sizes and all appearances and all genders and sexual orientations. Because your body is just a prop. The act is not about your body. This is a striptease, and as much as it does focus around the fact that eventually I'm going to see your boobs or your butt, it's a prop. It's something that you hang decorations on. It's something that you utilize to tell the story. It's not the story itself.

I don't care what's going on inside your pants or your bedroom. I want to know what you can bring to the stage. I want to be entertained, I wanna be delighted, I wanna be educated. I want this to be constantly changing. I want burlesque performers to constantly evolve. If something is challenging, do it! I believe it's Thomas Jefferson who said, "If you have a problem hang a lantern on it." Well, this is inspiring me. I want to do an act now where I just have lanterns hung all over me—this is my problem, I'm gonna hang a lantern on it. Let's all talk about it. I think that's one of the most powerful things about burlesque. You can draw attention to things in a way that people don't realize that they're being educated or provoked into a thought process that they didn't know that they were capable of.

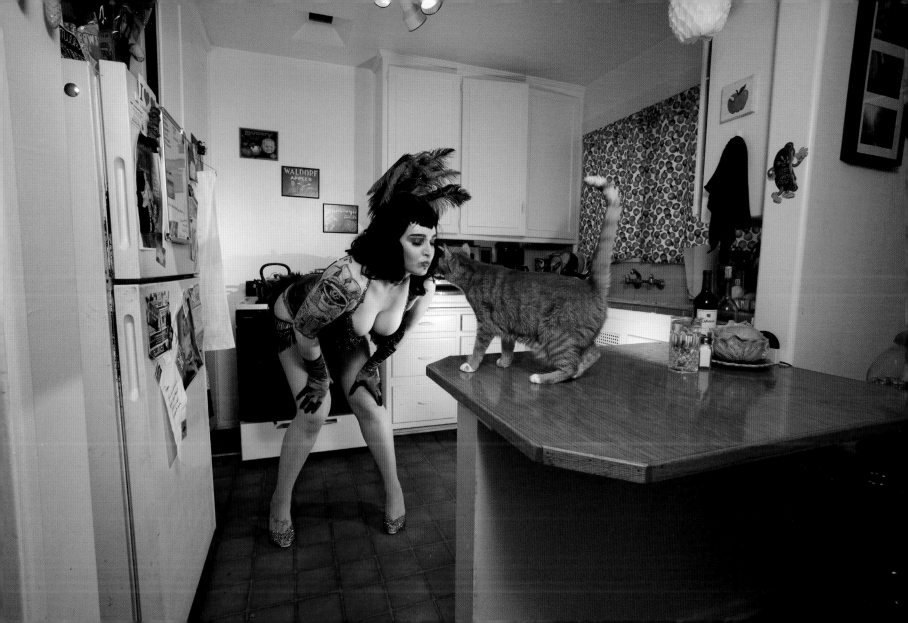

Lola Getz with Frankie

Burlesque Dancer

CHICAGO, ILLINOIS

I think it's just a combination of my dance background and my interest in creative and performing arts and feminism and just sort of a combination of all the aspects of my personality that I get to share with people. And, I think burlesque is just a good expression. People get to express who they are, both physicality-wise and who they want to be. It lets you take on a persona and I think that's pretty important for women at this stage because there's not a lot of creative expression that's easy to share with people. You can do paintings, you can do art, but a lot of times you're not going to get into a gallery show. It's mostly for you and for a small group of people. I think this is something that you can share nationwide as a creative woman and I find that really interesting.

I think it's accessible for almost all types of women. You don't have to have a dance background, you don't have to have performed before, you don't have to have the perfect body. You just have to have a good attitude and have a lot of fun doing it, and that's sort of the key point in this. You don't have to be a specific type of person. Everyone can do it, and I like that.

I think everybody has a specific talent. It's just finding where your talent lies. Some girls are really funny. They're not as fantastic as dancers, but if they hit a comedy number, they're amazing. Everybody has a specific talent. Sometimes it's being funny, dramatic, spinning fire poi, doing hoop. Everybody has something that they can do. It's just finding where that is and not trying to be something other than yourself. I think there are a lot of performers who try and be something other than themselves, and that's where you get to people who don't look comfortable onstage and don't look like they know what they're doing. But I think everyone has that talent to them and everyone could do it. They just have to find who they are.

It's really shiny. I like the glamorous aspect. I'm very not glamorous in my day to day life, and it's a good excuse to do the whole hair and makeup and put on something nice and go out and have that sort of 1940s feeling of a classy evening, which we don't get anymore because we order pizza and sit in our pajamas. So, I like that about it.

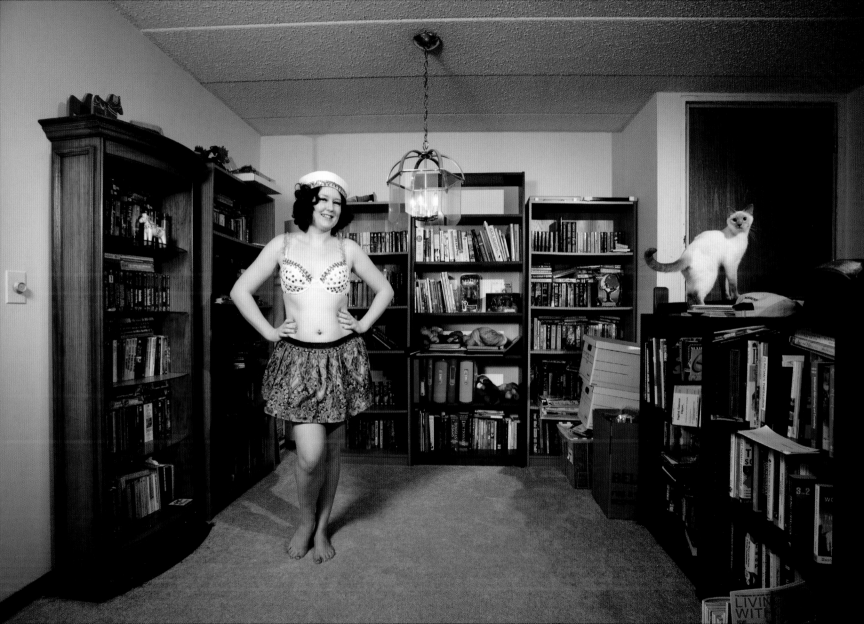

Mr. Happy Pants & La La Vulvaria

Mr. Happy Pants: Burlesque Host, Producer, Director, Writer, Music Arranger, and Band Leader

La La Vulvaria: Burlesque Dancer, Choreographer, Producer, and Circus Performer

GRAND RAPIDS, MICHIGAN

Mr. Happy Pants: To me it means not half-assing it, 'cause I couldn't stand seeing theater or music where people are wearing jeans and t-shirts on a shitty stage with a shitty backdrop in a poorly lit club where people aren't paying attention. When I get onstage I'm gonna look my best and everyone around me has to look at least as good as I do, and if you are there, you should be giving me your undivided attention. So burlesque is the real theatrical experience.

La La Vulvaria: Yeah, for me burlesque is like being a rock star onstage. For most of my theater career I did a lot of serious theater. I come from a serious Butoh dance background and all of this sort of dancing for your angst. And so burlesque kind of allows me to be a rock star onstage, but also, I think that burlesque and theater in general is sort of a sacred place and a tool that we get to use and …

HP: That people take for granted.

LL: … I feel very privileged to be able to use the theater and to use the stage to convey a message.

HP: Yeah.

LL: And we parody anything, including mostly local humor, mixed with political humor, mixed with any kind of current events, with themes, and I think we keep everything current and we keep everything fresh.

HP: But, basically because burlesque is what's happening right now,

that's our way to honor theater and do it right. 'Cause no one's gonna come see us do a monologue.

LL: We've found out that no one wants to see modern dance, no one wants to see a band onstage, no one wants to see poetry, no one wants to see a monologue, but when you throw it all together into one package with some glitter and some comedy, it seems like we can attract this big crowd. So all of our performers that perform with us on their own would have a hard time filling a 400-seat theater. But when we pull our resources together we can have a really great show, we can have a big crowd and people like to see our shows. It's so much fun. We have fun.

HP: I think the other part of that is we want an audience. Coming from a serious musical background, and Rachel coming from a serious theatrical background, serious music and theater is putting people to sleep. It's just not exciting. And people aren't paying attention to it, at least in this town. I mean, we're in a really sleepy, pretty salient Midwestern suburban area, you know, so you're just not gonna get an audience doing theater. I mean, the serious music or the serious theater. And then, of course, the other half of it is our egos and just wanting to get onstage and be the super-stars, you know? You can't wear glitter and read Proust, you know?

LL: You could …

HP: Well, I guess you could. We'll do that in another show.

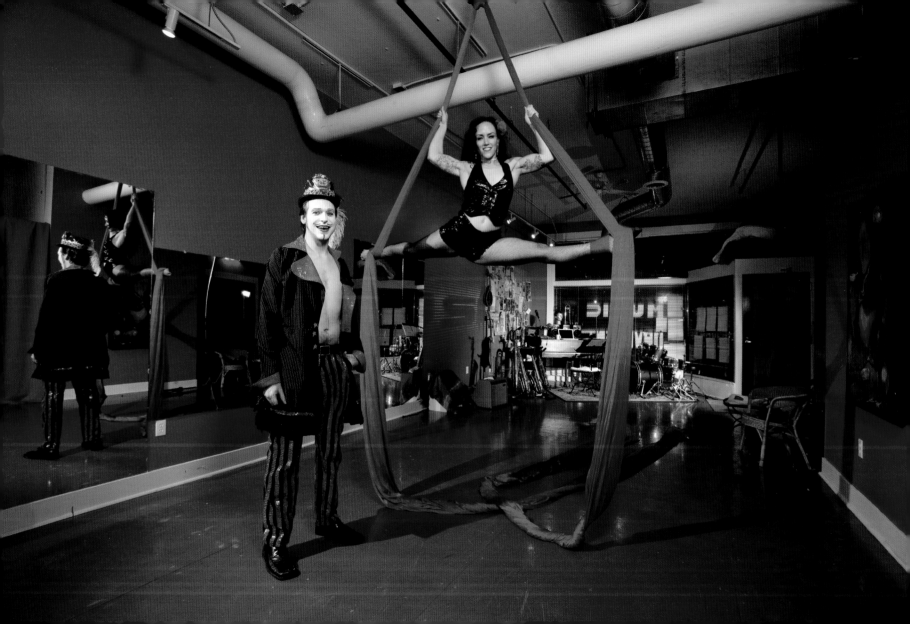

Foxy Veronica with Mr. Buddy Grimkin and Bug

Burlesque Performer and Producer

MADISON, WISCONSIN

It means a lot of different things to me. It means entertainment to start with, because when I started doing burlesque it was purely for a kind of narcissistic reason. I wanted to get up onstage and sing and dance the songs that no one else let me sing in theater. And then I started doing research about it and studying a bit more and I discovered a long history of the relationship to comedy and musical theater and song and dance as well as the naughty bits of women revealing themselves.

When I started out I didn't know very much about it, so I did a lot of research into it and found out a lot about the women that had been performing burlesque through the years, and it's been a very liberating experience for me in a lot of ways to change my opinions and perceptions of burlesque because when I was younger I always kind of classified it along with stripping, more so than any kind of historical value or entertainment value. I really classified it as something different. And now that I've done more studying and did it myself a little bit I found that there's a lot more freedom in it and there's a lot more room for self-expression beyond just the sexual object.

There's something about the way burlesque has progressed from the beginning where I think these days, depending on who the performer is, it can be a very, very feminist thing to do ... in some ways. The action of taking off the corset is a very liberating thing. When burlesque started, women had to wear corsets all the time. So for me, when I take the corset off, there is a huge statement being made that maybe not everyone will get, but it's a statement for me and that's really the most important thing. I feel that it's a liberating experience and that there is something to be said for actually stepping out of the corset, throwing it to the side, and saying we're done with this.

And getting to work with six other women ... and one man, who are wonderful and all get along really well, is a rarity. I don't normally get along with a lot of women. So, working with them and maintaining this relationship with them and finding a wonderful creative outlet has been the most freeing experience for me, the most wonderful rewarding experience for me with burlesque.

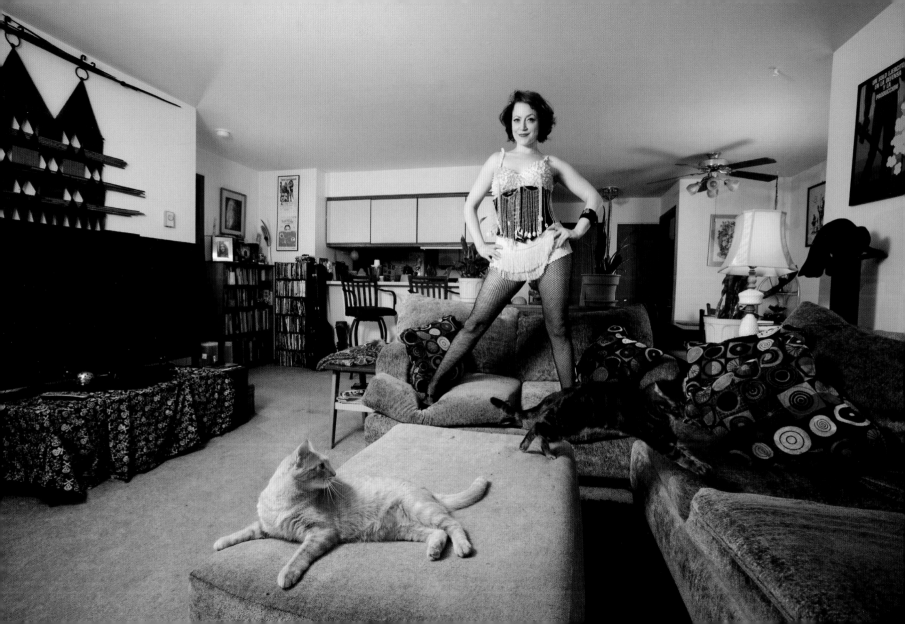

Minnie Tonka
Burlesque Performer

Originally from Minneapolis, Minnesota, and living in New York, New York

Oy. Okay. Burlesque means a lot of things to me. I would say right now what's really important to me in burlesque is community. Being in community in a very large sense. First, community just with the incredible support system of performers here in New York but also nationally. I just am so inspired and so grateful to be a part of this totally incredible, fun, unique art form which allows for friendships to be born and for encouragement and support and that is so important to me. I feel so grateful to be a part of that. But also our community of audience members and fans—being onstage and being a burlesque performer, it's very important to me to really very much give myself, my heart, and my soul, and really engage with our community of people watching the show as well. There's definitely this give and take and that really is so very exciting. The audience is just so key and so important to me. And I'm just so humbled and psyched to be a part of it.

Burlesque is very fun for me. It's a huge creative outlet and creative expression. I really love to challenge myself. That's actually one of the reasons why I got into burlesque. I was a figure skater for many years, and have a background in dance. I love costuming and performing; but, the striptease aspect was very intimidating to me. So, from the start of my burlesque career to now, it's always a challenge in different ways.

It is so much fun at the same time and I really love to be very playful. I think it's about making people laugh. I definitely lean towards the more comedic end of burlesque. And I love the playfulness and the comedy and the poking fun, all while exploring sensuality. Really incorporating all of that is something that I strive and aspire to do.

I love that people have fun when they come to shows and I love when people are really surprised because they didn't know what to expect, or they expected something different. But, I think in general I've heard a lot of feedback that people really are surprised because they love the thought that's put into performances and that they actually laugh out loud. That's so important to me and I think that's just like a huge part of why I'm drawn to this art form.

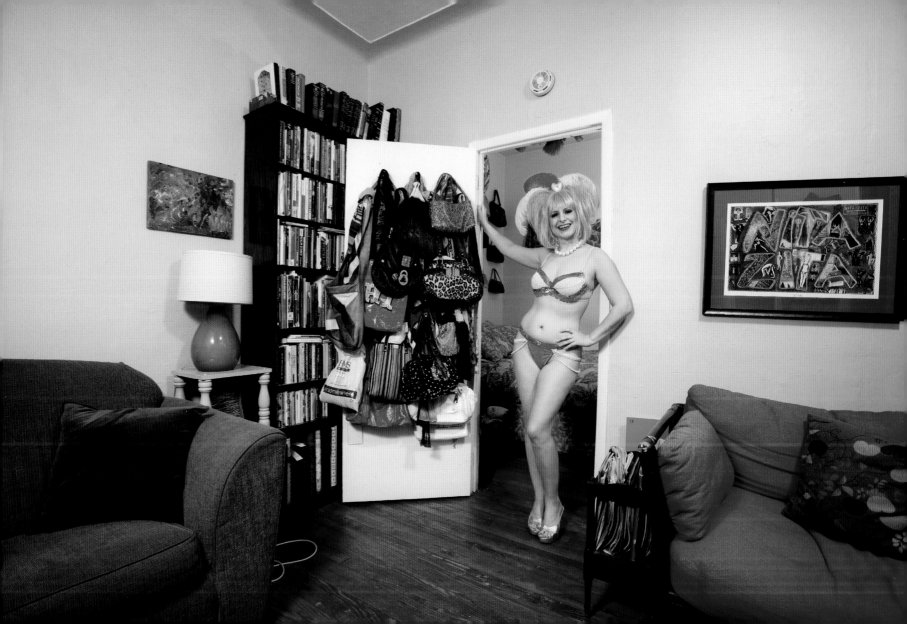

Sir Pinkerton with Lady Ambrosia
Burlesque Performer and Producer

MILWAUKEE, WISCONSIN

Burlesque is a long standing tradition of art in the form of social critique. It's often minimized to be striptease, and I by no means would try to downplay it as it's one of the finest factions of the spectrum of entertainment that burlesque falls under in my mind. Burlesque has a long-standing history of being a place for disenfranchised people to express ideas that otherwise would have no outlet in society. In the 1400s, burlesque was the only place a woman could be an actress or an actor and the art of their entertainment was downplayed mostly by patriarchal chauvinists who wanted to say that a woman has no right on the stage. Not that burlesque has been exclusively held by females either, but has been an outlet for people who have radical political ideas, different sexual orientations, or just this insane notion that you don't need to be a white male to be a performer. In that sense, particularly in America, most of the emphasis of burlesque is on the striptease aspect of it, which was popularized in the 1930s as that became the stronger focal point of the way these different vaudeville shows would basically sell their shows to mostly male patrons.

My perspective has always been this, and this is what I'll tell the dancers who work with me is: If they really wanted to see you naked they wouldn't have you come out with all those clothes on. That's not the art you're performing. Your art is not being naked. Your art is all in your presentation and attitude. You can be up on there eating a sandwich, but if you do it with enough attitude it'll be entertaining. And then, of course, it appeals to one of the most base human desires, which is sexual curiosity and the desire for it not to be a dirty thing, for it to be just a fun, light, playful thing that you can tease someone with and it's all in good fun. It's not the way the church or any of these other people who have negative things to say about the burlesque art form say it is. They say, "Oh, it's all these women teasing people and bringing out the worst in them." It's like, if that's what's inspired by you, by these types of performances, that's an internal issue and

has nothing to do with the art form. If you get violent and angry when you see someone free and playful with their sexuality, you probably shouldn't be in a position of power.

And, I find sort of a bastion in "the church of burlesque" in that sense where there's nothing that's against the rules as long as it's deemed tasteful and entertaining to the audience. And then also maybe taking it a few steps beyond what they considered tasteful because that's part of the thing that makes it challenging.

Burlesque has always been, as I said earlier, a social critique of sorts. In most cases it's a working-class critique of aristocrats and the higher class. But it also can be a very reflective critique as we've done numerous bits sort of making fun of musicians who take themselves too seriously, like the rock star attitude. Okay, you play a guitar. You're not Gandhi. You're not makin' that huge of a difference in the world. You're not really helping the world with your self-involved poetry. And I think with the Dead Man's Carnival and other shows I've produced, the goal is to recreate an atmosphere where showmanship reigns supreme and it has more to do with something that most people can relate to than something that the twenty people in the room who've read all of the other morbid poetry that you have can relate to. Not that we don't have the occasional highbrow literary reference in our stuff as well, but, you know, we're trying to make it accessible to a majority of the general public, not just those people who view themselves as society's outcasts or freaks or people who are part of the swinger S&M circle or people who are punk rock or rockabilly or all these others sort of limited clichés and cliques that it seems a lot of burlesque troops market themselves towards.

In conclusion, burlesque is really what you want to make out if it. It's one of the most open-ended forms of expression imaginable and if you haven't ever been to a show you really should check it out.

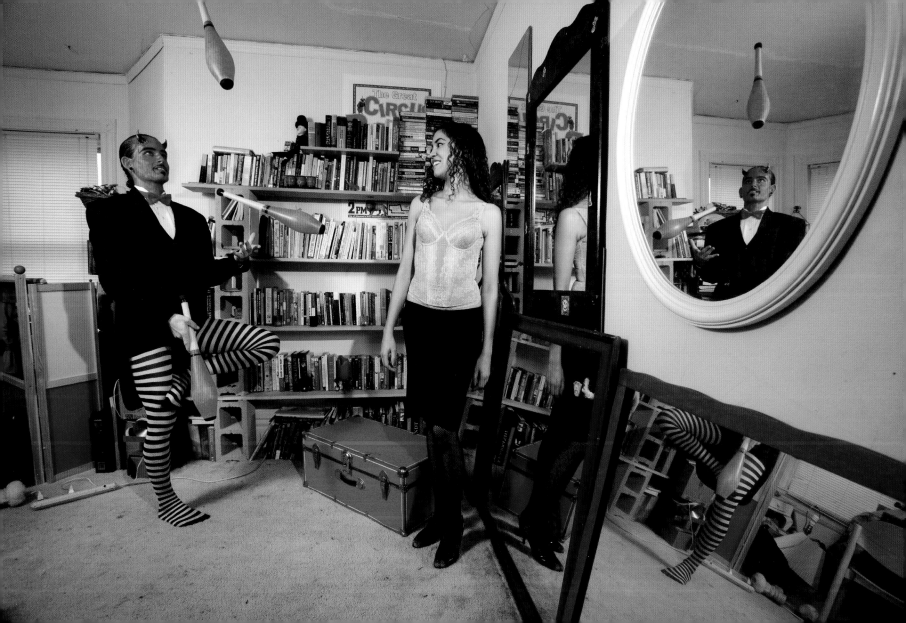

Audra Kubat
Burlesque Performer
DETROIT, MICHIGAN

Burlesque means freedom to me. I think I've been inspired by burlesque dancers from the 1920s and '30s. Sally Rand and Josephine Baker, even Marlene Dietrich. I just understood that what they were doing was really revolutionary and was breaking a lot of stereotypes down. And so, I really appreciate what that means. And I think people are way too caught up in the taboo of what sexuality is and what sensuality is. I feel like burlesque is a place where you can be yourself and you can be totally free to enjoy being beautiful. You share in that experience that those artists at the time created and used to move a lot of women forward.

Also, I think that burlesque today feels like there's such a variety of things that people are really doing with the art. It's not merely just the process of unclothing yourself in a classy way. You know, it's also seeing women of all body types sharing their work and being able to be supported by other peers and just patrons that want to experience that and just see that beautiful range of people and everybody enjoying that. So, I think that it's not only continuing to break down some barriers, what we traditionally think of as barriers, but also moving on to different colors and races and genders and all kinds of mixing and matching, and putting music into it again and putting tap dancing and bringing in instruments and putting all those things together in a show. I don't know, I just think it's really cool what people are doing. There's a lot of great things out there I've seen.

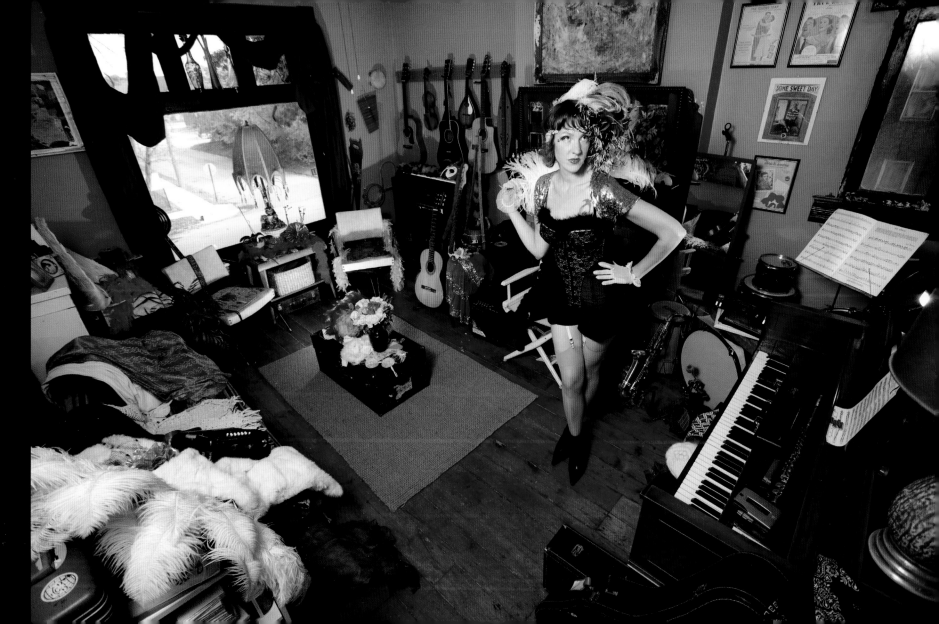

Viva La Muerte

Burlesque Dancer and Producer

CHICAGO, ILLINOIS

To me, burlesque means a chance to be accepted. It's meant a lot for me in the regards that I did always want to be a dancer but conventional dance to me was kind of closed off. I actually wanted to go to Columbia College to do dance before I decided to do marketing. That's how passionate I was about it, but being with a shorter stature and having a disability, it's just physically hard for me to do most traditional dance. People just don't look at me the same way they would a normal person. So, I was never able to pursue it. I ended up going to college, just doing the normal stuff, and forgetting about dance for awhile. Then I met Cathy with Fleshtones and saw her and Backdoor Aly doing burlesque. I saw that burlesque was people that were every shape and every size and that it didn't matter that I was small or had a disability. It just mattered that I was talented at what I did. It's great because doing burlesque, people don't see a little person. They see a performer first and my condition almost never comes up. It's just I'm there and I'm accepted and people see me and they don't see anything else. It's great. It's a really happy experience. It's helped me a lot with my self esteem, with my confidence, to know that I could just get up there and wow a crowd and they are not thinking about anything else but "hey that was a really killer show."

So, what I refer to when I say "disability" is, I was born with a form of dwarfism actually called "multiple epiphyseal dysplasia." Say that three times fast. But basically it means that I was born with no cartilage in any of my major joints. Over time, once I got to be about four feet tall, that growth kind of stopped. It means for me that I have a lot of pain in the cold. I have a lot of pain when it's damp. It's really difficult for me to be very fluid with moving and it's just really, really difficult for me to do conventional everyday things that one might take for granted. I mean, whether that's running or whether that's being able to walk far or stand for long periods of time, it's all kind of things you consider ordinary day to day activity that can be really hard for me. Driving is difficult.

So, how do I cope with it just day to day? A lot of medication comes into it. I have to take pain medication pretty regularly. But, I find that burlesque has actually helped. I mean you would think it would make me hurt more but what's great about it is it's gotten me to be more active than I was before. Whereas before I kind of sat, not feeling sorry for myself, but just kind of resigned myself to saying, "I'm in pain, I can't move, I can't do anything, and I am not gonna try." Now, doing burlesque and getting up and practicing almost every day and really strengthen my muscles, I hurt less than I did before I started doing it.

That's definitely not to say that there are not times when I've had to cancel shows. If I get a cold day like now my knees will swell up and my ankles will swell up. Over the years I have had to cope with it physically with a lot of surgeries. A little known fact is that I have a metal rod in my back. If you're thinking in terms of how it affects burlesque, I move in one piece and I move completely forward. There's no bend to my back. I have an artificial knee, so for me, floor work, getting up and down on the floor, is almost completely out of the question. You'll never, never see me do floor work, unless I have a little riser that I can get up and down off of. But, you find ways to adapt and that's where I found a more theatrical element, like having a lot of effects. I kind of compensate for what I can't do dance-wise with more theatrics, more rhythm, really working the songs and kind of moving away from the less traditional stuff and making it my own. I'm doing what I can do and just doing it as well as I can and trying not to get hung up on what I can't do for sure.

I think burlesque means to me the chance to really express my creativity in a way that I haven't found anywhere else and I know that probably means the same to a lot of people. But, heavy metal and horror movies are two of my favorite things and I love it so much. So this is another way for me to kind of bring it to the forefront and bring attention to things that I think are awesome and maybe people don't know about. Whether that is a really cool Motorhead song in a routine or highlighting the movie *Hellraiser* or having a theme show like the Pink Floyd show, it's another way to kind of spotlight some really amazing cultural things in different movies and stuff.

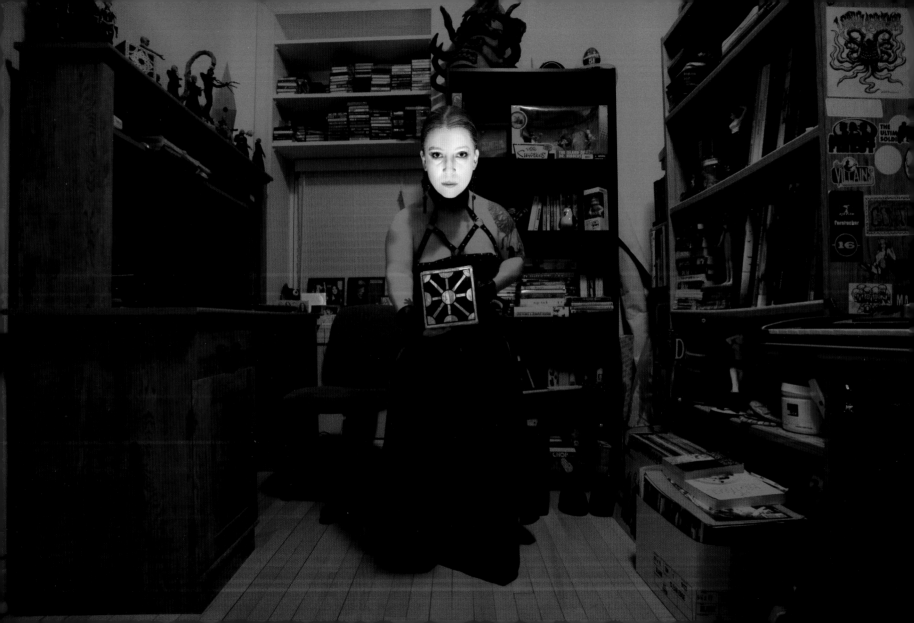

Vivacious Miss Audacious

Burlesque Dancer

GRAND RAPIDS, MICHIGAN

You know, burlesque means a lot of things. It's anything from sassy fun and a really amazing way to express yourself sensually, but very positively, to a great way to really further satire and poke fun at your surroundings, culture, the government, what have you. So it's multi-level. It's sexy and intellectual.

You know, I find that the really amazing thing about burlesque. Its empowering nature is often misunderstood. It's definitely a very feminist act when you think of a burlesque striptease. It's not something that's just grinding for … well … ok, it is … it definitely appeals to raw human interests … but, it's amazingly empowering in the sense that it's body-positive, you're celebrating your body, you're celebrating sensuality and sexuality, and you have control. Whereas, other types of dance forms could be considered more demeaning, burlesque is empowering because the woman is the one in charge … or the man.

I do a lot of education. When I talk about burlesque, not everyone knows what it means. From people my parents' age to the younger generation, a lot of people have no clue and the biggest thing that they think of is striptease and that it is this raunchy, sort of shameful act. And what I do is try to convince them otherwise and really assert that it is a powerful act. Everyone is sensual and sexual, and what better way to express that than in an artful sort of tease?

I express myself through many different art forms. Hula hooping is always incorporated into my act. I find that it's a relatively wholesome way of using your body, moving and moving and working your hips. As we like to say, we are "liberating the pelvis." It is almost a task, you know, "liberate the pelvis of the masses." Show them that it's okay to wiggle and move and not be so straight and narrow and uptight.

I found burlesque has just changed my life in that regard. Positively. Phenomenally. Confidence is raised, acceptance of my body. All sorts of things that I would've not had if it hadn't been for burlesque.

You know, I think it's really interesting watching burlesque rise into the mainstream. In the late 1990s, it started rising up. But, by the mid-2000s, that's when I began, I found that not much was out there in the way of books. I mean, there were old books, out-of-print books. Actually, a passion of mine is collecting burlesque books or anything kind of relating to the topic. And it's been really interesting watching books be published rapidly. I mean, even Gypsy Rose Lee just had a very comprehensive biography put out that had never been put out before. There's some other things, memoirs and such, so, it's really interesting watching it grow and enter the mainstream and see the way that it's affecting the masses. It's one of those things where you see some sort of print ad and there's a showgirl. She has nothing to do with the product or whatever it may be. But you see that showgirl and you say, "Ah ha! Burlesque is really creeping in." And, it's an amazing thing. I think burlesque has always risen up in times of economic depression. The long depression, the Great Depression, and now we've got ourselves a recession. And what's happening? Burlesque is big again. And so, I think it's a really great way to have a very direct experience that's fun, raucous, sassy, sexy, smart, and satirical, but also really having this kind of one-on-one entertainment.

Some of my favorite venues involve a more intimate setting. It's great to have a really big stage to move around in, but when you have a nice tight stage with the audience a foot away, you can really have that communication and dialogue literally or through your movements. It's a powerful thing and I think people are really thirsting for that in today's age of computer-generated graphics and this and that.

Another thing that's important and goes along the lines of empowering people and the way that burlesque can transform lives is that anyone can do burlesque. You don't have to be a standard babe, you don't have to have big hoo-hahs or a small waist. What's interesting about the burlesque show that I frequently perform with, Super Happy Funtime, a lot of us girls are pretty flat-chested, and that's okay. Or, some girls in any burlesque show are big, voluptuous. Or you think of, even, from the sideshow angle, there's plenty of people doing burlesque and striptease, male and female, who may have some disfigurement. But, it's okay, it's beautiful, they're celebrating their body and they're celebrating being alive in a sensual, exciting way.

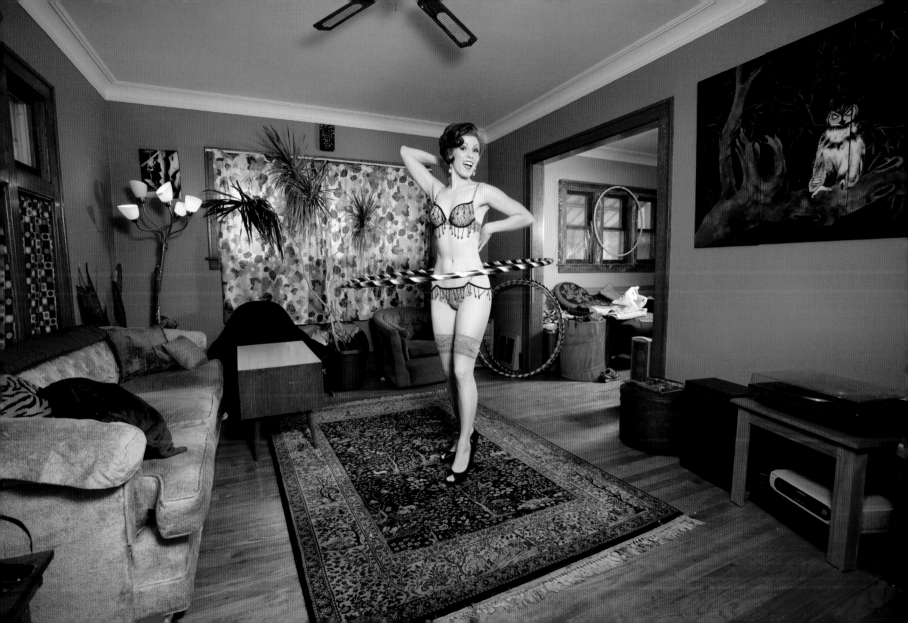

Lily LaRue

Burlesque Dancer

DETROIT, MICHIGAN

What does burlesque mean to me? It is a way that I spend time and get to be creative and feel confident about myself. It is paying homage to a great American art form and the ladies that came before … and gentlemen if you take it in the whole vaudeville meaning. As a spectator, it's a beautiful art form. I get to see lovely women perform, and also men, and people do all kinds of interesting, fun, and talented things, especially if you take the broad spectrum and include all my circus and sideshow friends as well.

Burlesque also means to me having the confidence to feel that I am also a beautiful and sexy woman, which I never thought I was or could be because in my youth I was given these images of one type of really, really skinny, skinny woman and that's not who I was. And it showed me that beautiful women exist in many different shapes and sizes.

In all the instances I've seen, burlesque has been an empowering force in my life and in the lives of people I've met. The women I teach in classes, I can see the confidence come into them after fifteen to twenty minutes from the things I say to them—the history lessons I give them and the confidence lessons. I've seen performers start and continue and flourish and just develop this amazing sense of self-confidence. In the last couple years, the journey I've had for my life, I think it's become tremendously better. I've become a more confident person. I've learned to handle myself, not only artistically, but in a business confidence sense as well.

I love to perform. I love to be onstage. I have since I was five years old. So, I guess burlesque has meant a way to express that passion for performance in this stage of my life.

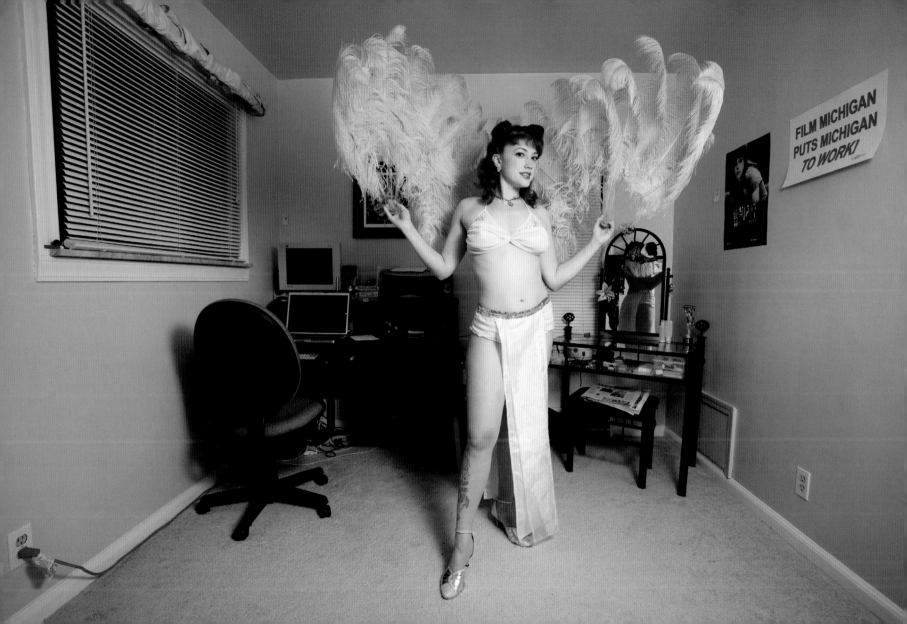

Waxie Moon

Boylesque Performer

SEATTLE, WASHINGTON

Oh wow, that's a really good question. Well, in its simplest form I think it means theatrical striptease. And there's a lot to that. I think it means humor and sex and personal style. That's actually Tigger!'s definition, "humor plus sex plus personal style." And it's a good definition. I'm also really drawn to the term "boylesque" because that doesn't actually mean anything. I mean, I guess in a certain way it means a male or male-identified performer removing clothing. As a teacher of boylesque that's the definition I kind of stick to. But, I like performing in the form of boylesque because I feel like I can do anything. I could do striptease, which is normally what I do, but I could also do a monologue, I could do a tap dance, I could sing, although nobody really wants me to sing. Or at least maybe I don't wanna sing! Nobody would ever say, "You're not doing boylesque. You're not doing proper boylesque." Because it's a relatively new term, and nobody really knows what it means.

I come from the world of professional theater and professional dance and one of the things I really love about this form is that I'm responsible for the work I put forth, almost entirely. Occasionally I work with collaborators, but for the most part it's an independent form, and that feels completely liberating. I'm not beholden to anyone else. I can make the act I wanna make, I can put myself forward, I can put my ideas onstage … center stage. I can put male nudity center stage. Not full nudity.

Exploring the field of burlesque feels completely liberating … in every way. Liberating to show my personality and my body and my sense of humor and my interest in performing sexuality, but also liberating in terms of having total creative control over what is depicted, what is seen, what I put forth.

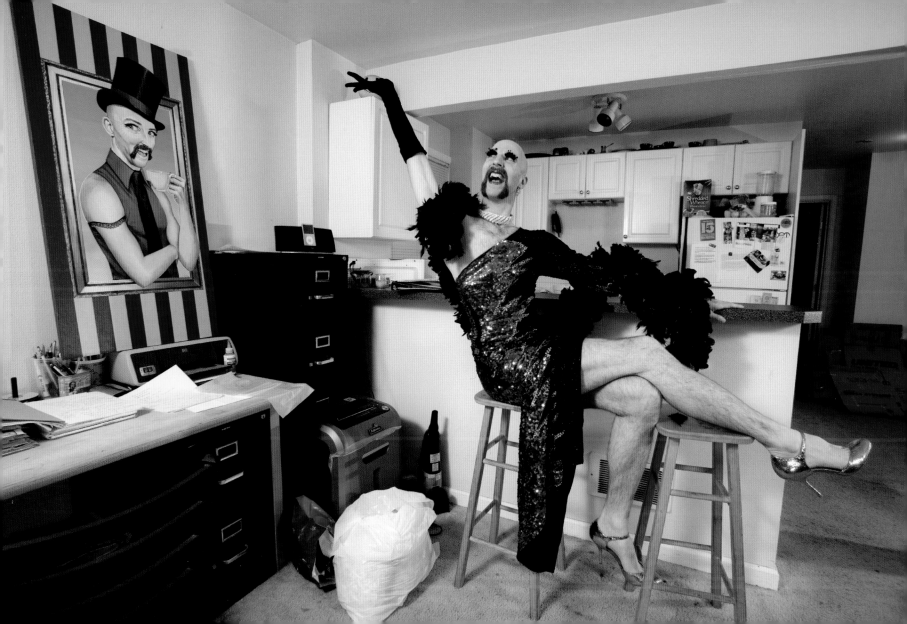

Wild Cherry with Nala

Burlesque Dancer

NEW ORLEANS, LOUISIANA

It meant a livelihood, it meant a lot of fun, and it still does. But it also means good entertainment. Real burlesque is good entertainment. It's not the same thing you see today, and it's not vulgar at all, and most women really enjoy it. Older women, middle age group, young ones, it doesn't matter. They all love it. They like it. They enjoy it. And they ask us to keep on doing it this way. And there's several troupes all over the country that are trying to bring the old-time burlesque back, and they do a very good job of it. They even have girls working in aerial acts, stripping while they're doing aerial acts.

Burlesque doesn't change, that's just it. They just didn't have burlesque, they had something else. What? I don't know. I've never found a name for it other than girls walkin' around afterwards, or while onstage, looking for tips. To me that's begging for money. And when they ask me what I would tell the new girls today, I tell them, get a salary.

I don't even know how they got this going. I really don't. If they were trying to get us to work for nothing and just for tips, they'd have been laughed out of business. Nobody would've done it back in my day. I don't know how they ever got that going to begin with. I really don't. That's still a question in my mind how they managed that.

A friend of mine says she thinks that because some dumbbell was hooked on drugs and wanted to make some money for drugs and was willin' to do anything, you know. And, that might be where it started, I don't know. But, however it started, it should end.

The Shanghai Pearl
Burlesque Performer

ORIGINALLY FROM TAIPEI, TAIWAN, AND LIVING IN SEATTLE, WASHINGTON

Burlesque means so much to me. Burlesque is, well one it's theatrical striptease, but it's also easily the best thing that's ever happened to my life. Burlesque is the freedom to explore my femininity, my gender expression, and my sexuality with hilarity and weirdness. I get to celebrate it and I get to share it. It's really love. It's love. When I'm onstage, I'm in love. When I'm getting ready to go I'm nervous. But when I'm onstage I'm feeling the same feelings, that I'm in love with everyone in the audience. I'm in love with what I'm doing. It's a celebration.

It's a celebration of me. It's also a celebration of freedom and individuality and art and sauciness and fanciness and glitter and rhinestones and glamour. It's a celebration of everyone's unique, extraordinary journey with their sexuality and gender and femininity, or masculinity if they're a boylesque performer, or a mix of both. It's a celebration of all of that. So I guess you could say it's a celebration of our unique human experience.

Yeah, I think that pretty much covers it. Burlesque to me is a celebration of every person performing it, their unique experience with their bodies, their unique relationships and explorations with their bodies, and their experiences being a lady or being a man and incorporating glamour and humor. Yeah, that's basically it for me. It's radical! It's the best thing ever. There's nothing like it.

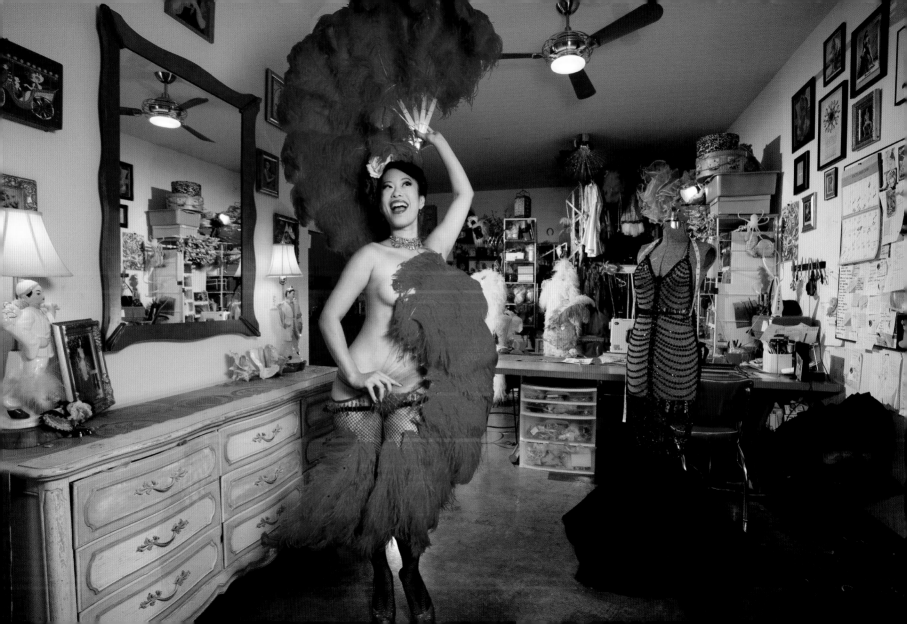

Kellita

Burlesque Artist

SAN FRANCISCO, CALIFORNIA

To me, burlesque is immediate, transformative, magical, fun, lifesaving.

In burlesque, I feel invited, wholeheartedly, to be my full self, to literally shine out from out ... oh, this is so hard to talk about. Burlesque, to me, at its height is pure love, really. It's love offered generously to friends and strangers alike. At its best, it's in a safe context where you have a stage, you have a location, you have a set amount of time, you have a ready and willing audience, and hopefully also some technical support around you. In that time and space you have a blank slate on which to paint your colors, literally. Choose your music, choose your costume, and express more fully than we have the opportunity to in most contexts.

Before I started doing burlesque, I much more frequently found myself editing, editing out, dimming down, and holding back. Burlesque for me is a training ground, and really I aspire to have my full self, like I do when I'm mid-act, all that time. So, it's little spurts of training to embrace myself and allow myself to be embraced by those who are gathered there, too. It's really like a ritual, a ritual that, even when fully choreographed, is never the same each time. There's always a different amount of spirit that comes through, a different flavor that comes through, there's a different conversation with the audience because the audience is always different. Even if it's the same people, it's at a different time. It's a crucible. It's a crucible in which the performer shows up with all their concrete elements—the music, the costume, the choreography, the makeup—and invites the mystery in. It so clearly touches the performers and the audience that I've never had an experience of performing or watching a burlesque show and not left with my perspective tangibly changed. I think really cellularly, *cellularly* I feel different. Almost invariably. I think I can count twice in the last ten years that I've left performing not feeling "more than." I think it's this thing of feeling more than. So, yes, that's why I subject myself to these long lashes and this glitter on my eyeball and in my mouth. May my digestive tract forgive me.

Burlesque is like a body poem. I would go so far as to say it's a body prayer. In preparation, you're touching that place where you're going to go, but when I'm actually in the act, my entire body is open to my greater self. That's where I open to my own magic and my own mystery with the widest mouth. What happens truly ... truly ... truly is magical. My own sense of being shifts and the amount of gift exchange that I have with an audience is at least ten-fold from regular, non-stage life. But again, this is just a training ground so that I can eventually live that all the time.

Really, the nakedness in burlesque is just a metaphor for nakedness of spirit. And I see body and spirit very, very, very connected, not as two separate beings or at all. But really, the nakedness that is most interesting is the metaphorical. You get to see someone. Everyone should have to have a burlesque act. Not that they would be a performer, but so there would be an easy way to know them, quickly. In my opinion, what you see onstage is simply that person magnified. So it's a very quick way to touch a person's essence. It's profoundly revealing or revelatory.

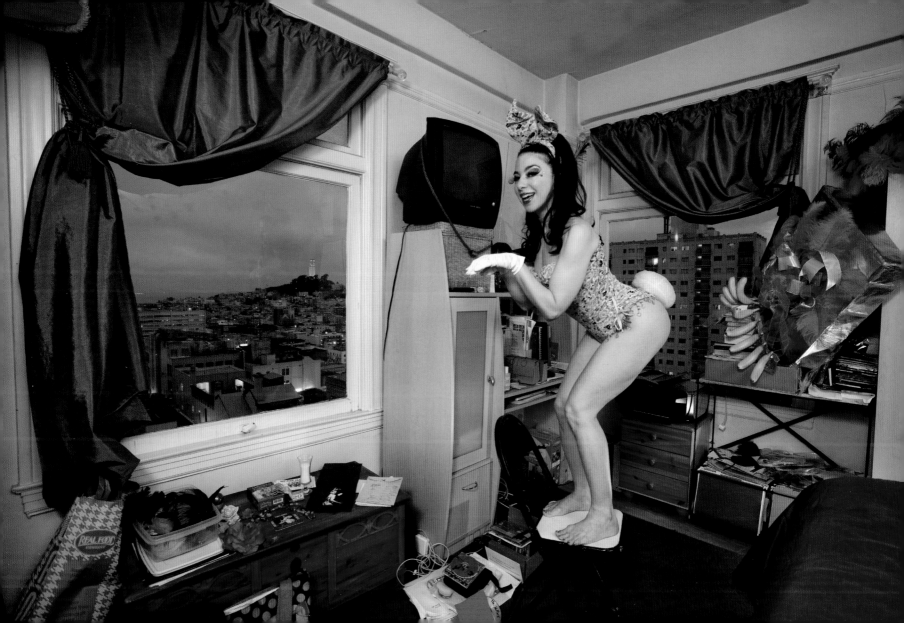

Cherry Bomb
Burlesque Performer
PHILADELPHIA, PENNSYLVANIA

Burlesque means everything to me. It's become who I am, how I act, how I dress, how I ... *am*, really. It's really kind of encompassed every aspect of my life. It's what I think about when I first wake up in the morning and it's what I think about when I'm trying to fall asleep and can't stop thinking about burlesque. It's kind of really become a lifestyle.

Burlesque to me means meeting tons and tons of different interesting people from all over the country and all over the world that all kind of come together and really share in the most amazing thing. And we all just kind of have this same drive and the same energy to really get out there and entertain a crowd, unlike any other facet of the arts. It's totally different, I believe. I feel like your connection with the audience is completely different than when you're a modern dancer or you're just an actor or whatever else. There's no fourth wall. You are with the audience and they're with you. And I feel like, when I'm performing burlesque, everyone out in the audience just wants to see your number go well and wants to see you do well and ... love what you're doing.

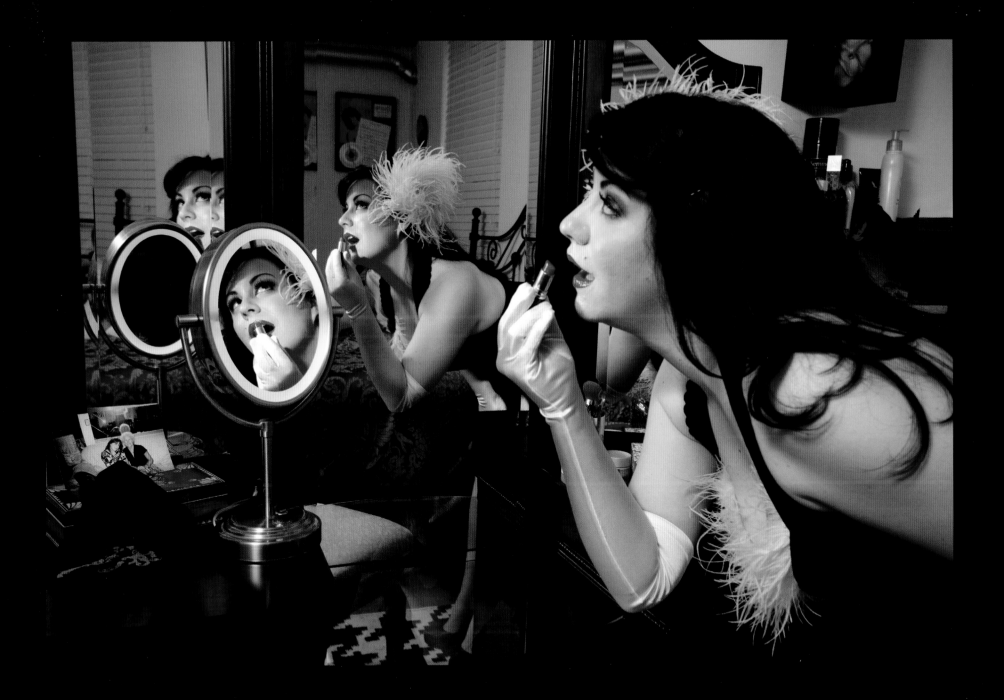

Sadie J. Byrd

Burlesque Dancer

MEMPHIS, TENNESSEE

Burlesque means glamour, lots of glitter, theatrics. I love it. It means a lot of selling a product, a fantasy, to the audience. I really love that. Interpreting something to them that is you and glamour comin' together.

I would say it's like you're presenting to the audience a character, a part of yourself, I think. You're relaying something that's in you to them that you may not be everyday. It's above and beyond theatrics and includes lots of glamour. There's lots of glamour in there.

I think burlesque is something that we really need back right about now because everything seems so plain sometimes, as far as just your everyday folks that are just kinda walking around, you know. But if you put that little bit of extra something shiny, with a little bit of fringe or something on, it makes you feel so different. I think burlesque needs to be added to a lot more lifestyles nowadays and I definitely recommend it to anybody that's out there. It's a good self-esteem booster. It makes you feel better about yourself. You walk differently after you do something like that. You interact with people differently afterwards. You definitely do. It carries over into your everyday life. I would say burlesque is something that everybody could probably include into their lifestyle in some form or fashion. Watching or performing.

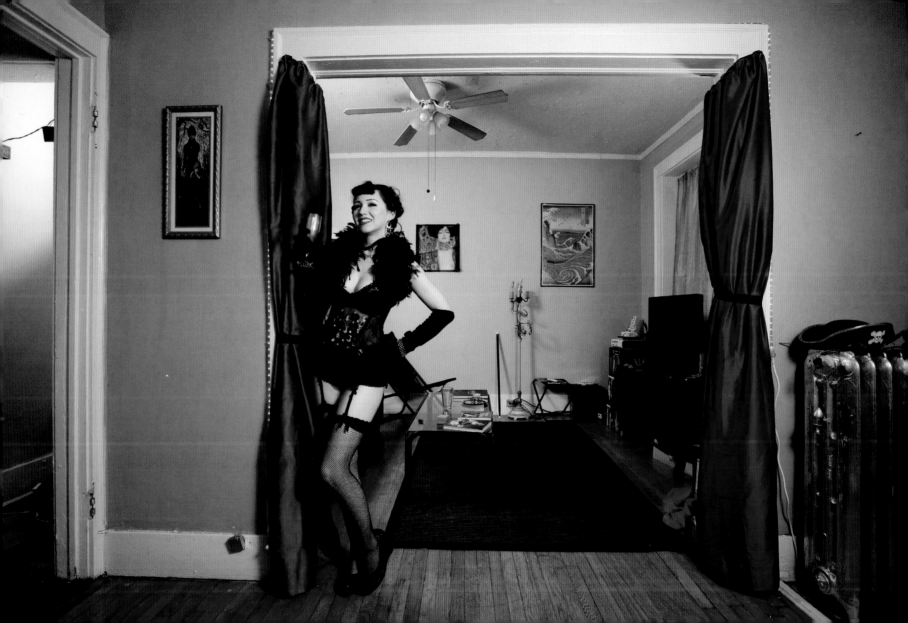

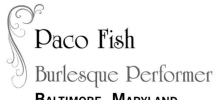

Paco Fish
Burlesque Performer
BALTIMORE, MARYLAND

For me, I think of burlesque as a rebellion. In general it's a rebellion against social norms and societal assumptions, in my opinion. For example, you know, in general, that you should keep your clothes on in public. That's assumed or taught to us. But burlesque messes with that. Also, for the most part, burlesque messes with the assumption that women are sex objects without power. In burlesque I really think that's an important component. Actually, I think it's the only viable attitude to perform in burlesque. You're in control of your own objectification. Otherwise, it's just really seedy and uncomfortable to watch. If you don't project the attitude or if you aren't in control of your own objectification then it's not a successful burlesque performance. So, in general terms, I think that burlesque is a rebellion in that sense. And historically, for the same reasons, it was always edgy, and it was always playing with certain assumptions and norms of the culture that people lived in, that we live in.

More specifically, I like that burlesque, especially neo-burlesque, challenges assumptions. In my acts, for example, I do a lot of character stuff. I have a lot of archetypes in mine and each archetype has its own assumptions, like the homeless man. I like to play with those assumptions and flip them so that the arc of the performance begins by presenting people with an archetype with some established assumptions known about it and then turns them on their head so that the final reveal is the opposite of those assumptions to make the audience think about that.

For me, burlesque is a subversive performance, and that's what really draws me to it and that's what I like about it. Lately, with boylesque, with male performers, even that is subverting the assumptions that have developed about burlesque. It's about breaking assumptions. So, you think that burlesque is only an art form for women, or that men are not sexy or beautiful beings. And I think that's an important assumption to mess with. I don't remember where I saw it, but there was something that I was watching on TV where they were talking about how a naked women is beautiful and a naked man is funny. And so with men performing burlesque it is reestablishing the possibility that, or the notion that, men can be sexy and beautiful and worthy of objectification, that men can control that for themselves. And I think that plays with people's assumptions and wakes them up a little bit. I really like that about burlesque.

So, that's what drew me to it as a form of performance and as a form of art. Burlesque has a whole bunch of standard notions to play with and it really plays with them.

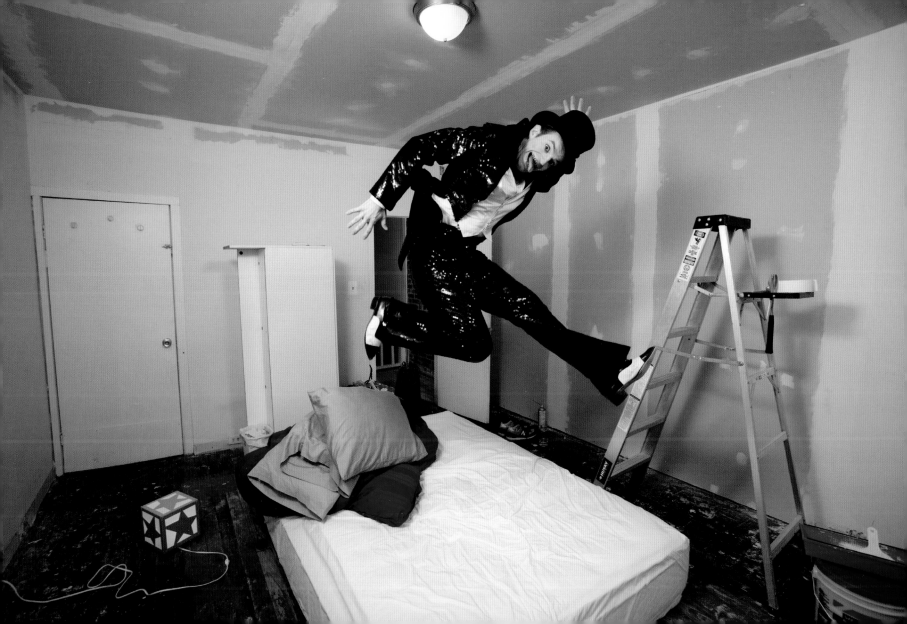

Tomahawk Tassels

Burlesque Dancer

MINNEAPOLIS, MINNESOTA

To me burlesque is about expressing sensuality and sexuality, but doing it with grace and doing it with poise. It's about bringing back the history and the culture from our past, basically. Whether it's glamorous Hollywood or whether it's other parts of history that may be neglected. I think that's kind of what I try to do. I try to bring in my inspiration from the past, from my culture, and from American history. Then I mix that with my current inspiration and sort of a glamorous theatrical stage performance.

But I also think that burlesque is about comedy. It's not so serious or so sultry all the time. A lot of people, when they first see burlesque, they are really surprised and they feel like they are kind of shocked because it's not as intense as they expected it to be. It's actually really fun and it makes them laugh and that's kind of the point. But then, at the same time, there's very important topics that are being brought up and very important subjects that are sort of being presented in a cheeky way. Burlesque is putting it in your face and that's why I love it, I think.

One thing that I don't think people realize about burlesque is that you create the concept, the idea, the act, and then you do the costume design, find your music, you edit the music, and you choreograph. It's a lot of things that are involved with just one performance. It's kind of like a whole theater presentation, a little mini-theater presentation. But then it's also bringing together the audience. The audience is definitely a part of it. You're able to kind of feel their excitement and when you hear them hoot and holler and when you hear them scream, it feels good and it's a confidence booster for sure. At the same time, it's sort of showing them, "Hey, I can do this and you can do it, too." I feel like that's something that I really appreciate. A lot of women will come up to me after shows and they're so excited about it and they ask, "How can you do that," and they say, "I wish I could do something like that." I don't always think about the fact that not everybody feels like they can do that. Being able to do that and sharing that confidence with people, it's really my favorite part about burlesque.

I'm Cherokee. My name is Tomahawk Tassels and I very much use my heritage and bring Native American culture into my acts. And for me that's something that I feel really inspired by. I grew up in Oklahoma, was very exposed to Native American culture, and yet not. My birth father is native. I am basically estranged from him, so I didn't really know him. I didn't really get to grow up in that culture. But, as I've gotten older, I've become more and more drawn to that, inspired by it, and excited by it. So it's been my personal journey and it's kind of been my method of finding myself and expressing my sexuality and my sensuality. At the same time I have been diving deeper into my culture and representing it.

It's easy to get onstage and do a quick little striptease and be pretty, but I feel like burlesque is more than just about being pretty or just about having a nice costume. It's also about having that power. It is an empowering thing, and I feel like that's a part of burlesque that is most important to me. It is being aware of that power. Sometimes it's easy to go onstage and to not do that, to get so caught up in the choreography or another aspects of it that can take our attention away. But, the times when I feel like it's most fulfilling, and when I really feel most satisfied with what I'm doing, is when I really drop in and I'm able to make that connection with the audience.

My family's never seen me perform and a lot of people that don't really know what burlesque is say, "Well, why do you have to take your clothes off? Why can't you just go onstage and dance?" But I feel like that vulnerability that we were talking about, that part of it is what makes it so special. That's what makes it burlesque, actually going onstage and, by removing your clothes, by going through that striptease, saying to yourself and to the audience that you're comfortable with that. Why do it? Well, one it's fun. It's fun to be naked. But, at the same time, it's also breaking those barriers down and it's breaking down the cultural judgments and the cultural criticisms about nudity and about a woman and about her body and I think that connecting to that part of it is the most important thing in performing burlesque.

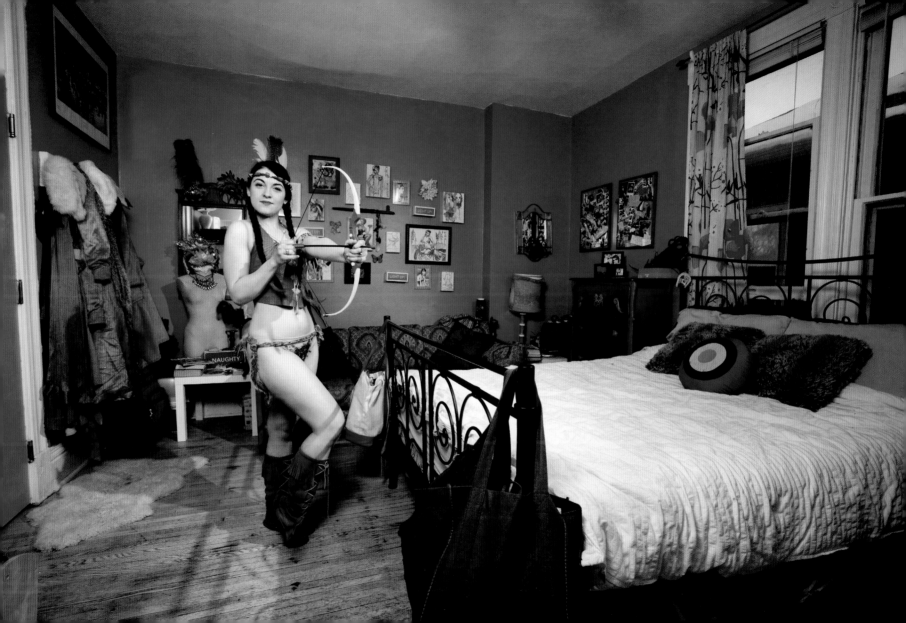

Naughty Natanya with Kyle and Darth Noodles
Burlesque Performer

CHICAGO, ILLINOIS

To me burlesque is another theatrical form for me to explore. My degree is in acting and when I came to burlesque I was approaching it in the same spirit as any other theatrical form that I wanted to explore. Commedia, Greek theater, Shakespeare, Chekhov, it was just another thing to dig into. And what I discovered about burlesque is it allows you a lot of license as an actor to sing, to dance, to do comedy, to do the striptease, to relate to the audience in a very different way than I had previously. I had been a Shakespearean actor and there just was this sort of formal distance between me and the audience. When I started doing burlesque, part of my journey as a performer was learning how to address the audience, how to play with the audience, how to bring the audience in to my performance, because to me, in burlesque there's a lot of give and take between the performer and the audience ... way more than in the forms that I was more used to. The way that the dancer addresses the audience, how she chooses to relate to them, is part of what makes an individual performance.

When I started doing burlesque I sort of maintained this formal distance. I had numbers that were created to be looked at. And I was sort of putting this image on the stage. I had chosen to go with sort of a classy sort of high brow intellectual character because it came fairly naturally to me and I felt comfortable doing it. And so all of my numbers that I put together were meant to be looked at, but I didn't really have a way to bring the audience into it. It was reasonably successful; it was reasonably satisfying.

I found as I became more comfortable as a performer I could let the audience in a little bit more. I didn't have to maintain that distance; I didn't have to be scared of them. I could be more playful; I could be more flirtatious; I could be raunchier; I could be funnier. It really opened up a whole different aspect of burlesque for me. And it's been very satisfying as a performer to discover different aspects of yourself in a role. I think this discovery is one of the great joys of doing it. Burlesque has that.

Some people think that there's not that creative aspect to being a burlesque performer, that somehow it's different from doing Shakespeare. They think that you're not inhabiting a character, that you're not making those choices. But you are! And that's been a wonderful discovery and it's been useful to me.

When I bring my discoveries in burlesque back to the other performance styles that I use as an actor, I find that I have more tools in my toolbox from having made discoveries on the burlesque stage.

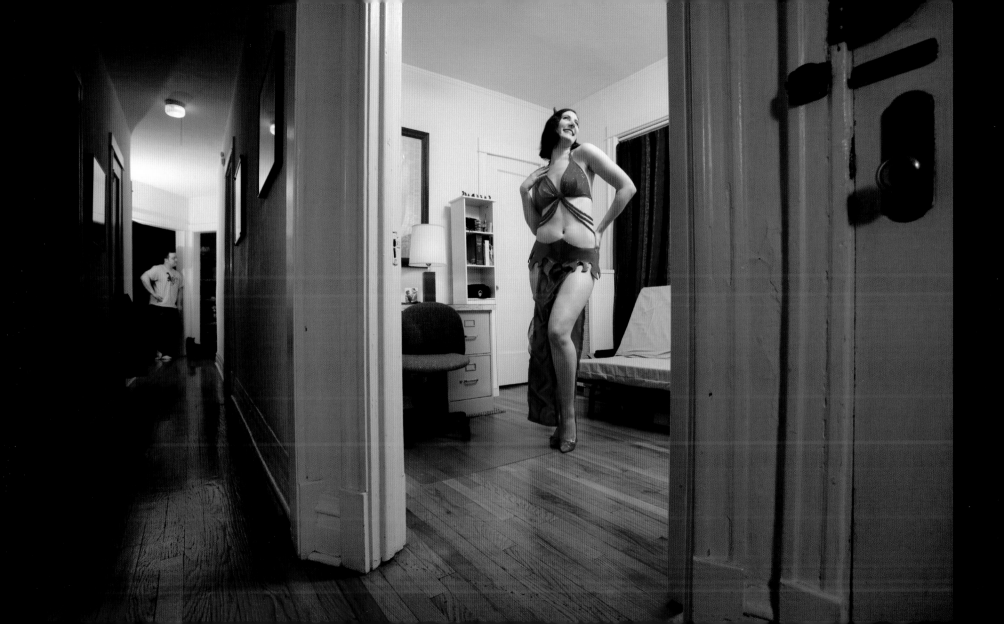

Irma Bumstead-Winterbottom & DeeDee Madison, Esq. with Amelia
Burlesque Dancers
MADISON, WISCONSIN

Irma: I want you to talk first cause I think you talk more intelligently about the topic.

DeeDee: I'll have to think. Burlesque means to me ... a way to really, truly, creatively express yourself without any rules or limits to how you do it. As you can tell we don't do well with rules. We defy explanation a lot, some have said. Truthfully, it's a wonderful community to be involved in because there is everything. There is not just one standard or one type of girl or boy that you have to strive to be or look like.

I: Yup.

D: It's really wonderful and refreshing to be in a community that you can be anything and look like anything and do anything and as long as you do it competently and with some sort of showmanship and with some sort of love for what you're doing, it goes over.

I: I really second ... I second that and ... burlesque for me is a rather new concept, honestly. I mean, I've always been aware of it, especially as a theater person, you're aware of that theatrical art form known as "burlesque," but it does sort of have that ... what's the word?

D: *Je ne sais quoi?*

I: That, too, but ... stigma about it? Maybe?

D: Yeah ...

I: I never thought of myself as ever being involved in burlesque. But now that I am, I'm happier as a performer than I ever have been because it allows me the physical expression that is intrinsic in who I am as a person, as well as my need to be in control a lot of myself as a performer. I get to create the entire act, the costuming, the emotion behind it. A lot of my solo burlesque has to do with experiences or breakups or people. It's sort of like my therapy. So that's that.

Burlesque to me is a fascinating art form that has been around. I've been told it's the earliest art form, actually, dating back to Greek theater. But, basically, it's defined as being a mocking or an exaggeration of something and I really take that to heart in the sense of performing burlesque in a modern setting. Burlesque is not being a stripper. Burlesque performer, stripper ... not the same. The stripper ... there's, I would dare to say, lack of artistry where burlesque ...

D: There is, there's not creativity in it because with burlesque you're ...

I: It's a striptease. You're working to make the audience work with you—to be with you in that moment and to tease. And, especially with what DeeDee Madison, Esq. and I do, it's not about the clothes. It's about the friendship. It's about the relationship being formed during the act. And the clothes coming off is really just sort of second hat.

I: I know there's a lot of argument about burlesque and what it means. Honestly, I struggle sometimes with it too, what it means to me. I haven't honestly, fully come to terms with what it means to me.

D: Well, I don't think it has to mean something. I think if it just makes you feel good, it's a way of creative expression in a way that there are very few other outlets, like in theater.

I: Okay, I will agree with that and yes ...

D: Because you're creating it.

I: I am creating it. It does make me feel good. It is a good outlet for a lot of necessary emotion that I have. I'm also kind of an exhibitionist, so that part of me is highly satisfied. I know that there are a lot of different reasons why people do burlesque, but that is mine. It's an art form and a necessary need for expression and if I can't tell a story in my burlesque then I feel like I've failed. Mostly it's telling a story—the clothes coming off is secondary.

D: It's telling a story without saying a word.

I: And taking your clothes off ...

D: And being naked. Not fully naked.

I: But artfully.

D: Artfully. And with sparkles.

I: I think that's all I have to say. I feel pretty good about that.

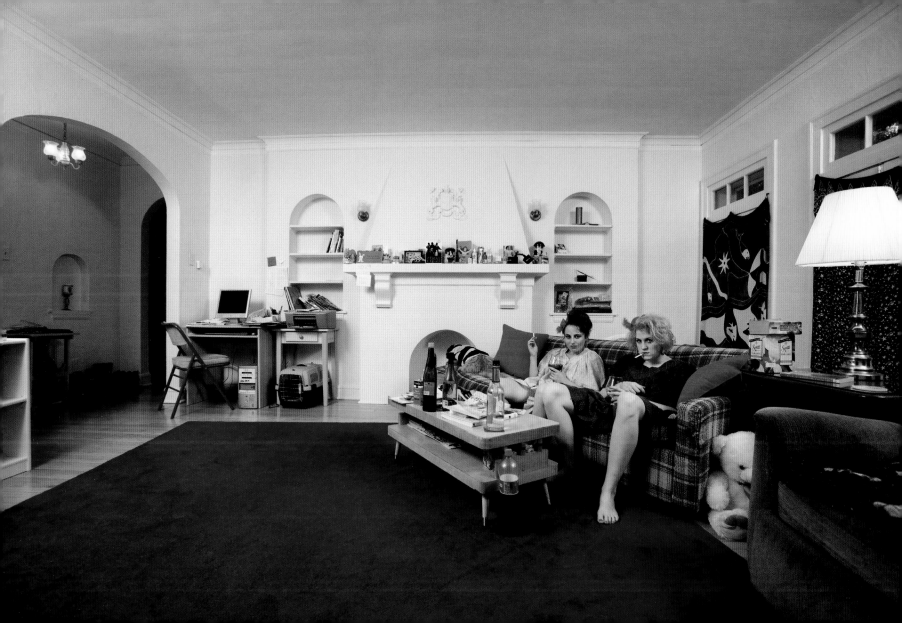

Honey Cocoa Bordeauxx

Burlesque Performer

DENTON, TEXAS

Well, burlesque, I think, means a lot of things to me. Originally, when I started doing burlesque it was because I really needed a creative outlet. I've danced all my life and I had come to a point where I hadn't been dancing in over a year, or doing any type of performance art, and I just really, really needed an outlet. And burlesque came right in the nick of time.

Burlesque has allowed me not only to express myself as a dancer, but also just as an artist in general. Being able to put together a piece involving dancing—and if I wanna sing, I can sing, and if I wanna act, I can act—and being able to design what kind of prop I'm using, and a theme. Basically, I'm taking whatever fantasy is in my head and putting it onstage and having the crowd relate with me and understand that fantasy. It's just a wonderful and very rewarding experience. And it's something that I really needed in my life. As a performer I just really needed to be onstage and I needed to have that kind of discourse with an audience.

I think, also, burlesque always reminds me about the ideal of sexuality and sensuality and the idea that it is timeless. You look back at the history of burlesque and how long people have been doing burlesque or arts that were entangled somewhere within that genre, and it's just amazing. And you see how what's old is new, what's new is old, and it's all intertwining there and I think that's something that burlesque does for me. I think, as far as me coming to my sexuality and sensuality in a society where maybe everything's kind of a little extreme, burlesque takes me back to the basic core of things. Yeah, it's just been a very rewarding experience and it means a lot to me.

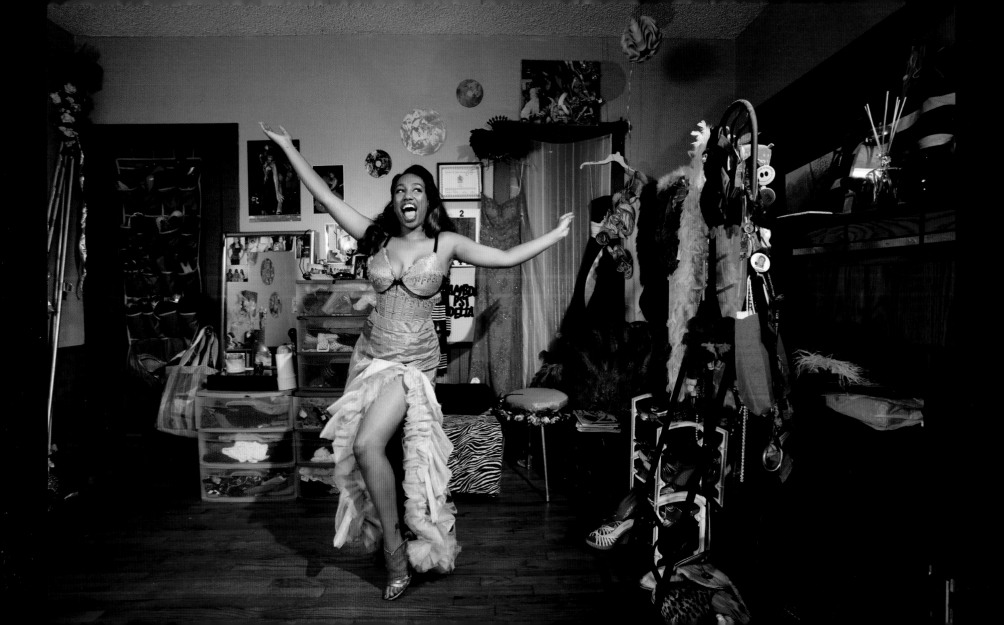

Teddy Bare
Burlesque Performer
ABITA SPRINGS, LOUISIANA

I started doing burlesque in college. What is so exciting about the possibilities of burlesque is, I believe, that there's a lot to delve into in terms of sexual politics. And so for me, it has to have a meaning. It has to have story and there has to be a reason why I'm taking off my clothes. You have to have some specific reason, not just because the audience wants you to, which can be fun, but for me, for my background story, I have to have something. This is the moment that this has to happen.

I feel like there is a fine line between burlesque and stripping and I believe it's all about what the intent of the performer is. As a performer you have no say over what the audience is gonna feel and how they're gonna react to you. And that is the main thing that is a sticking point with me and my father, because he's like, "Well, all these guys are just going to come and, like, stare at you and objectify you" and it's like, I have no control over that and I'm not going to let them, that's not where I am with it. So, it's difficult. That's a hard rule, to live for yourself, because sometimes it does affect you in how someone treats you later or how they talk to you.

Well, I've had to describe to my parents and to various family members why this is important to me. And so I've come up with a lot of reasons, like, well, it has political meaning. I can say something about social situations. It can be topical, it can be political, it can be all these things because there's so much there to delve into in sexual politics.

And I find that it's fun. I just feel more comfortable in general taking off my clothes in front of people. The rush is the best. I've performed various forms of theater and dance, and it's still the best rush ever. So yeah, that's I guess a little bit about why I do it.

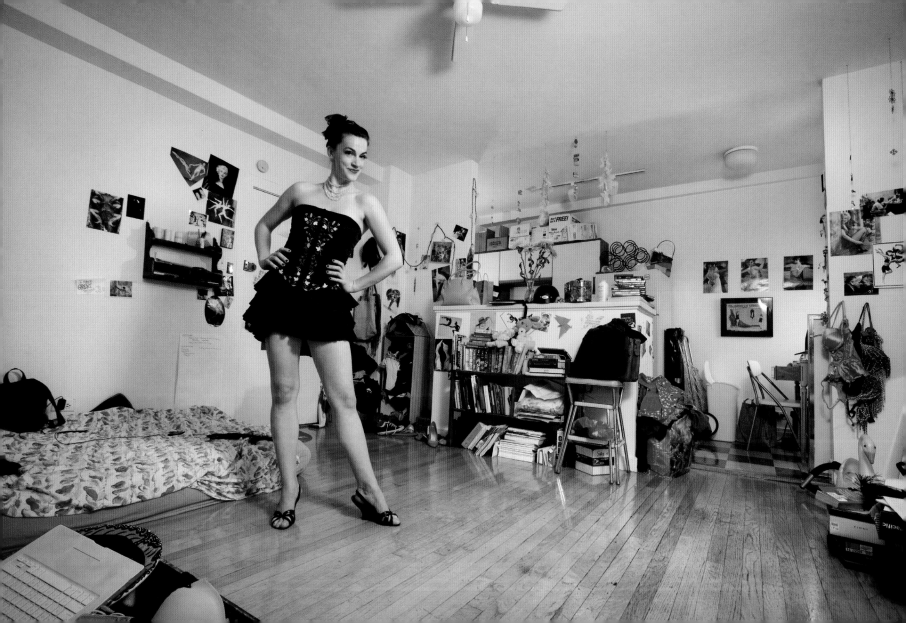

Ol' Scratch

Burlesque Impresario

ORIGINALLY FROM NEW YORK, NEW YORK, AND LIVING IN BOSTON, MASSACHUSETTS

American burlesque, to me, means striptease, which is sort of the same thing it means to everyone else. I think of burlesque as being this funny chimera of dance and theater. Working in Boston here in the various arts communities, it's pretty clear to me that the dance community thinks that we're theater or dirty, and therefore doesn't really need to have anything to do with us, and the theater community is pretty sure that we're dance or dirty, and therefore doesn't need to have anything to do with us. So ... I reconcile the tension between those two worlds by using it as inspiration. It means that the shows that I produce, or the shows that I'm involved with, are more professionally run, more polished, more put together than anything that is either solely in the dance world or solely in the theater world. Well, I mean that's what we aim for. Obviously, in Boston there are a number of very good professional dance and very good professional theater companies, troupes, and so forth. I mean, we're not really competing with them, but comparing ourselves with companies that have multimillion-dollar endowments is a little bit tricky.

I think that there are a lot of different flavors of burlesque, but it's like art. It's hard to describe but I know it when I see it, and I know what it's not when I see that, too.

Burlesque means a lot of things to me personally. I mean, for the Boston Babydolls, we take a lot of pride and pay a lot of attention to our roots, to the history of burlesque. One of the lines that we often use is that we create a golden age of burlesque that never really existed. Our numbers tend to be glamorous. There's a lot of other different types of burlesque that aren't necessarily about the glamour. But our numbers tend to be glamorous and fairly polished, like they frequently were back in the day.

But, to me, burlesque is that funny hybrid of theater and dance and comedy, striptease, but not all striptease, variety acts.

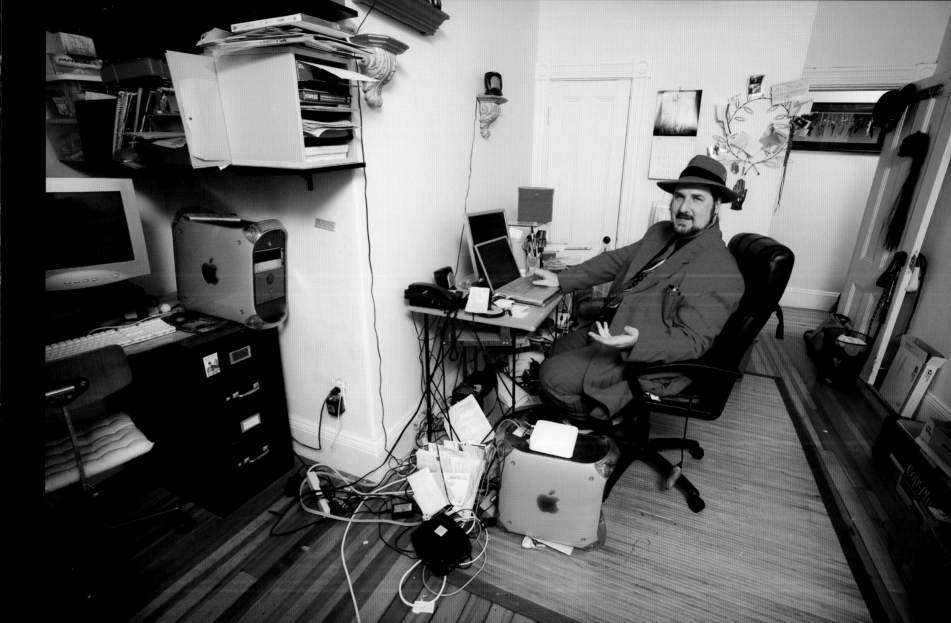

Venus DeMille

Burlesque Performer

LOS ANGELES, CALIFORNIA

Burlesque to me is like mini-theater. It's an opportunity for me to create an entire theater piece within a very specific formula, within a specific format, that allows total creativity. And it allows me to be the director, the lighting designer, the costume designer, the choreographer, and the artist all at the same time. I get to tell a story, and it can be either funny or poignant, or have a statement.

But within that really restrictive formula, it's really fun to create anything I want. When I was in graduate school in theater studying costume design, one of the assignments from our scenic designer/professor, was to tell little narratives, because when you're doing theater you need to tell a story. That's the most important thing. And I had a really hard time coming up with stories to tell. My problem was I didn't have anything to say, and all the other students seemed to come up with these amazing things to say and I just sort of flubbed through and did what I could. But for some reason, when I started doing burlesque performances I found a voice. I found there were things I needed to say. And it was something about the formula or the format that made me think of things all the time that I wanted to do. I don't know where those came from, but I still think of acts today that I want to do. And I'm to the point where I just can't do them anymore and I'll give them away, because I don't have time. I don't know where that came from, but somehow I found my genre. Accidentally.

Another point I think is that in my day job in theater I am creating and I'm realizing other people's creations. I'm making other people's costumes and I'm supporting the stories that they are telling. But in the world of burlesque, I have an opportunity to step outside of that and do my own little shows. Every act is my own little show. It gets plugged into the larger framework of somebody else's show that they're producing, but within my little act I have complete control, and I love it.

One of the things I think about burlesque is it's little theater. Burlesque is also drag for girls. It's drag reviews for girls. Boys in the drag scene have their drag reviews where they can do their karaoke singing and they can do their little performances and they get all dressed up and glammed up and do their drag reviews. And girls don't have that outlet, but we have burlesque, which is a very similar thing. It allows us to get completely glammed out and dressed up and go out and perform for other girls.

Plus, because it's a bunch of girls doing it together, usually in shows that are produced by women or have a lot of women in the cast, it's also very liberating and freeing, and it provides a great atmosphere to develop camaraderie and friendships that are fantastic. Most of my best friends today I've met through performing with the Velvet Hammer and after. And it's just been great.

Burlesque also to me is a kind of an alternative to the independent or alternative music scene where everyone gets together and watches each other play music. We all get together and watch each other take our clothes off. There's a certain camaraderie and a certain social milieu and a certain social networking and bonding that happens there, which is also tied into the sort of emancipation of our own sexuality where we can be sort of … how do I say … where we can be okay with our sexuality, and sort of flaunt it or embrace it in front of a crowd. For a lot of people, it's very liberating. Sometimes that's a big part of the performance, but sometimes that's not. Sometimes the performance is another thing. But I find that it's kind of like a music scene for us.

Even though I tend to concentrate on the theatrical part of burlesque, as far as entertaining the crowd, I find that some of the most successful numbers are the ones that fall back on the classic, tried and true, really, really well done striptease, because that has been perfected by the legends of burlesque and that will always work. I find that a lot of times the strongest performances are the ones that really get back to the basics.

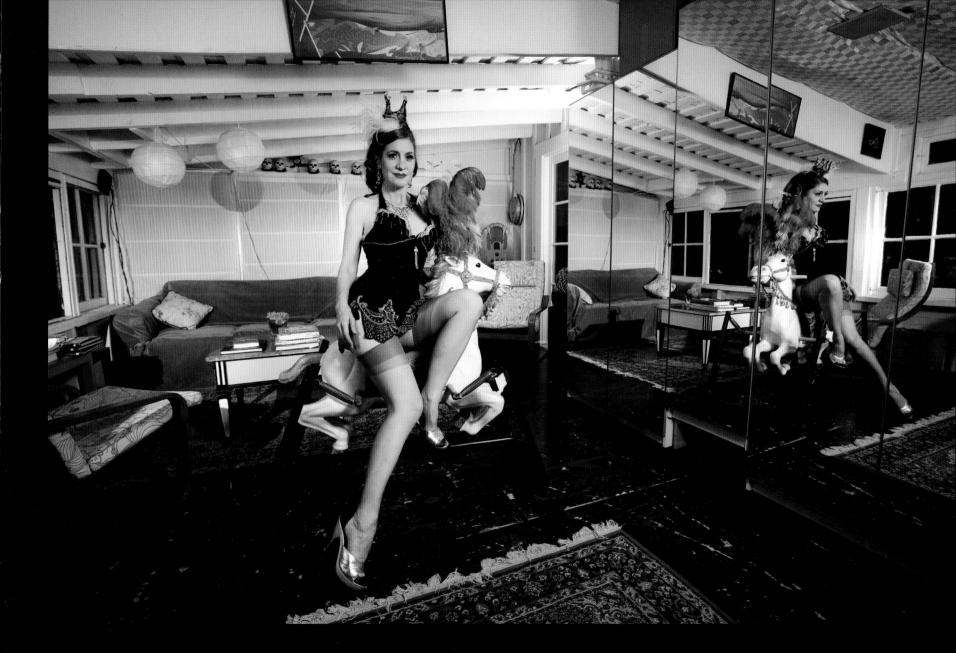

Delilah D'Bauchee

Burlesque Dancer and Choreographer

DETROIT, MICHIGAN

What does burlesque mean to me? Well, it's exciting and it is a good form of expression and it's very empowering. It's just a whole lot of fun. It's cheeky. I love the comic aspect of it, cause you can be really tongue in cheek with it. And there's always double entendres and euphemisms being flung around everywhere. I think that's probably my favorite thing about it.

Being, and becoming, somebody else onstage—I'm always really nervous before a performance—as soon as I step onstage I become that character, I become Delilah. So offstage sometimes I'm not always her, but onstage I'm always on.

It's very empowering, though. I think that's the most fun about it. The performances to me are always very commanding. You know that everybody in there is, like, "Wow, what are they gonna do next?" or ... "When are the clothes coming off?", that kind of thing. So I think it's empowering personally and as a woman to be able to do that without any kind of stigma, I guess? I think people understand it as an art form.

Burlesque to me is very separate from stripping, you know, like what a stripper would do if you're going to a strip club. A lot of people don't understand that at first, and then they realize you bring in this vaudeville act. Our acts are usually little skits or something, so there's usually a little story being told. So I think that's the difference, it's more of a fuller performance, a little vaudevillian. The Hell's Belles try to hold true to that very classic burlesque theme. So, even if we use modern music, we keep the acts very classic.

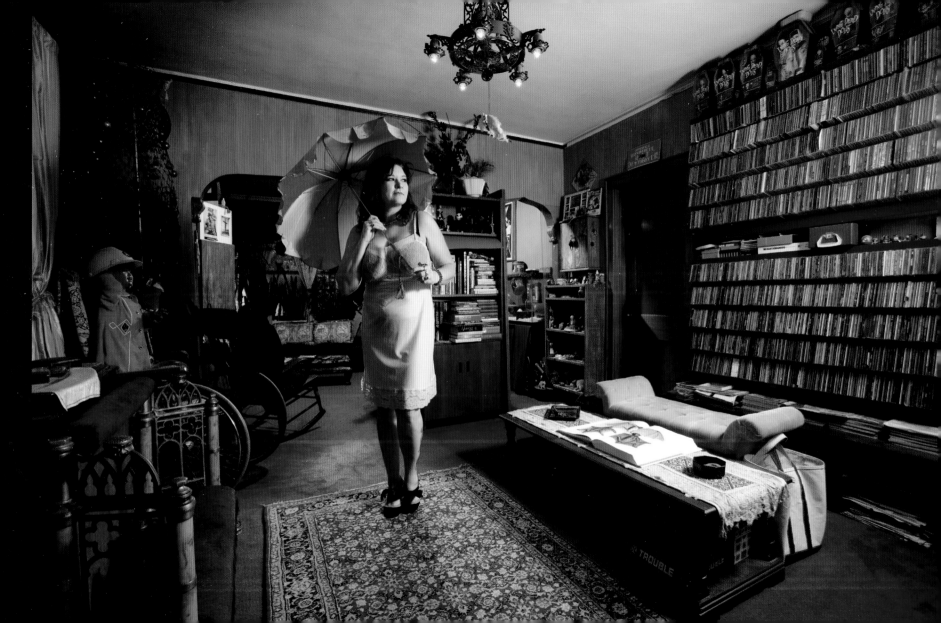

Madina Madis
Burlesque Dancer
BUFFALO, NEW YORK

Burlesque means to me being an artist. Being a creator. Exploring my creativity, getting into new music for different acts. Developing style and how to make costumes, kind of like DIY interests of how to save money without going and buying new things. Just putting my own creative energy into things and making something out of thrift shop finds or bedazzling something, or developing style. Old prom dresses, gluing or adding to them, pinning them up with flowers or just using sequins and brightening up something. You know, actually prom dresses are super easy to alter.

My life without burlesque would be a little more on the dull side. I mean, doing this so regularly I can use my imagination. Part of it is not growing up and playing, developing fantasies or ideas that could be numbers. Using my creativity to design or put together a number with costume and music.

I think also just having an alter ego, too, or a stage presences versus your daily life is fun. I mean, it's definitely blurred a little more for me lately, but it's fun. There's nothing more fun than playing dress-up and getting to do this on a regular basis. So, I think it's just continuing my ability to create.

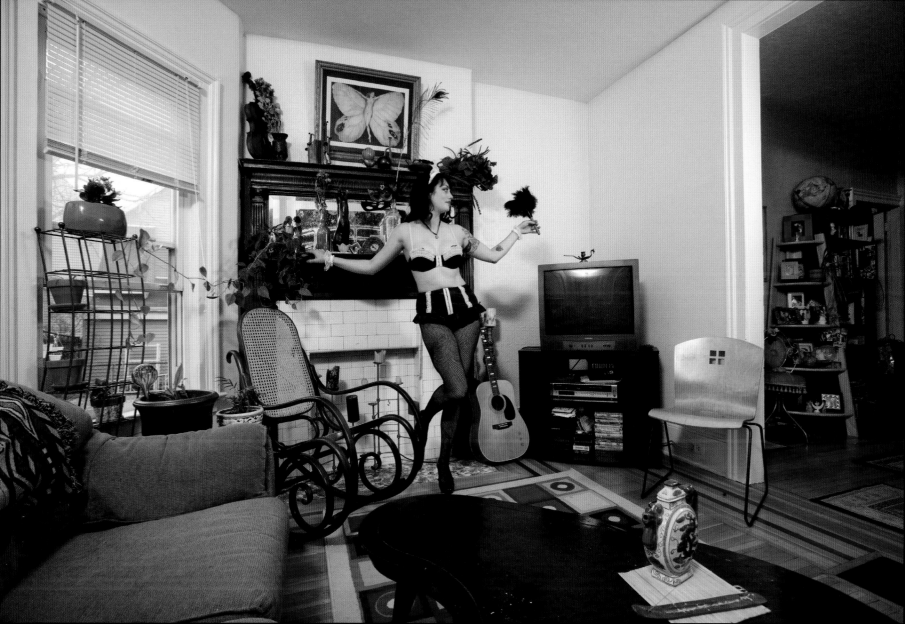

Miss Karla Joy
Burlesque Performer
LAS VEGAS, NEVADA

What does burlesque mean to me? Burlesque to me means self-esteem. I had absolutely no self-esteem whatsoever until I started taking my clothes off, which is very random or odd. But I used to weigh a lot more and I had giant bazungas that I was horrified of and I never showed to anyone and I kept them to myself and I never thought of myself as pretty. I basically cried every day when I looked in the mirror. And someone told me about a burlesque pageant called Miss All Tease, No Sleaze that's held in Las Vegas every year that the group Babes in Sin puts on.

And I said I was gonna do it. I knew I was gonna have a breast reduction and, I guess you could say I wanted to go out with bang. And I did it; I ended up winning, and I had so much empowerment from it. So much, I guess you could say, control over who I was and what my body looked like. And a couple months later I did have a reduction and I just decided to keep with it. But if it wasn't for the back pain I probably would've kept my chest, just because of how I felt afterwards. I felt like I was pretty and I felt empowered by the act of this is who I am and take it or leave it. But I know you're gonna take it and love it.

I did not need to have that surgery to have self-esteem. It was mainly because my back hurt so bad and I just couldn't take it anymore. I felt I didn't need the surgery after performing. Maybe it was the roar of the crowd or the fact that I went blind from the light bulbs flashing when I took my top off. But ... it was nice. It was fun and it was a lot of self-esteem that I had been holding back for twenty-one ... almost twenty-two years I'd been holding it back, so ... it was nice.

Burlesque to me is fun. I look at my burlesque routines as a comedy skit—a way to show you something that you're not gonna see every day. Being that I'm from Vegas—I live in Vegas—you're gonna hit a strip club on every corner. There's showgirls; every single Vegas show has nudity and all these size twos with fake boobs and there's nothing wrong with that. You got it, you flaunt it. But when you come to my shows, when you see me perform, I connect with you. I will look you in the eyes, I will flirt with you, I will flick you off if you're not giving me enough applause. I will joke with you. All my routines have some sort of comedy in them, and I feel like, you're already going to see me take my clothes off, you already know what you're gonna get, I might as well make you laugh. Laughter's the sexiest thing in the world, and I've become more aware of who I am. I guess you could say I'm more aware of my comedy skills from it and just how far I can push the boundary of comedy and of sexy while still keeping it very entertaining.

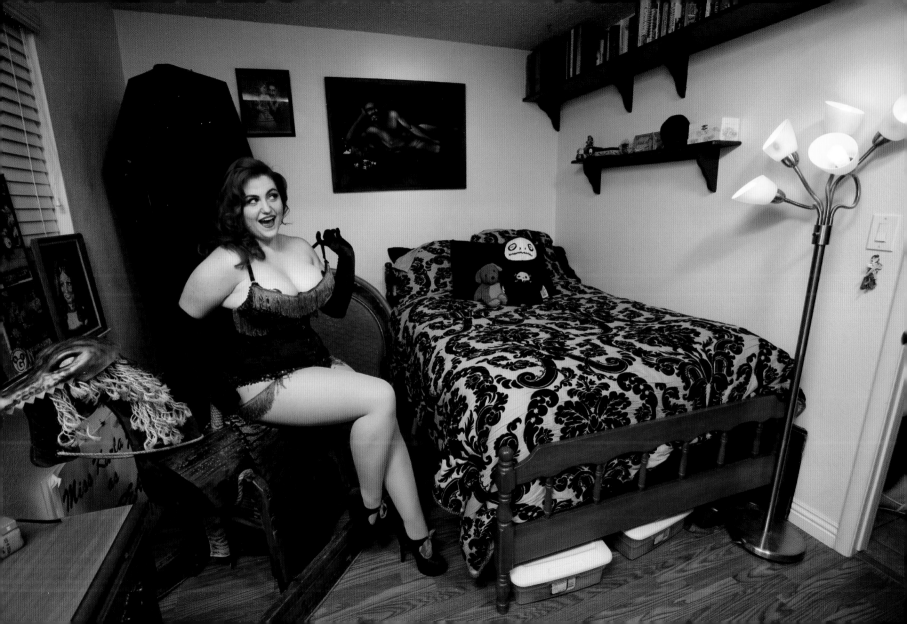

Chanel le Meaux with Jackson

Burlesque Performer

MILWAUKEE, WISCONSIN

Burlesque to me, number one, is about empowerment. I think that, for a long time, I tried to shut down my whole sensual, sexual kind of thing that I put out there to the world. For me this was the opportunity to really bring that back and use that in a positive and entertaining way. I think it's also about the artistry of it. Having a drag queen as a brother and growing up with big feather headdresses and all that kind of stuff, and a mom that's an antique dealer, I grew up with lots of things that really fed into the Chanel persona today. So, I'm definitely a lot about the artistry.

I am a burlesque singer, so I do lots of good old stuff like Peggy Lee. And for lots of people, their favorite is "Why Don't You Do Right" which everyone says is the Jessica Rabbit song, which is actually Peggy Lee, which is one of my favorites to perform. So, I do a lot of Peggy Lee, Billie Holiday, Eartha Kitt. All those sassy older singers.

For me it's a lot about the camaraderie as well. I think that so many times in life you have your cliques of people, and you fall in and out with groups like that. With burlesque I found people that I really click with and can have good conversations with. They understand that whole sexy empowerment kind of thing that I think so many in the people in the world just don't get. Or it's too hot and it's a subject they can't even talk about because they're afraid.

I think these are a bunch of women that are really not afraid to approach those kinds of things and they do it in their performance and they do it in their lives as well. So, I think they are good examples for me to be around and I think we really feed each other in that sense. So, it's been a very ... very nourishing environment.

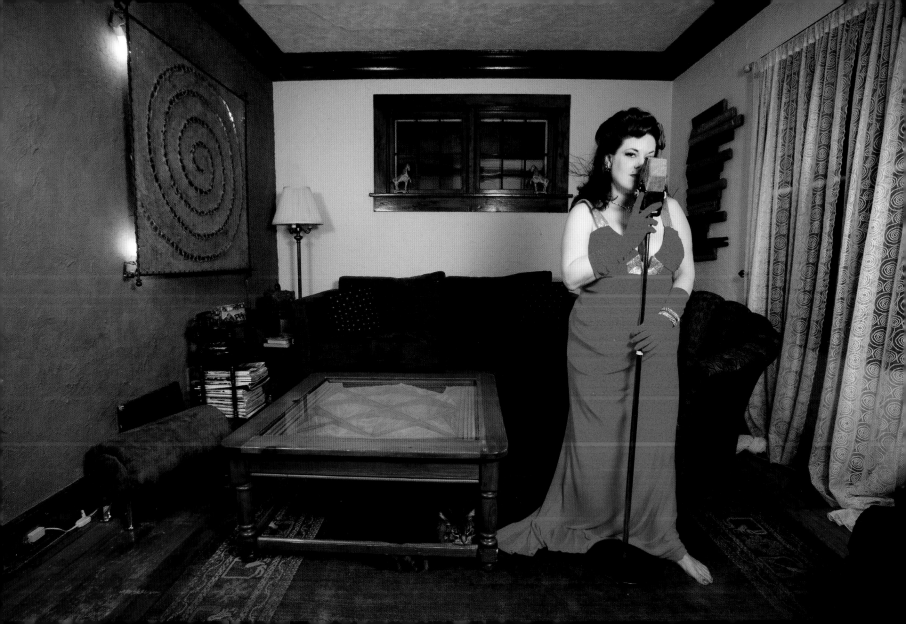

Cherish the Burlesque Goddess

Burlesque Dancer and Producer

CHICAGO, ILLINOIS

Burlesque to me is a form of expression that I am very, very proud to be a part of. To me, it's a little theater, it's a little dance, it's a little performance, a little sexiness. It can be classy, it can be sexy, it can be sleazy, it can be all of the above. But, it's definitely fun.

The elements of burlesque that really get me going would be the gimmicks. I am very well known for dancing with my snake, a seven foot long red tail boa constrictor. But I also like working with other unusual gimmicks. And when I say gimmick, gimmick could be anything from spinning around in propeller pasties for a stewardess outfit or the surprise of a magician pulling a rabbit out of his hat. I like the element of surprise in burlesque. I like interacting with the audience a lot. I like a lot of audience interaction. I like the crowd to be entertained. If I'm not getting the expression that I want, if I'm not getting the response that I want from an audience, I will definitely ask for it and engage them. My gimmicks are snakes and fire and knives and all sorts of fun things, which may not be necessarily classic burlesque, but we're not in a classic burlesque time. I perform classic burlesque, but I feel like any mode of expression, any mode of dance, which this is, and performance—and I've been in theater a very long time—grows and changes with the generations, the culture, and with what's going on. I feel

like for me personally in burlesque, I have brought in elements with a bit of danger with the snakes and the knives, performance, and sometimes a little bit of fetish, because I've been involved in that for many years as well. A little sexiness, costume dress-up, like all of the above. Personally, I find it a fantastic mode of expression for women to be able to shake it and enjoy themselves and have it not be in a sleazy manner.

Another aspect of burlesque that I really enjoy is the vaudevillian comedy that's involved with it. I like to employ comedy in a lot of my acts. Oftentimes I would love to be sexy all the time or look fantastic, but I'd stumble, or my snake would pull my wig off, or his tail would go up in between my legs, and next thing you know, it's funny! And you just go with it onstage and if it's going to be a funny, sexy act, you can be funny and sexy, which you don't really see a lot of times when you see sexuality on TV or you think about a strip club or something like that. You think about, "Ooh, it's sexy," and it can be very funny stuff. You see that a lot at burlesque shows. You see a lot of laughter and a lot of enjoyment and I personally think that's one of the best things about the show. You can enjoy yourself and it's something for everybody. Fun for the whole family, but not really. Above eighteen please!

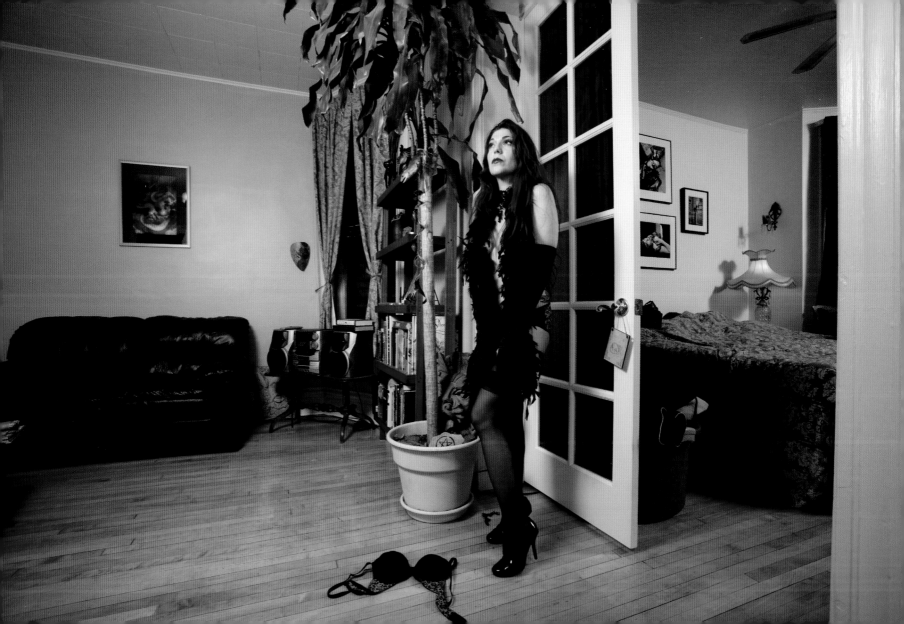

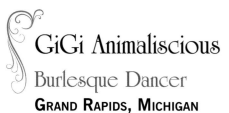

GiGi Animaliscious

Burlesque Dancer

GRAND RAPIDS, MICHIGAN

Burlesque means escapism to me. It's being able to just be whoever I want. On long road trips I can drive around and think about what I wanna do for my next show, think about the different characters that I want to embody. It's like having Halloween all the time. That's what I absolutely love.

I celebrate Halloween probably seven days in October if I can. I have many costumes. I just love dressing up. I love being creative. People that know me would say if you looked at my closets and my dressers and my garage, you'll see I have so many things that I've probably been anticipating this moment all my life. I have so many shoes and hats and accessories and dresses that, as of yet, I think I've only had to go out and buy one thing for any of my performances so far. I'm really happy to be a part of this and it's probably one of the most exciting things that I've ever done.

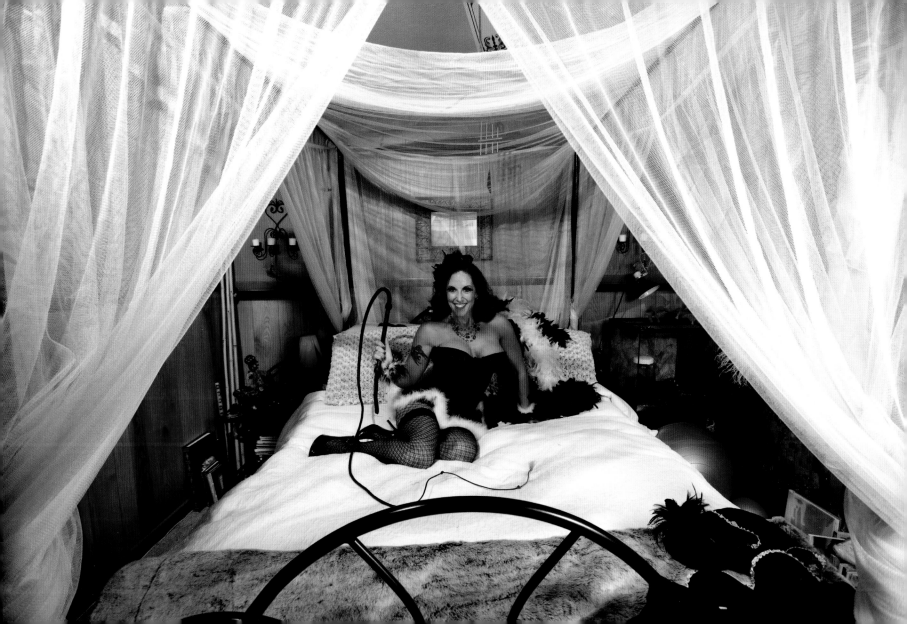

Pearl Pistol with Kitty

Burlesque Performer and Producer

CHICAGO, ILLINOIS

Burlesque means a lot of things to me. I find it very interesting to play around with burlesque because we can be pretty cheeky, we can be pretty smart, and of course showing a little skin doesn't hurt. That keeps the attention of the audience. Burlesque has already been done, so to reinvent it we have to get a little smarter and use maybe a pun or two more and get a little bit more sarcastic, I suppose.

So, being a proud feminist or a neo-feminist, somebody who's actively working and engaged in her own life and being her own person and creating a lifestyle. In this particular lifestyle, based around sex and sensuality and femininity, it's the perfect melding of these things that have already been done to create a very smart theater type that is again engaging with our audience and keeping their attention with something that we know everybody loves, which is sex. Let's be honest.

The feminist part of it is being able to be very proud of your sensuality and involved and kind of in charge of your body and not somebody else's property or ideal or sensuality or their notion of sensuality. You know, *Playboy* was started by a bunch of men and I suppose if it was started by a bunch of women we'd probably all have more subscriptions to it. Us ladies, anyway.

I really love what I do and I love entertaining people and I love it when an audience is happy. They're so thrilled, they leave with big smiles on their face and then they go home and get laid. That's what it's all about, you know? I mean, I'm just happy to be a part of that and every show that I've done. I can't say that I get an e-mail or a phone call saying, "Thanks Pearl Pistol!" But I've definitely had interaction with people who say, "We always like coming to your shows." That's the point, you know what I mean? Like, more lovin'.

Velveeta the Cheetah
Burlesque Dancer
GRAND RAPIDS, MICHIGAN

I have been thinking about that question for several days now, and I still have no answer because I did not join a burlesque troupe or become a burlesque dancer because I was interested in the history of burlesque. I started because I was interested in performing and there weren't very many outlets in Grand Rapids. I do have a lot of acting training and I'm pretty versatile as an actor, which, in high school and college meant that I was the old person, the crazy person, the mother, and so on, because, yes, I could have played the lead, but the girl who got cast as the lead could not have played the lead's mother or the crazy woman, and so on. I started to resent the way makeup for a show inevitably involved aging me thirty to fifty years. When I was a senior in high school, I played a woman who must have been eighty. Makeup took forever. I really wanted to be a bombshell.

Also, the producers of Super Happy Funtime told me that I didn't have to shave my armpits. In fact, I did not start shaving my armpits for two to three years. I think I started shaving my armpits three years later for unrelated reasons.

What attracted me to burlesque was that I had total control over the act. The only restriction was that I would start clothed and end mostly naked. Or rather, end topless because there's nothing that says you have to even take your corset off.

I started doing burlesque dances because I wanted to be the bombshell. I wanted to have somebody make me fabulous and make me look like a heightened super-glamorous version of myself. But, for a long time in every burlesque dance I did, I ended with my symbolic death. I was a robot and I unplugged myself. I was Joan of Arc and they burned me at the stake … the voices told me to take it off. So, I start out wanting to be this bombshell, but I realized that I'd gone to so many places, I'd actually gone to lengths in dances to make myself unsexy or to play with what is sexy.

I think ultimately a woman taking off her clothes is not that interesting. We have to make it interesting. That's why it's a skill that people learn. And I'm finally getting okay at it after nearly four years. There needs to be something more, and something that I've always tried to do. As I'm trying to take off something else, what is left? Now that you're naked, what else can you take off? How can you be more exposed? I think I'm trying to make it difficult for myself to keep it interesting. I find that I don't get really excited about a piece that I'm working on unless there's some strange concept or something that distorts the dance and subverts it so it's less sexual.

I keep burlesque interesting by making it as close to performance art as possible. Even to the point of doing things in dances that are not as effective or not as sexy, because it's important to me just to be bizarre, apparently. Or not, … it's important to me to be a little off and a little unsettling.

It's not that it's sexy. It's actually very easy to be sexy. Anybody can be sexy. The question is whether you can be memorable. So, I'm not trying to perform a sexy dance so much as I'm trying to perform a memorable dance. I really do believe that anybody can be sexy, you just gotta present yourself right.

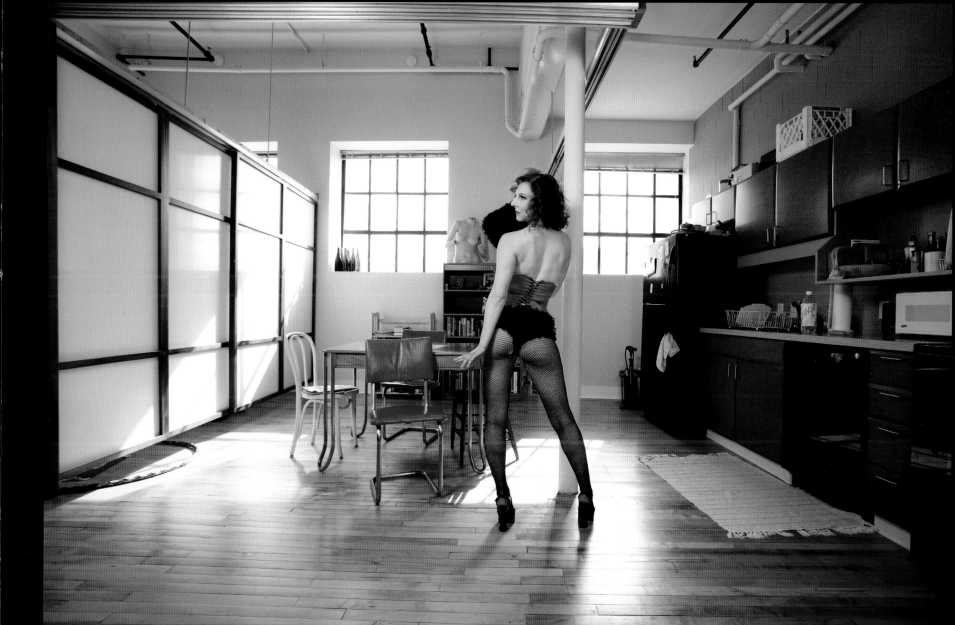

Siren Jinx

Burlesque Dancer

CHICAGO, ILLINOIS

What does burlesque mean to me? I would say burlesque is a way to express who you are as a person. It's kind of doing the whole Gypsy "Gotta Get a Gimmick" I think, in a way everyone has their own gimmick both in real life and then as a performer. And sometimes those two cross. I think burlesque is a great way to express your creativity, in costuming or dance or acting or singing or whatever that is. It gives you full control over what you want to do as a performer. That's one of the reasons why it appeals to me so much.

Well, I think plays and musicals and stuff like that are a little outdated, to me. I mean, they're still going on and stuff. You've got the Goodman, you've got Steppenwolf, you've got all those big-name theaters, but I think a lot of times—I've said this to a lot of my friends and I can get on my soapbox about it—they're too expensive. I think that a lot of times you're doing the same plays and musicals over and over again. You've got *Our Town*, you've got *The King and I*, and then you've got burlesque now that's kind of coming back and becoming a new thing. But it's not necessarily a new thing because it was done back in the day. Now you're kind of bringing it back to a new group of girls, a new group of people who want to take it and create it, making it more contemporary.

For me I think it's fun to experiment with new ideas and see how far you can go with those ideas. I mean even as like a kid I remember having these creative spurts, and as an adult, too. I still have those creative spurts that you can't necessarily apply to a play because that has an outline, that has a specific script, whereas this is something that is live, so it's different every night. I mean, a play is also live and can be different—you can get different vibes from different audiences. But burlesque, yours and yours alone and you can shape it every time you perform it. You can go, "Okay that worked there." Sometimes when you're workshopping it, you're performing it still anyway, you know. So, it may not be done yet, but you're already in the midst of performing it. And then, every time you start doing more of it, costumes are different, new ideas come into play, and so that's what makes it kind of fun. It's always changing.

It's about creativity and creating something that is you. I think that is it. That's the thing that makes it the most entertaining and the most fun to see in each act that you get to experience.

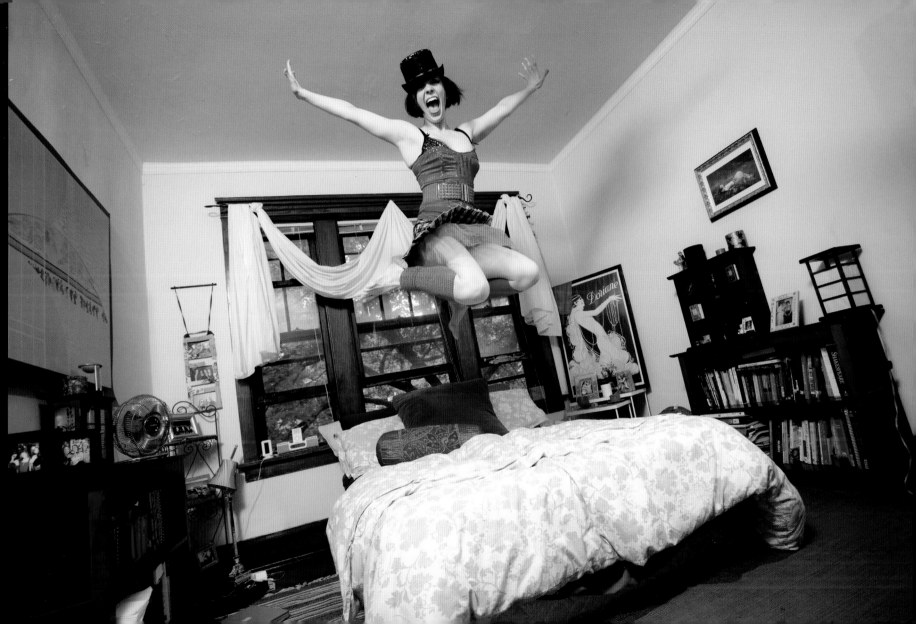

Clams Casino with Brett

Burlesque Dancer

NEW YORK, NEW YORK

So, burlesque to me is striptease, especially emphasizing the tease part of it. One thing I find really exciting about contemporary burlesque is it also combines a sense of humor—it allows a woman to be sexy and funny at the same time.

I think humor's really sexy and I think sex is really funny. And ... so, I find it really exciting when you can combine those things. I also find that generally in pop culture sexy women aren't funny and funny women aren't considered sexy. But I think they are really sexy. The fact that we can be really feminine and play with it and blow up our femininity and be funny at the same time is really exciting.

So, gosh, I mean, it's so many things. It's just a way for me to combine my love of drag queens and rock stars all at the same time. It allows me to be a drag queen and a rock star without any musical abilities or a penis. Yeah, it's inspiring and exciting.

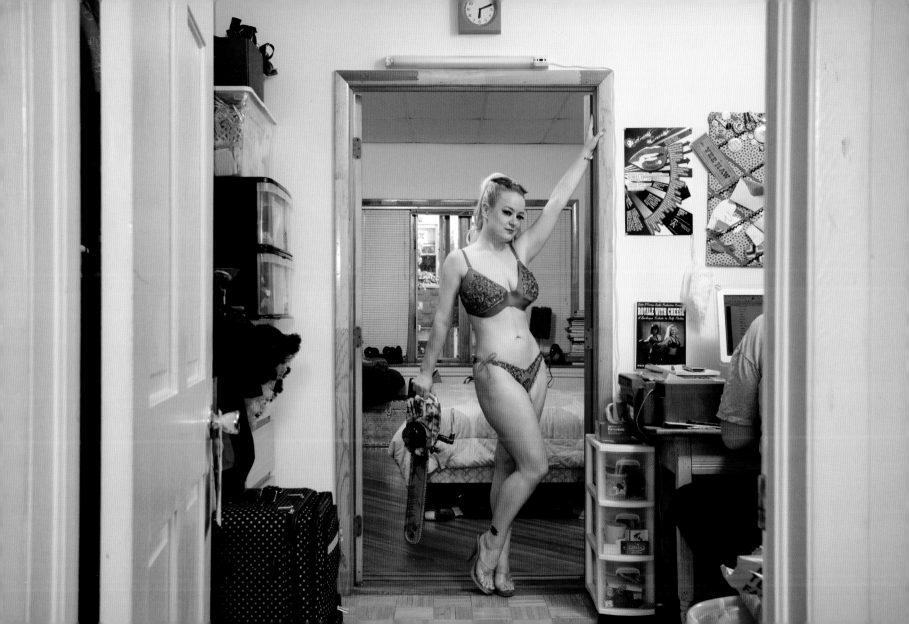

Red Hot Annie with Waffles

Burlesque Dancer

CHICAGO, ILLINOIS

Burlesque means to me an expression of one's sexuality. I think that it can be any expression of one's sexuality including absurdity, or silliness, or also very personal or sexual or pretty things about sexuality. I think sexuality is how you would identify the things that get you off. Although, I don't feel like, as a performer, I get off on my performances. Although, there is certainly a part of being an exhibitionist I enjoy.

I think sexuality can be anything from your sexual orientation to the fact that you wear perfume to entice someone or the little things that you do to entice someone or to keep their attention.

I think that burlesque is similar to that, in that you are exhibiting something that has the intention of alluring, even if your intention isn't necessarily to have sex with the person. Certainly I've been in relationships where I am interested in flirting with somebody more than having sex with them. So, perhaps that explains where I'm coming from when I say that it's an expression of sexuality.

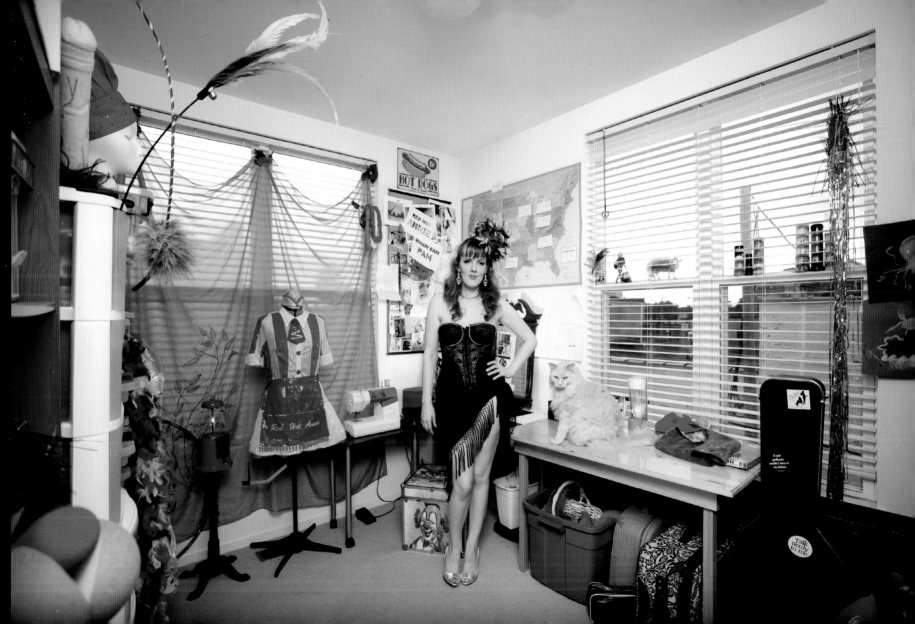

Velvet Dan & Rita Ambrosia Schuvitinitcsz

Burlesque Performers

GRAND RAPIDS, MICHIGAN

Rita Ambrosia Schuvitinitcsz: Burlesque to me signifies freedom. Being able to do whatever the hell you wanna do. Burlesque is the first performing on a stage I ever did, legally, I guess you could say. I do speeches where I talk about my opinions. I teach dance moves to try to enrich the community and make them as cool as me, which can be difficult at times. I like being able to take my panties off in public. It turns me on. Velvet Dan, do you agree with what I'm saying about panties?

Velvet Dan: Yeah! Yeah, totally. Panties off!

RS: Panties off.

VD: Panties off. Bras off. To me, I am a magician in the burlesque show, so I found it pretty challenging to do normal stuff, because I was a magician before I got into the burlesque show. But, you have to compete with boobs and butts and penises and balls. So, you gotta take it up a notch. There isn't a thing a magician can't use that I can't take out of my butt.

But anyway, we really like being in the burlesque show. We think it's a really cool thing to do, especially when we come to a town in Michigan that hasn't seen a burlesque show and they're like, "What the heck is this all about?" Then we get there and after the show they're like, "Oh my God! I shoulda worn my helmet 'cause you blew my mind!"

RS: Yeah.

VD: You know?

RS: Burlesque to me definitely means freedom.

VD: You can do whatever you want.

RS: Whatever you want, as long as, in Grand Rapids, Michigan, at least, you have 75% of your breast covered …

VD: Yeah, and you have to be at least twenty feet away from the spectators.

RS: As long as you don't simulate sexual acts …

VD: Sex. No sex.

RS: … which can be really hard for us.

VD: Yeah.

RS: Going back to the breast thing … breasts are already covered 75% by skin.

VD: Yeah, and this is only in Michigan. And there's a whole array of things that you can't do, like show your butt hole.

RS: You can't show your butt hole.

VD: Apparently, after I showed my butt hole I found you couldn't.

RS: We found that out the hard way. You have to wear a thong and it can't be flesh colored.

VD: Yes. Oh Yeah! Every now and then you'll look out into the audience and you'll see somebody writin' down notes. They're takin' notes on our show so they can report it back to headquarters and then we have to have a meetin'.

RS: Um … so, anyway, it means freedom.

VD: Yeah!

RS: Really.

VD: Total, uninhibited freedom.

RS: Unin … uninhibited.

VD: Well, a little hibited.

RS: Kind of hibited.

VD: Little, little hibit.

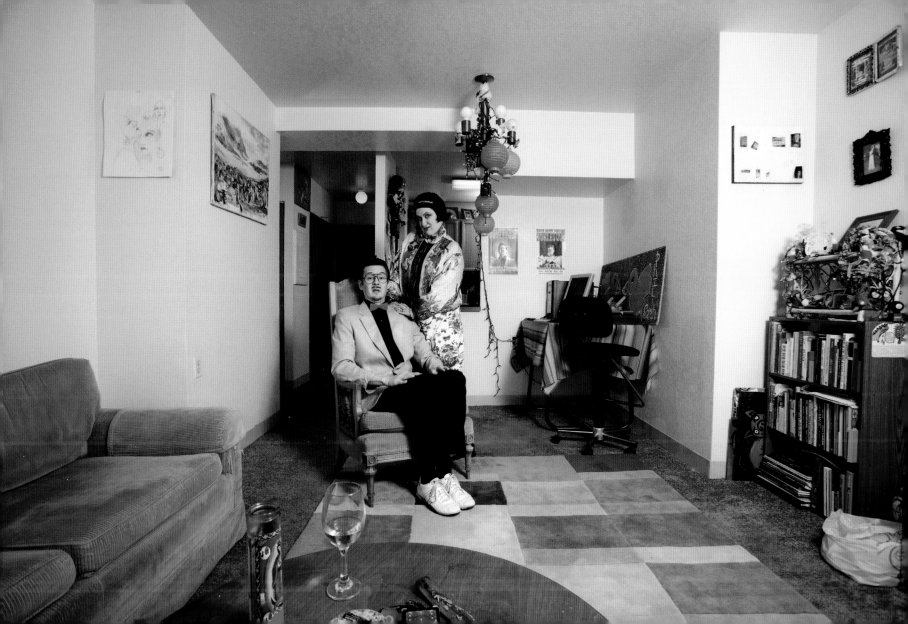

Ruby Joule

Burlesque Dancer

AUSTIN, TEXAS

What does it mean to me? The way I've used it is a way to express myself with complete and utter freedom. Coming from a background of professional dance and acting and film and theater, we're often waiting for a director to cast us in a role, to say, "Here are your lines, here's your blocking, here's what I want you to do." In burlesque, I can decide that I want to play the Sugar Plum Fairy, and there you go, I get to do it. I can be anything, anyone, play any role and direct myself through it, and it's really a challenge sometimes because I can't direct myself out of a paper bag, but I can dance my way out of one, apparently. So, for me, burlesque has a lot of freedom to it. People could say, well, why not just put on a one-woman show? Well, what burlesque has built into it is, it's compelling. People are interested in it right now, so there's a lot of opportunity to perform if what you're doing is burlesque.

And incidentally, I just happen to love all the glamour. The striptease element of it is very transformational, I think. So, on one level it's really superficial and it's about beauty and glamour and features and rhinestones and sparkles. On another level, for me, it is about transformation, from the beginning of a three minute to six minute number to the end. Your character that you're playing is transformed, whether it's just clothed to unclothed or from a moth to the fire itself. So there's a lot of room.

The very first time I set foot onstage in this role of Ruby Joule that I created, I was terrified. I'd never had stage fright before. But this was so daunting because it was all me up there. There was no choreographer, no costume designer, no director to say if this fails, don't look at me, I was just doing what someone told me to do. This was *all* me. So if it flopped, it was all me. So, things have definitely changed from that point and now I feel much more confident and comfortable with what I'm putting on stage. And there's a lot of joy in it. It has been transformational. I've gotten to know myself better and experience the freedom and the joy of creating something. And I feel much more comfortable sharing that with people now than when I first started.

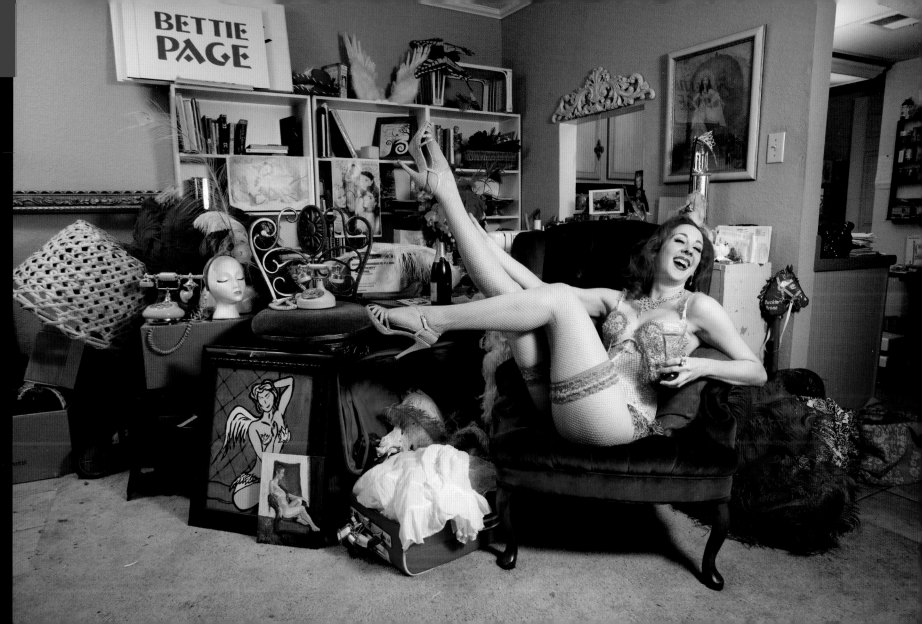

MsPixy
Burlesque Dancer
CHICAGO, ILLINOIS

Burlesque to me is an opportunity to celebrate being a girl. During my day job on a weekly basis I spend a lot of time in sensible clothing wearing jeans, tennis shoes, taking care of myself so that my knees don't hurt and my back doesn't hurt. And once a month I get to dress up like a pretty, pretty princess and a whole room full of people cheers for me when I take off my clothes. It's kind of relaxing to just know that once a month I get that chance to get all of the fun glittery happy girly excitement out of my system so that I can live my sensible life on a regular basis.

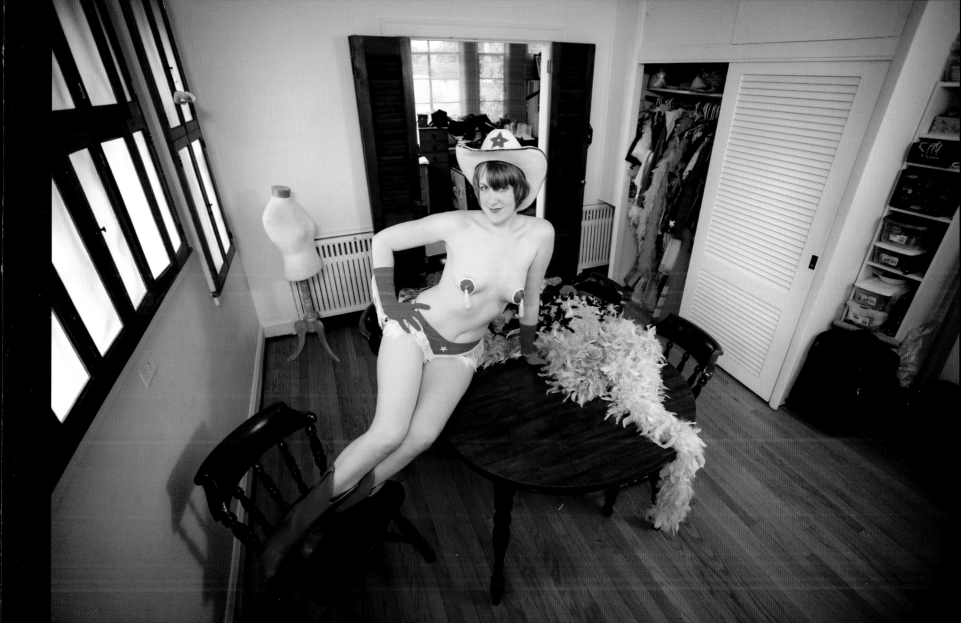

Foxy Tann

Burlesque Icon Wannabe and Emcee

TWIN CITIES, MINNESOTA

What does burlesque mean to me? It means I actually had some place for Foxy Tann, as a character, to go. It means, in the hippie-dippy San Francisco kind of way, issue-oriented; it means female empowerment. It means that I really, truly get to indulge in my nasty addiction to rhinestones, glitter, and all things shiny. It means that I get to perform in a genre that isn't necessarily accepted as a quote-unquote high art form in the traditional sense of the word. It also means that I get to say what I wanna say, when I wanna say it, where I want to say it, while wearing as little as I want to.

Where Foxy Tann was before, and I don't mean to be obnoxious by talking about myself in the third person, but (even though I find it kind of funny) Foxy Tann was brought up by a wild pack of drag queens and had been performing in the drag bars in the drag world as this character, as a female, female impersonator. So, I was like, well, if they can wear all that, I mean, they made it for me in the first place, so I might as well get to wear it. Then that just became politically incorrect because I was confusing to people. I still don't understand that. So I had kind of ceased to work as an emcee in the drag bars and performing in that kind of genre, and then burlesque just kind of liked popped on and seemed kind of perfect. So here I am.

The drag world has informed, made, molded me, shaped me, and pooped me out exactly as I am. I can only say that I have been completely and utterly in debt to drag queens across the planet, across the universe, because I would not be Foxy Tann if it wasn't for them.

There's a lot more that is being done in the drag world that could be incorporated into burlesque and still actually be representative of what people call burlesque, or quote-unquote neo-burlesque. It's all the same.

That's amazing about burlesque, though. I mean, if you think about what we're doing as performers today. You might as well have been humping a stripper pole, doing the whole sniffer's row thing way back in the day. And to us, it's kitschy. I find that a wonderful, beautiful advancement in American psychology and sexuality. Now you can take a stripper pole class for fitness. This is a legitimate business art form and something that a person should actually get paid for. I mean, entertaining people, even though it's theater, people seem to think that, "Well, it's art! You should want to do it if you love it and you should do it for free." You know, no. That's bullshit. People that are good at what they do should be compensated and should be paid for their entertainment value, whether it be naked or not. Just because somebody's getting naked does not mean that it's entertaining.

Burlesque used to be a way for women—independent, forward-thinking, progressive women—to make money. Unfortunately, the further burlesque has marched on in time, and is marching towards the idea of it being an art form, the lower the pay scale has gone. It is one of the most entertaining things that you could possibly see if you're eighteen or over. But, I think that these ladies should be compensated. So, as we march forward in time, I would like to march forward as well to make sure that everyone gets paid for actually showing their boobs. I think everyone should be able to make a dollar off of that. So that's just something I wanna leave you with. Just don't turn it into painting for fun on the street. Okay?

Hunee B. Hayve

Burlesque Dancer and Producer

MEMPHIS, TENNESSEE

Burlesque to me is about bringing out the most power that you can out of the female form. To be as sensual as you possibly can. Because honestly if you were standing in a line at Starbucks getting coffee or something and you're being overly seductive people are going to look at you like you're crazy. So, it's an opportunity to use female powers to their utmost extent, if that makes any sense. Seduction, the striptease, just being overly sensual and being able to get away with it.

I think something that kind of pinpoints that to me is … I don't know if it's going to make any sense or not, but, I used to watch the *Benny Hill Show* when I was younger and there was this one skit on there that I remember. It was my favorite. It started out with them in a nudist colony. They're standing in hot tubs and behind strategically placed fencing. They're just talking and hanging out like its a bar or club or something and everyone's naked. One of the women gets ready to leave and she goes into the changing room and comes out, like, in her work suit. She's walking past the fences and stops to hike up her skirt and adjust her garter. And the men go crazy. They're leaning over the fence, hooting and howling and there's all these naked women behind them. So, it's the art of the tease, I guess. Being … sensual.

In my day-to-day life, I tend to be kind of a tomboy. When I'm onstage, it gives me an opportunity to have the diamonds and the fantastic costumes and the dresses and be kind of over the top, I guess. It's fun.

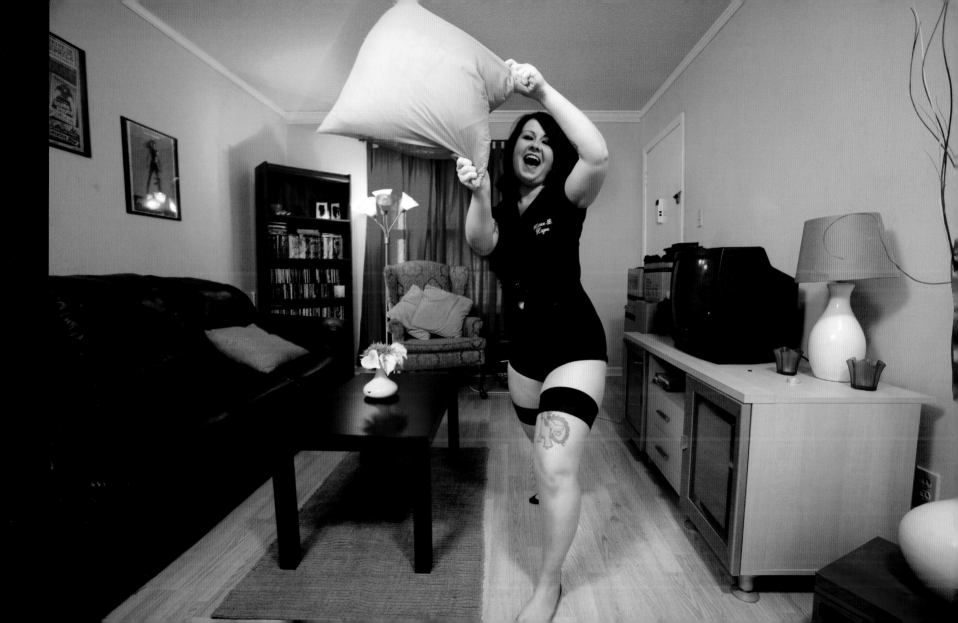

Reverend Spooky LeStrange
Burlesque Performer and Producer

NEW ORLEANS, LOUISIANA

Oh gracious. Wow. I guess I should have thought about that a little more, but ... I don't know. It's been a mild, well, not really a mild obsession. It's been an obsession of mine since I was four years old. I used to tell my mom that I was going to be a stripper when I grew up. I guess I sort of did. But, I guess ... I don't know.

Burlesque means a lot of different things to me. It's a chance to be creative. It's a chance to be a little bit political sometimes without beating anybody's head over it. I don't know, my troupe's not really the pretty girls. We're more like the thinkers, I guess. We do more nerd-oriented shows. So I guess we're really a bunch of strong women that really like to get our opinions out there in whatever we do.

It's creative and it's fun and it's a chance to be a big ham in front of lots of people. It's a chance to be excellent in other people's presence, which I enjoy.

I don't know, it's just always been really interesting to me and I've always found it really amazing and inspiring. I guess mostly just because women back in the day, they didn't have a lot of options to be independent and that was really a way for them to do that. They didn't have to get married or have babies or, you know, have a secretary job. They actually made a lot of money and they lived their lives the way they wanted to, which I've always kind of admired. I really like the freedom of it. Freedom from convention or freedom from ... not really criticism, but I guess, just ... freedom period. To be yourself and to be creative and not have to, like I said, get married and be a housewife, or have to be a secretary until you got married. All those women were amazing. I can't even believe that they they had that opportunity back then. It's really, really interesting. I don't know, I've just always been really curious and I have my heroes. They were all hard drinkers and hard livers and, you know ... *had* hard livers. (Ba-dump-bump!) You know, you can't really put it into too many words.

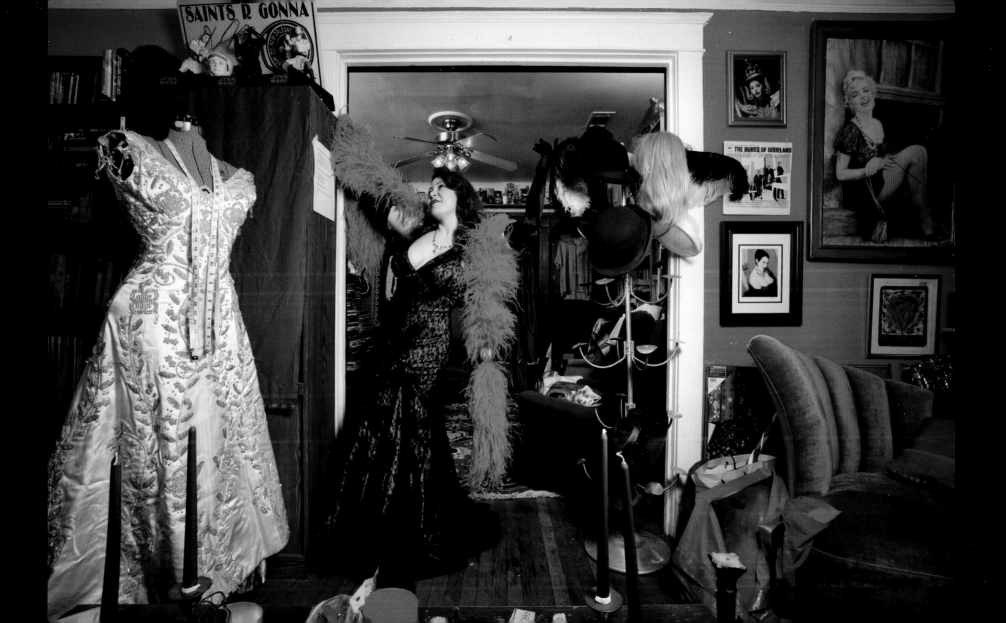

Ginger Valentine with Gypsy

Burlesque Dancer

DALLAS, TEXAS

Oh brother. What does burlesque mean to me? Well, since you asked what it means to me, I'll tell you what it means to me and not a textbook definition, I suppose. But, for me, burlesque is a wonderful art form in which men or women are able to express themselves through physical movement and in ways that are engaging and teasing to the audience in a sexy or funny way.

It means an awful lot to me ... what I do. This opportunity to create, to have an outlet for my cheeky, sexual side as a little bit of a tart, I guess. I also do know that, since I've been doing this adventure, doing burlesque, I've never been happier. I've never had such a wonderful time where I've met such a concentrated amount of like-minded people, fun people. I've never felt more authentic. So, it really means a lot ... to me.

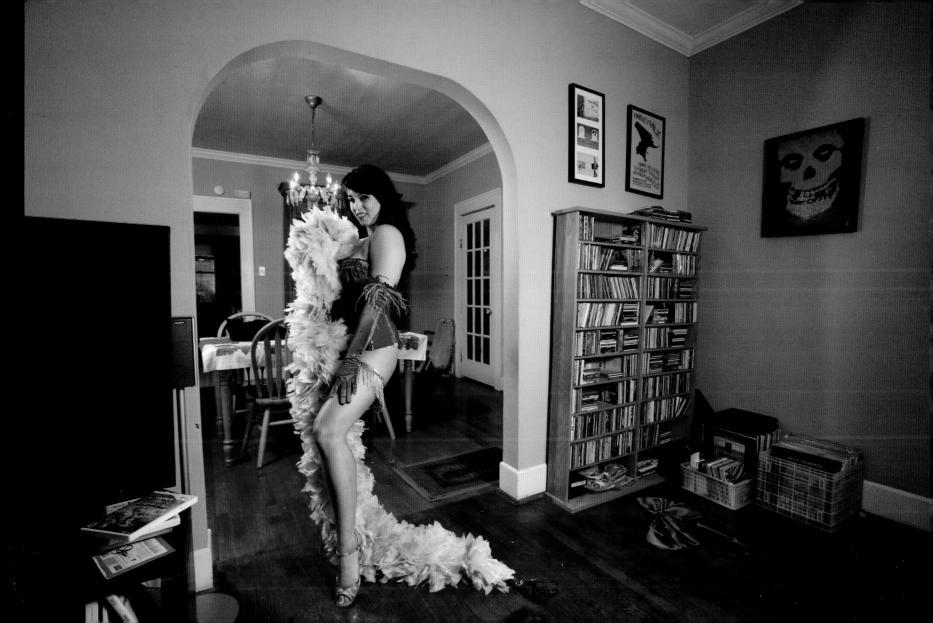

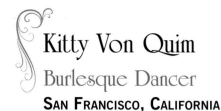

Kitty Von Quim

Burlesque Dancer

SAN FRANCISCO, CALIFORNIA

Burlesque is an art form that incorporates theater, dance, entertaining, that I believe is empowering to women in that they can conduct the way they present themselves onstage and they command the audience and what they're presenting. Burlesque is a way for me to be onstage and to let people know that, just because maybe my body is different than your body, or the idea of what a burlesque body should be, it's no less entertaining or less attractive.

I've always found burlesque to be empowering because we're the ones calling the shots about what comes off, when it comes off, how it comes off. We're completely in control of the situation from start to finish, and it was more maybe about that. Whereas now nudity is so everywhere, there are some performers that don't take off their bras and I've known other performers even to be judgmental about that, "Oh, why doesn't that performer take off their bra?" I don't feel that you need to take off everything. I happen to take off everything because that's kind of like my mission statement. Taking off my clothing is revolutionary because my body is not like the next person's body. It's just not what burlesque has always been seen as.

I feel like we try to do different things to entertain our audience more than just taking off our clothes. I think that's what burlesque is now, and it's entertaining in its own right just as classic burlesque was entertaining in its own right.

I do have something else I want to share. I perform with Rubenesque Burlesque. Juicy Delight with Rubenesque Burlesque, she's the founder of our troupe, and one of the things that she's always said is, as a fat activist, we as a troupe don't go onstage with waist cinchers on because—and this is something that I've incorporated into my own burlesque experience—we're not letting people pick the parts that they want to see of us. We're not trying to hide our bellies or parts of our body that might not be as aesthetically pleasing as other parts. I mean, beauty and attractiveness are open to interpretation. When I get up on a stage, I have people yelling for me just as loud as the person that came before me.

The first time I performed, hearing an audience scream when I would take off my clothes, when I was taught all my life as a fat person that people don't wanna see that, and hearing an audience scream for me when I was taking everything off … I mean, there's no way you can think that your body is unattractive when an audience of 300 people is screaming for you to take more off. And that's something that has been really empowering to me onstage. I can't walk around feeling that I'm unattractive now, just because I grew up feeling unattractive. I can't walk around thinking that I'm unattractive when people yell for me and people love watching me take my clothes off onstage. And that's the best thing that burlesque has been to me.

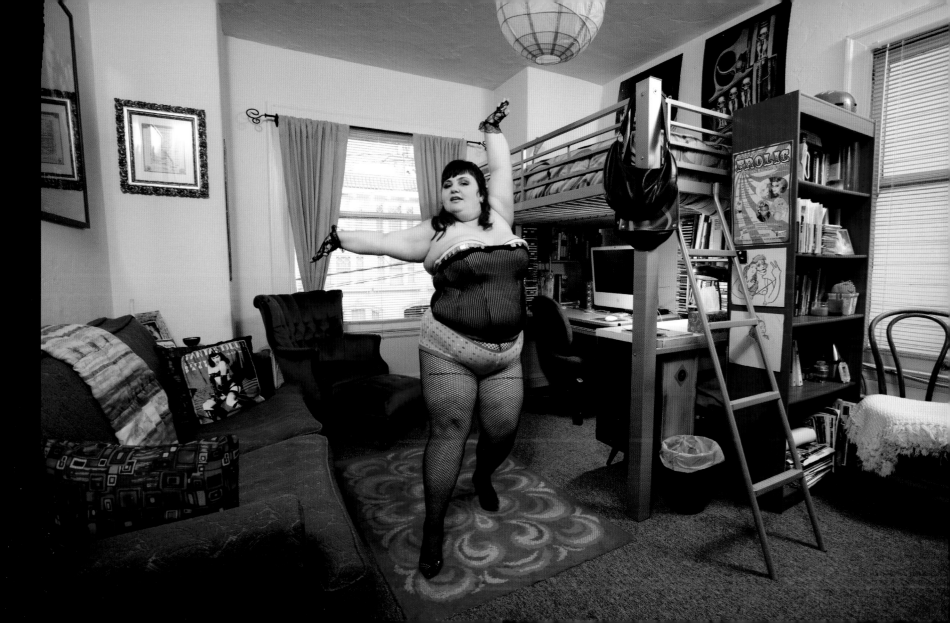

Jolie with Katie-Bear

Belly Dancer

CHICAGO, ILLINOIS

That is a loaded question.

To me burlesque is about a woman reclaiming her body and her strength and herself through performance and creating a story for people and bringing people into your world. It's not necessarily about the taking off of clothing, but that just aids in your self-expression.

I think there is a lack of understanding about what I do versus what a burlesquer does because it's like night and day. I mean it's performance, but coming at it from two completely different points of view. Whereas I am creating something purely based on movement, they're creating something that's based on setting a scene and painting a picture and bringing people into that kind of moment. So, I think a lot of what I get is just people trying to put me into the burlesque niche and saying, "Can you do something that's sort of about you being a housewife," and it's like, no! As a matter of fact I cannot because that is not what I do.

So for me as an interloper it's just constantly having to explain, that's not how I operate. That's great that you do that, but that's just not something that I'm comfortable with doing as a belly dancer, and kind of trying to navigate my way in that world.

I would say that I am purely a dancer, that what I do is to interpret the music rather than to paint a scene. So, I operate on a three to five minute level where it's not like I'm actually creating a large scale dance piece that does tell a story. I'm taking one song and saying this is what my body tells me to do instead of maybe creating "this is what my body would tell me to

do if I were a geisha." It doesn't really work that way for me.

I have an interesting privilege of being an interloper and being privy to a lot of things without having to necessarily accept a lot of things. For me, I get to enjoy it for what it truly should be and I get to ignore the politics and the drama and things of that nature. I do get a lot of confusion about why I'm a part of it, because I don't necessarily fit what they want. I mean, what people are looking for when they create a show is to create an exotic experience for the audience. Sometimes people don't quite understand how I fit in there because I am not doing striptease.

I feel like I get the privilege of bringing something different, like, clearing the palate, so to speak. And also, just being in the scene, getting to experience all the different people without having to say I really have to be in this and I really have to be in the politics, so I kind of get the best of all of it and I get to avoid the worst of it. I've got enough of the bad on the belly dance side.

I think I just get to be there to support my sisters when they say this is what I choose to do, this is how I choose to express myself. This is a statement that's saying I'm not ashamed to do this and there's nothing dirty about it. There's nothing dirty about sexuality. There's nothing dirty about being a woman and there's nothing dirty about looking at the human form and saying, "That's beautiful, I like that." So, for me it's empowering just to watch other people do it and to be a part of it and to be there cheering on the sidelines and hooting and hollering when something gets taken off.

Lulu Lollipop
Burlesque Performer

PHILADELPHIA, PENNSYLVANIA

What does burlesque mean to me? I've thought a lot about this. But, basically burlesque is a means for me to perform. I'm a trained dancer. My goal was to become a musical theater performer. So, it allows me to put all that together in this fun song and dance. But the truth is that I would never perform burlesque without my troupe, Peek-A-Boo Revue. If I was with any other troupe in any other state, I wouldn't have done it. So, burlesque is meaningless to me without my troupe.

We have a very special way that we deal with each other. We perform as solo artists within the show. But when we're collaborating we're not solo artists, we're a team. And we're a family, and we help each other produce numbers, and we help each other with costumes, and we help each other with movement quality, and what works, and what doesn't work, and that is the only way that I would ever perform this art.

I thought about it a lot because, I don't want to sound judgmental, but I was like, "Oh ... it's empowering to women." I'm like, "Nah, that's not what it means to me." "Oh, it makes you comfortable with your body." "Nah, don't really give a shit if somebody else is comfortable with their body." It's not about them. For a lot of people it's about this community of performers and there's a level of history that our show stays true to. We wanna stay true to the vaudevillian, cabaret, and burlesque variety show. It's not just, "let's take off our clothes." So that's important to us. But it's also important to us to keep things contemporary enough so that it's current enough to be palatable to audiences.

So yeah, is it awesome that there's this great community of women out there, that we all do the same thing? Sure! Does that mean anything to me? No. Because I could not be doing this and they're gonna continue to live their lives. So, so yeah, really the only meaning that this has for me is what I personally have done my best to create, what has been created, and the family that continues to create it. So, that's it.

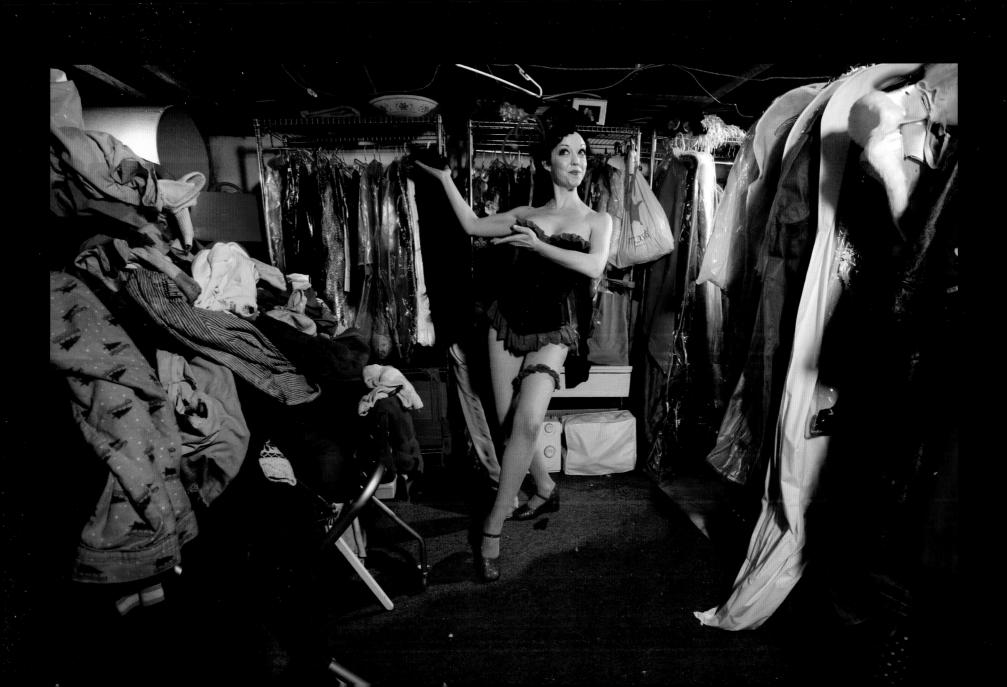

Kitty LaRue
Burlesque Performer
MADISON, WISCONSIN

To me burlesque means being able to be in a group of like-minded individuals that are interested in expressing an aspect that maybe they wouldn't normally feel comfortable doing. Part of that might be dressing a little funky and fun, doing showtunes, stripteases, dancing. I enjoy the variety show aspect of it. It's really a chance for me to express that side of myself that's always there. I'm always expressing it, but it really gives me an outlet to have it be front and center, kind of the silly, goofy person that I like to be and I get to be onstage and actually be enjoyed for that completely.

I would say that side of me loves performing. Getting attention, which is kind of opposite how I am in normal life. I'm not a big attention seeker, but when it comes to being funny, getting people to laugh, enjoy my singing, a striptease I'm doing, a dance, I just love being able to do that and really make people laugh and make people smile. I really like to foster that every day and this gives me a chance to really ... POW! ... bring it right in their faces.

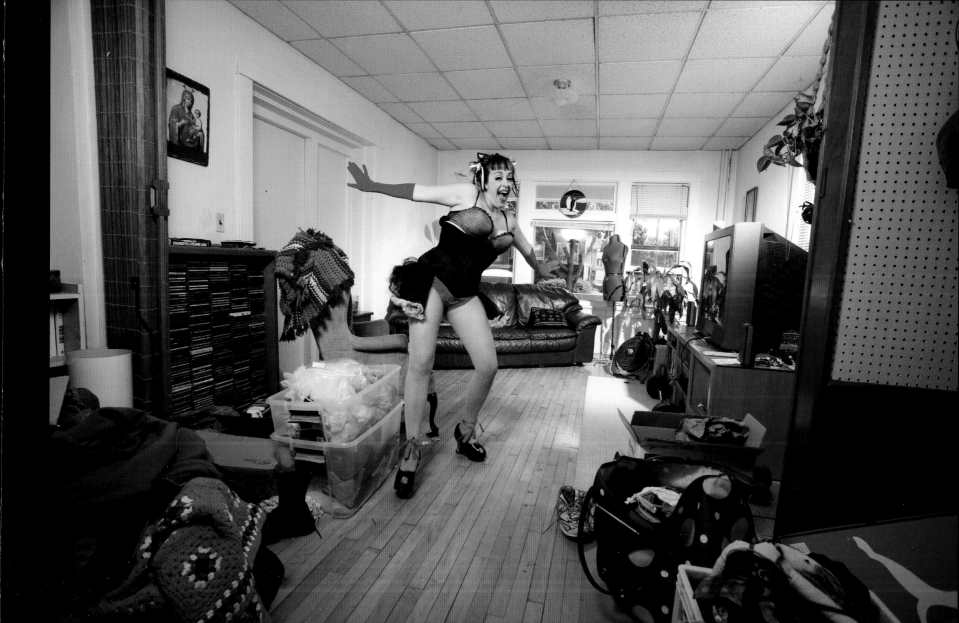

Goldie Adore

Burlesque Dancer

DETROIT, MICHIGAN

What does burlesque mean to me? I've been thinking about this for the past couple weeks because I knew that I was going to be asked this question and I don't really know if I have a great answer for you, but it appeals to the exhibitionist in me, of course. The whole dress-up thing has always been sort of a passion of mine. And, it's just fun. It's just something I like to do. I don't really know if there's a better way to state it.

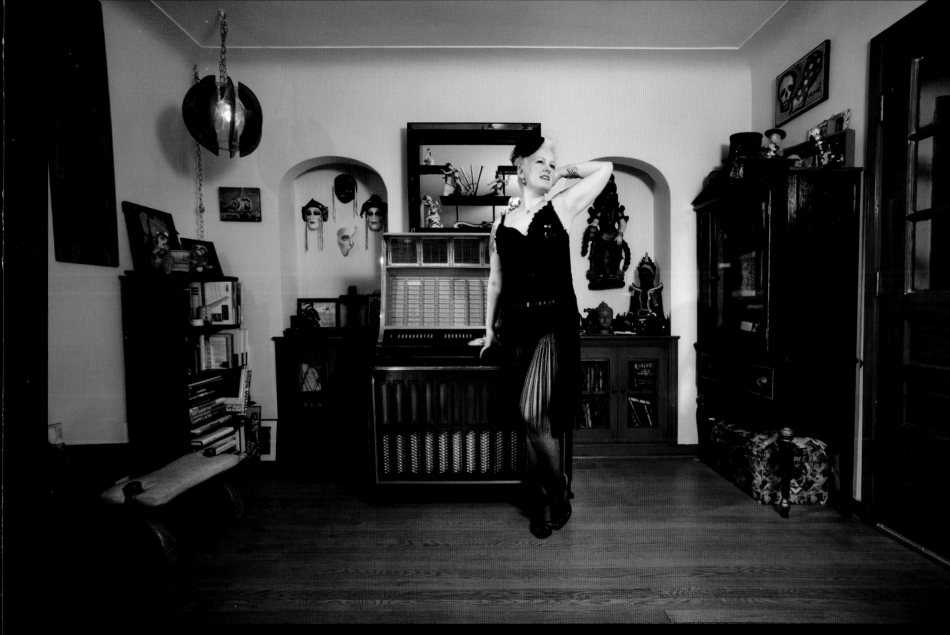

Coco Lectric with Otis, Peaches, Pudgy, Donovan, and Chip

Burlesque Performer

AUSTIN, TEXAS

Man. What does burlesque mean to me? Well let's start big and go deeper, how 'bout that? Burlesque to me is, on the more shallow end, the thing that takes up all my time, that makes me spend all of my money, and makes me download 3,000 songs from iTunes.

More importantly, burlesque is a way for me to use all of the talents that I have. Singing and acting and dancing and costuming and shopping. And snake wrangling. I use it to bring theater, to bring something amazing and exciting, and a show that I'd wanna watch.

Also, as a person who studies psychology and women's studies and ethnic studies and all kinds of things like that, I get to bring all of the power and all of the sensuality and all of the seductive arts to the stage as well.

So, yeah, I am bringing to the stage something that represents power and grace and culture. To me burlesque is like what women do in other countries to show their culture, to show their femininity, to show their fecundity, I guess would be the right word, to show fertility. In America we don't have anything like that, except for burlesque, that's really a dignified art, that's something that is very matrilineal that we can pass on to other women and to get that girl out of the night club with the skirt going up her butt dancing awful and go, "Hey, you have a lot of power there. Why don't you be graceful? Why don't you really bring pride to other women by being respectful to yourself?" That's not without being sexy, I love being sexy and I love being sensual. I love owning my sensuality. To me burlesque is the American sexy-girl dream. Absolutely. The smart, sexy, powerful, American girl dream that we get to pass on to other girls. Yeah.

Burlesque is also a way for other smart and talented women to get to know each other from all over the world. We can all get together and learn from each other and be supportive of each other. That's missing. That's missing with beautiful women around here. Especially in the U.S. We haven't been taught to really be nice to and embrace other beautiful and talented women. We've been taught to see them as a threat. We've been taught to run out and buy more cosmetics so we can somehow be better than that person. But, in the burlesque community, 99% of everybody I've met are very supportive of each other and everybody's getting dressed in a closet, basically, backstage. And still, we find enough room for everybody's stuff, and we help everybody find their stuff. We zip people up and we help everybody. We egg each other on during photo shoots and we're very strong and very supportive and everybody's beautiful.

I think that, now that burlesque is becoming more in the mainstream consciousness, it's so important for those of us in burlesque to kind of stick to our guns and to base all of our numbers on what really turns us on and what really inspires us. And not so much, "Oh, I ... oh my gosh, this camera crew's coming out, I need to lose ten pounds." Because the second we start pandering to mainstream ideals, that second we're gonna start losing sincerity. I think in burlesque we have the opportunity to be so sincere and so real and embrace women of all body types and all ethnicities and all styles. There are so many styles in burlesque. So, I hope we all just stick to our guns and keep on passin' it down. Yeah.

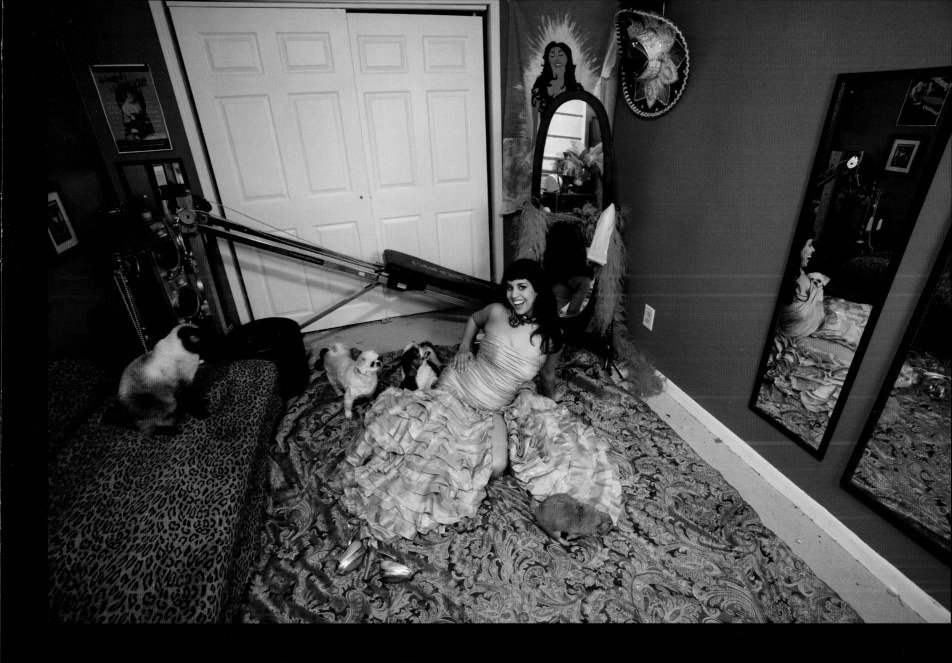

Jack Midnight

Burlesque Emcee and Co-Producer

CHICAGO, ILLINOIS

Well, when I think of burlesque I think probably of its heyday in the thirties and the forties. And when you think of burlesque back then, it was almost like a cabaret, almost like vaudeville. It was the next evolution of vaudeville, but a little more bawdy. I believe the word actually means a bawdy joke. So, there were men performers and women performers. Today the focus is more on the women and there are some shows that are all female. But for me, I like to look back at that heyday of the thirties and forties 'cause you had Abbott & Costello, Don Rickles came from burlesque, Lenny Bruce. So you had a lot of really great performers that came out of there that just weren't some of the amazing dancers.

I like a lot of the neo-burlesque, but sometimes I think some performers forget when they talk about neo-burlesque that the second part of neo-burlesque is still burlesque. Some of it, I think, has gone so far out that it's more like performance art and I don't know if it's necessarily still in the same genre, but I think in general the movement's pretty strong. I'm pretty excited by what I see.

I think the neo-burlesque is starting to move more back into a retro look recently, in the last couple of years. Prior to that, when we started with the Belmont Burlesque Revue, there weren't a lot of troupes. It was a lot of individual performers and the acts were, like I said, almost like performance art. But you see a lot of performers now, a lot of the women, are going back to things like fan dances and you see some talking strips out there from the twenties. I mean, they're really going back and mining the really original work.

There's been some great books written about Lily St. Cyr. I think a lot of what happened after the death of Bettie Paige was people took a look back as well and really looked at some of the stuff that was going on in the 1940s and the '50s. They are going back and mining that again. So I think that neo-burlesque is actually having a revival of retro burlesque right now.

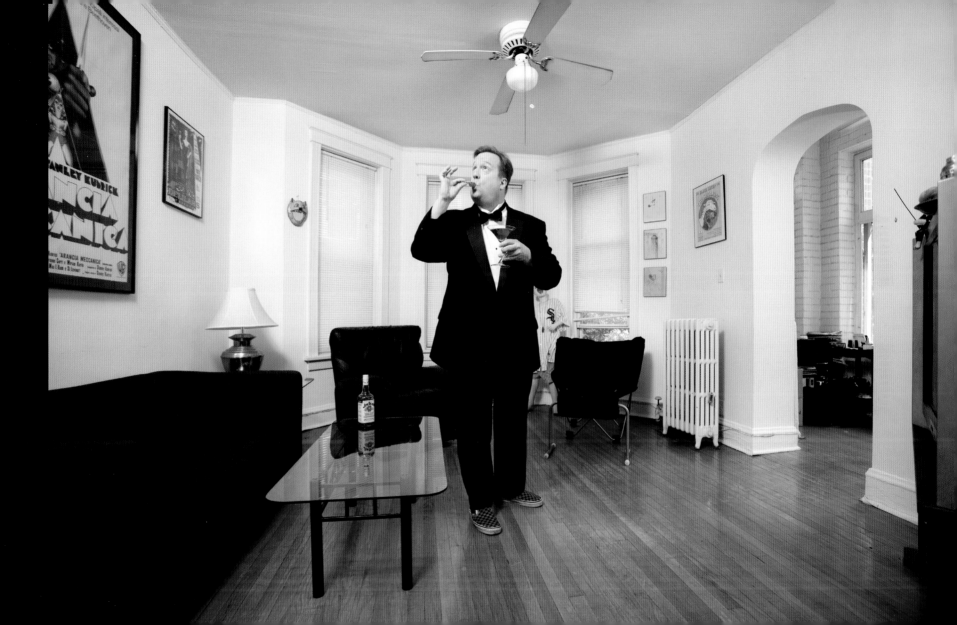

Bella Sin
Burlesque Dancer and Producer
CLEVELAND, OHIO

Everything. It's really simple. When I thought about it, it was more of how it took over my life to a better kind of sense of direction. It busted out my creativity and just everything became a whole world of awesome, as I like to call it. It kind of taught me how to appreciate a history and a heritage more than some people might. Appreciating my daughter, appreciating my family, appreciating my background, appreciating everything I make and the time I put into it. Regardless of how it might look or how it might feel to certain people, I am simple. It's just simplicity in everything. It's not about the fancy costume or the pretty makeup. I think it's more about everything being simple and feeding into a creative whole.

From the point that I wake up in the morning, any song that I listen leads me to ask, "How would I dance to this?" Or, something quirky my daughter would do—like sing, or a cartoon—how would that be incorporated into something? Or going outside and seeing different fashions things. My brain is just constantly thinking about it. If I don't stop thinking about it, I overload and I need to stop, but it's a constant lifestyle for me.

I think burlesque, for me, is just a way to go ahead and reach out and help out. Because, yes you're onstage all the time. Yes, you're getting clapped on and the people see you and stuff. It's a way to use the light that you get onstage to go ahead and bring light to everybody else. We do a lot community outreach, like Cleveland Pride and Susan G. Komen Breast Cancer Foundation. We do research for AIDS Task Foundation here in Cleveland and Toys for Tots as well. So, grabbing that little thing that you have, helping other people, it kind of makes it a little bit more meaningful when they know, yes, you're not just getting onstage to be vain and just not getting onstage for the history of it. You're actually getting onstage to help.

Yeah, burlesque is awesome. I wish everybody that actually does it would recognize that. Hopefully one day we can all look back and be in our rollers and our teal nails and our blue eye shadow and muumuus and sitting back at eighty and going, "You know, I used to look hot onstage. Not quite ready to let go of it yet. I can still tassle twirl." The image of it just make you giggle? So, that's the burlesque for me. It's … it's what I like.

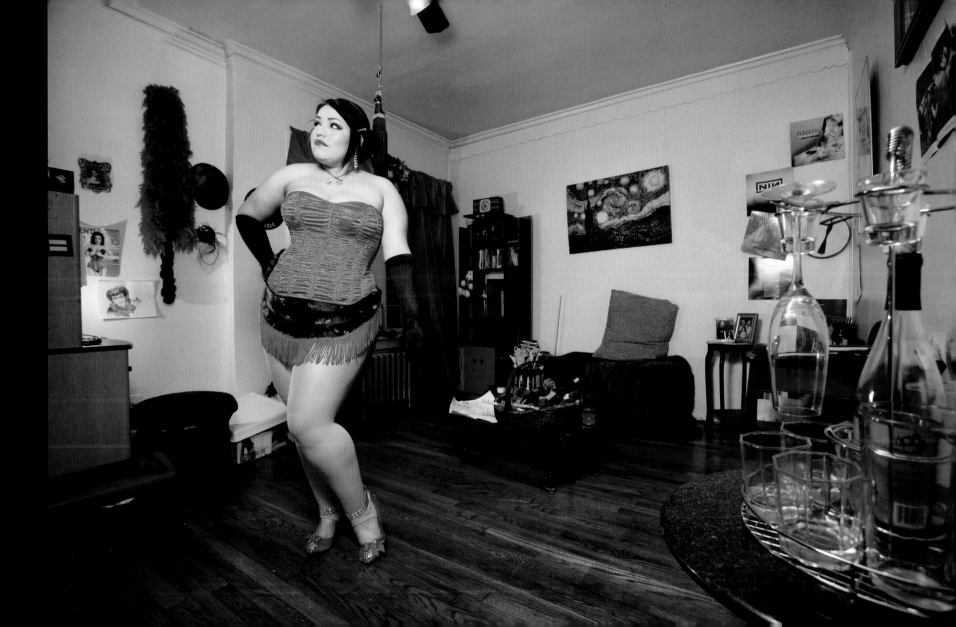

Lula Houp-Garou

Burlesque Dancer

CHICAGO, ILLINOIS

Burlesque to me means running away with the circus for one night at a time, but not the modern day Cirque du Soleil overblown high production value circuses. The small shoe-string-budget traveling circuses of the depression era where you just sort of took what you naturally could do or got someone to teach you how to do something and packed a suitcase, made a dress out of a curtain, and ran away and put on a show and just brought some magic to some small town people for a night.

A lot of what I do is kind of channeling that. I make almost all of my costumes. I make my hoops. What I don't make I get from the thrift store and I modify for my purposes. I don't like the idea of spending money on burlesque because I think it should be something that comes from your imagination. I think that's part of what makes the illusion so great is that it didn't get manufactured in China, that you took something so ordinary and bedazzled it and suddenly it's a sparkling jewel onstage.

I come from a theater background, so for me burlesque is a form of theater. It's a sort of common man's theater where we're just gonna try to communicate something to you for three or four minutes onstage. There's humor, there's spectacle, there's glamour, there should, hopefully, also be a message. And we're gonna take our clothes off, but that's the icing on the cake, it's not the whole buffet.

Burlesque to me is not so much about the stripping, and not even so much about sexuality, but about making the magic happen and about connecting with the audience and just sort of that bohemian sensibility of being alive and being passionate and connecting with other people and having joy. We live in a society where sexuality is so exploited and packaged and marketed and shoved down our throats and you can't get away from it.

Burlesque is not about the sexuality, it's not about live nude girls. You can turn on the Internet at any time and see a naked girl doing terrifying things for your amusement. I don't think people come to burlesque to necessarily be seduced so much as enthralled, enticed, amazed, mystified. And that's why I love the fusion burlesque: Aerial burlesque, hooping, fire performers, really elaborate stories into which the burlesque is worked. The

stripping is worked into the story but it's not the main focus. That's why I think it's theater for the common man; it's not going to try to intimidate you or condescend to you. It's everybody meeting on a common level and there are also some sexy ladies involved.

I feel like we've sort of lost that, or maybe I'm just romanticizing past eras. But I feel like there used to be these cabarets where people would go and they would escape for an evening and there would be all these different death-defying acts and beautiful, glamorous women and magicians and illusion and ... now we just sort of turn on the TV. I think burlesque is calling back to an older, more romantic era where people wanted to escape for a night and suspend disbelief and believe in magic and believe in these glamorous beauties, drawing you into their own secret world just for a couple hours. And then kicking you out onto the street to have a beer at the bar next door.

Well just in terms of a very personal level, I am way more comfortable with my body now, and that's not even from performing; that's from being back stage where everyone's getting into costumes, ripping off pasties, putting on new ones. The first burlesque show that I did I was trying to change in a corner like in a locker room in middle school. And now I'm just like, you know, it's just my body.

In terms of being empowered by performing on the stage, I don't personally feel empowered because people cheer when I take off my clothes. I don't really get that "oooh, they think I'm pretty" kind of rush. I am empowered by the fact that they're enjoying my performance, that they're getting what I'm trying to get across, that I'm making some sort of connection.

I and most of the other performers in Chicago are not ideal beauty pageant queen body types; we're normal girls. We go to our day job and then we come home and we put on our wigs and false eyelashes and we go perform this extension, this hyperbolic gender role.

That's what I hope we're doing, at least here in Chicago—putting something different out there and blowing people's minds and widening people's horizons and changing their perspective. Making them believe in magic.

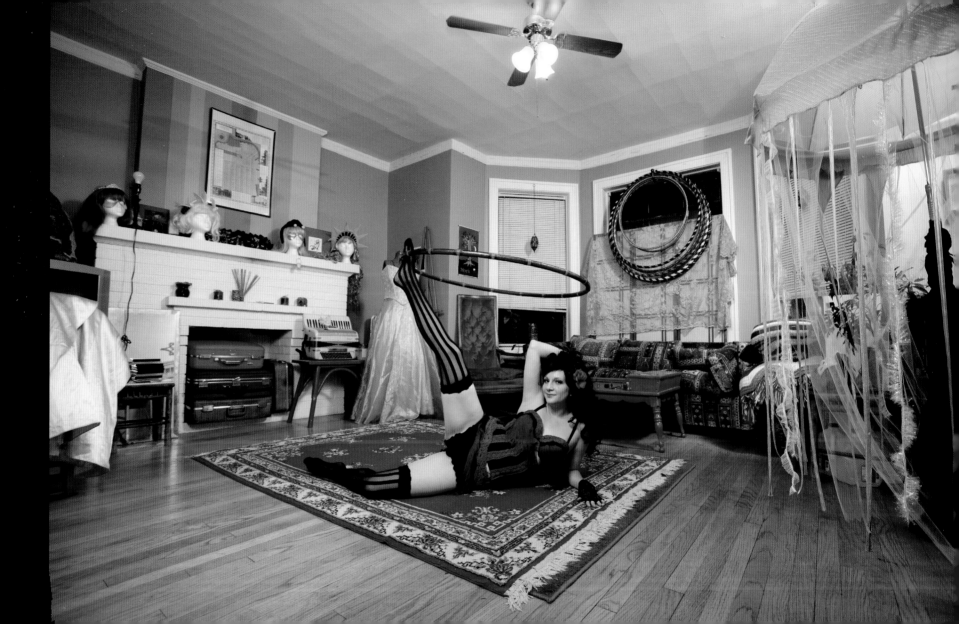

Big Mamma D
Burlesque Performer and Producer
CHARLOTTE, NORTH CAROLINA

Burlesque to me is a life-changing event. What I didn't realize when I first came into this burlesque world and somebody approached me and said, "Hey, I want you to put on a show," is that four years later I would be so blessed and so gifted in life by being able to positively impact other women's lives. They come to me in the beginning and they've seen a bit of show or they've been interested in the pictures and the video, and they say, "I would love to do your show, but I hate my butt and I hate my thighs, or I hate my belly, or I don't like my arms, or I don't like the way my boobs look." And I say, "Honey, as long as you ain't got a bucket o' ugly up here I can costume around everything." And I say, "You've got personality and that's the important part." And then I bring them to my home and we sit down and we costume and we come up with an idea. And I let them pick their music and I tell them how to create a routine. We go over it. We build this beautiful persona. And that first night, about thirty seconds before they walk out on the stage they go, "Gasp! What am I doing?" And I go, "You're being a star. Go!" And I throw them out onstage. They walk out and there's five hundred people screaming and applauding and excited about seeing these great women. And, you know, six months earlier they were bored working an eight to five job with no idea and no ambition to ever be onstage and do anything. The girls in my show are all average ladies, but they're above average when they leave. And that's the wonderful thing that burlesque is to me.

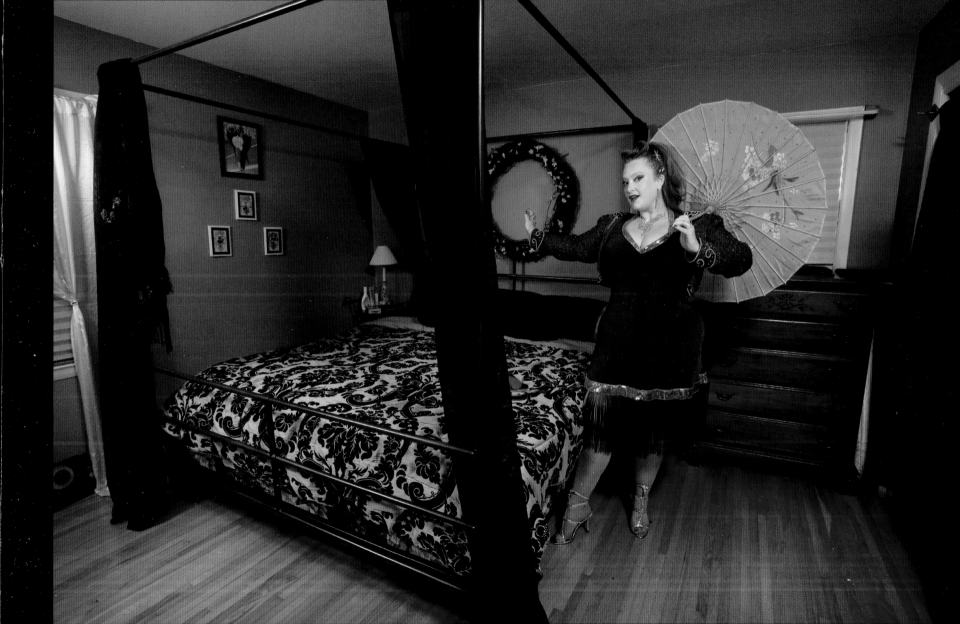

Rowdy Ann

Burlesque Dancer

MEMPHIS, TENNESSEE

Burlesque to me is a great outlet for women to be able to perform. It's an excuse to get all sparkly and to wear fancy costumes. To me, I wanted to do it because I still love playing dress up. Ever since I was a little girl I loved putting on fancy dresses and so it allows me, now in my thirties, to be able to go onstage and show off and give entertainment to people.

Since I was probably fourteen or fifteen, I was really interested in vintage clothing and vintage hairstyles and fixing up glamorous. I grew up in the 1990s when it wasn't very popular to be glamorous. Everybody was kind of dressing down and going for the whole grunge look. But, I didn't have a lot of money and so I would shop at the thrift stores and I would find all these wonderful vintage prom dresses and party dresses with sequins and rhinestones. So I actually started dressing that way just for fun and I would wear these clothes to school. Of course everyone would tease me and laugh at me. But, to me, I thought it looked good so I would do it. As an adult, I actually met other girls who liked dressing this way. Some of them were in the group I'm in called the Memphis Belles. Anytime you see us out, we'll probably be dressed up like that. It's not just for the stage. I go to work even, and I have a fairly conservative job, but I usually do dress up. A lot of the people there, they kind of know me for my red lipstick, which I never really thought of too much. But people a lot of times, they're like, "Yeah girls just don't wear red lipstick anymore." But to me it's just ... it's me.

I think before I was performing with the Memphis Belles, most of my friends were male and I was typically hanging out with a lot of guys. To me, burlesque has helped me create this wonderful group of girlfriends and we have girls' night one once a week where we meet and make crafts and so it's given me this community. I think there's a wonderful burlesque community these days. I've been meeting people from across the country, from other countries, who are doing burlesque and it's been kind of a great way to connect with people who have similar interests. With the Internet we've connected with so many people and we brought people here to perform and I've gotten to go to other cities to perform and so it's been a really cool experience, just connecting with similar people.

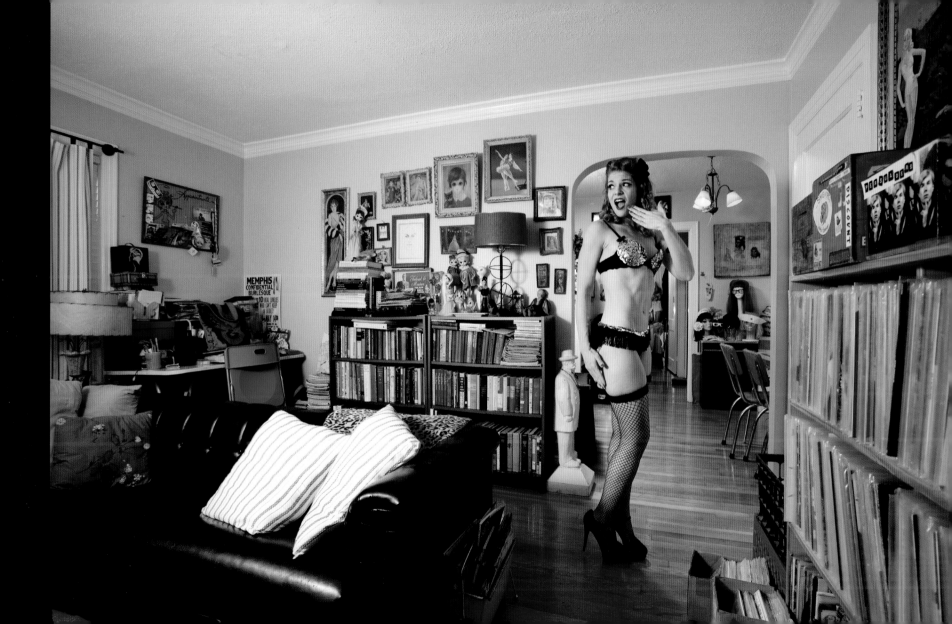

Donna Touch
Burlesque Dancer
CHICAGO, ILLINOIS

Burlesque, for me, is an unconventional outlet to use my dance skills, put sequins on pretty costumes, and be a performer in the way that I want to be a performer, rather than doing something with the troupe. Although I do group numbers, for the majority of the pieces that I do, I am my own choreographer, I am my own costume designer, I am my own makeup artist. Burlesque allows me to do a little of everything, experiment, and still grow with each performance.

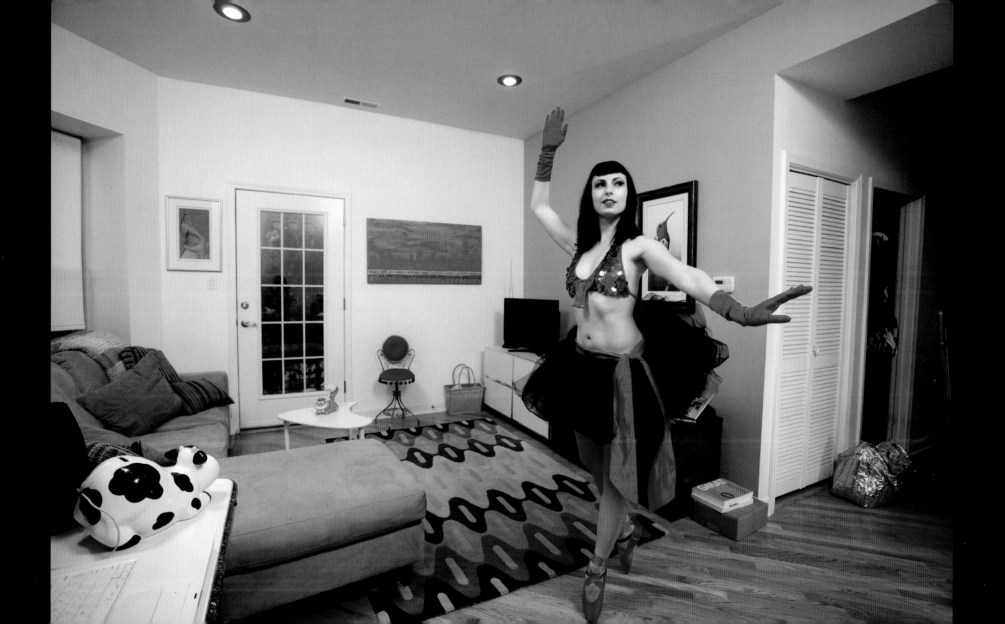

Lady Ambrosia with Isis
Burlesque Dancer
MILWAUKEE, WISCONSIN

There were three things that drew me to burlesque originally. The first one is that you get to choose your own costumes and you get to choose your own music and you get to create your own choreography. So, I'm a dancer originally. I've been dancing since I was four. I've done ballet and dancing in high school and ... stuff like that. So, I was really drawn to the dance aspect of it and I love the fact that I can create my own moves and my own improvisation with dance moves when I am up on stage and it's a lot of fun to me. And the costume part is just kind of getting lost in the glamour of it all, just enjoying being beautiful. I just have fun putting on makeup and trying different makeup, trying different hairstyles sometimes. I create a lot of my own costumes, which is a lot of fun. When I'm onstage, I feel like it's really me, that I'm projecting.

Yeah, and for music, I like all kinds of music. I like a lot of international music. I've gotten into some, Salsa and French music and stuff. I'm also working at the Dead Man's Carnival. Done a lot of stuff to live music, which is a lot of fun because I get to work with a band and I get to put in little nuances. I can do choreography and it's a lot of fun. I think it adds that more vaudevillian aspect to it, too.

Burlesque dance is the only kind of performance dance I am involved in right now. I actually am working on for an upcoming show a group dance and I found five other girls who, some of them are dancers, some of them have the same training as me, and we're really mixing in that aspect of dance with burlesque. I really like the dance aspect of burlesque because I'm a dancer and I feel like that's my niche. So, yeah, I prefer the burlesque. I think it's the whole idea of a burlesque show and the audience and all the cast members that make it more welcoming to something that you create on your own. Like, they wanna see something that you created, not necessarily something that's really stiff and choreographed, like a ballet or modern dance or something. It's much more from the heart.

I think that nudity is a beautiful thing and I think that, originally, when I started getting into burlesque and started learning about burlesque and what it was, there was the whole taboo for a lot of people and a lot of family members, "Oh you're ... you're ... you're getting nude, you know. You're showing your ... your body to strangers." Over time I've come to realize that part of what's beautiful about dance in general is that it's movement of the human body. To mix that with nudity, with taking off of the clothes in a graceful and a beautiful way, I think that's a really beautiful thing to do. It's sensual and it's sexy and I think that that's cool too.

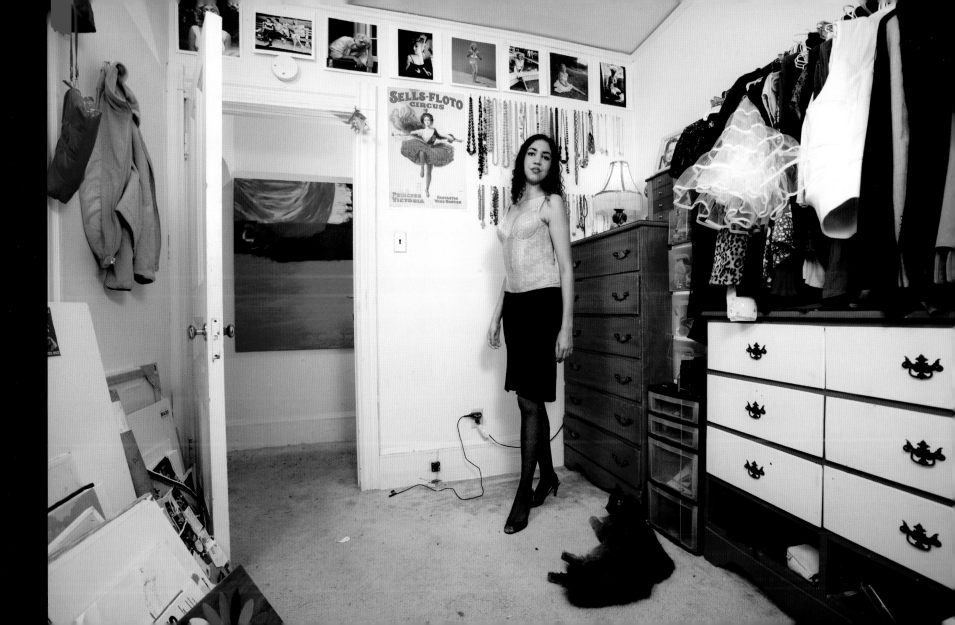

Betty Blaize
Burlesque Dancer and Performer
BOSTON, MASSACHUSETTS

Burlesque means, wow, a ton to me. It is, for me, sort of old-timey. It has some kind of retro component of yesteryear to it. I think of it as a very live and intimate art form. And I also think of it as having some sort of adult content. It may not be rated R, but it might be something you're gonna have to explain to your 13-year-old, if you even want to. Some level of naughty, I think, is an essential component of burlesque these days.

For me, burlesque is very classic. I think it would be hard to say that for the whole community, because I've seen some modern performances that I love. But, it's hard for me to count those things as what I think of when I do burlesque.

My favorite elements, although I don't think they're necessary, are the glamour, precision, and maybe an illusion of a dream. For me at least, that dream is somewhat yesteryear. I'm a 1940s girl, but I have no problem stealing from other eras when it suits me. So, 1950s, '20s, '30s … you know, if I can make it work, maybe it'll get in there.

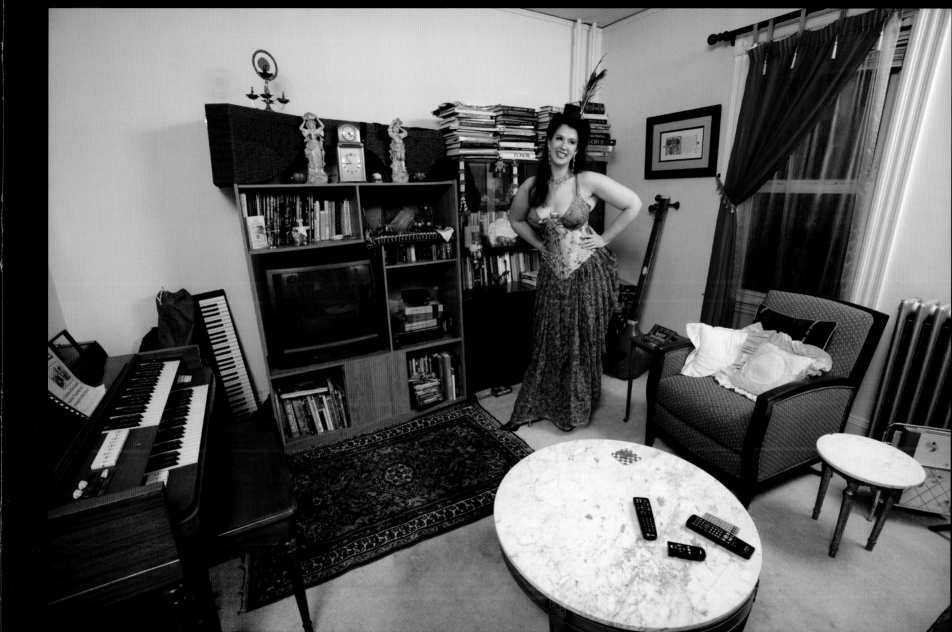

Maria May I
Burlesque Dancer
CHICAGO, ILLINOIS

Well, burlesque means to me my little golden opportunity to show people what I got. I've always been big into theater and acting and did not always have the opportunity to do it in school. I went to a school that didn't have an arts program or anything like that, but I've always been quite the ham and at the same time I had little bits of insecurity. This has really been my way to become a ham and also conquer those insecurities that I've been conquering for a while.

So, burlesque has definitely helped me through insecurities and allowed me to show a little bit of my personal side. That's what burlesque means to me.

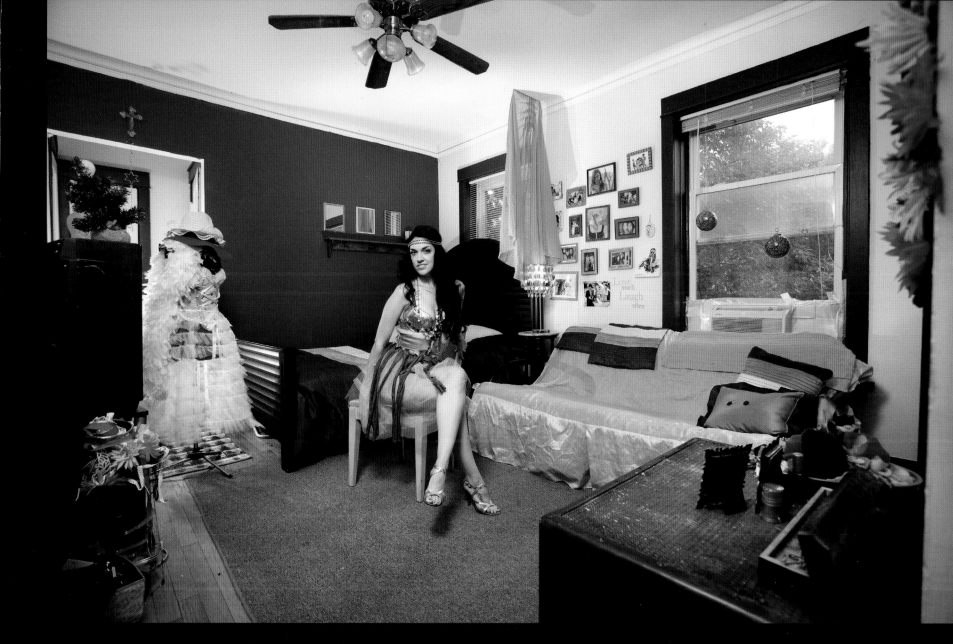

Crystal Pistols with Kano and Skelly
Burlesque Performer
DENTON, TEXAS

Burlesque means several things to me. One of them, and one of the biggest things it means to me, is sisterhood with fellow women sharing an interest in doing burlesque and the relationships you build. I've made quite a few friends over the years that I am very close to. Also, being creative, having a concept and then doing your best to bring what's in your mind to reality and then having that happen on the stage and also the audience getting that. Your creativity, having it, making it, and then giving it out to the audience, which is a big part of why I do burlesque, is the entertainment aspect of it. Also, it's keeping an art form alive. If people hadn't decided, "Hey, let's do burlesque and keep that alive," it could very well be a completely dead art form.

Learning—there's always that, self challenges. For me, one challenge I face is that I have an injured back and neck from a car wreck. But just knowing I can do these things, I can still do it, it gives me a very good sense of self-empowerment, just overcoming things. Speaking of empowerment, definitely there's the woman part of me. I get to go out there and show myself in the way I choose and kind of share that with people. That is very special, actually, to do.

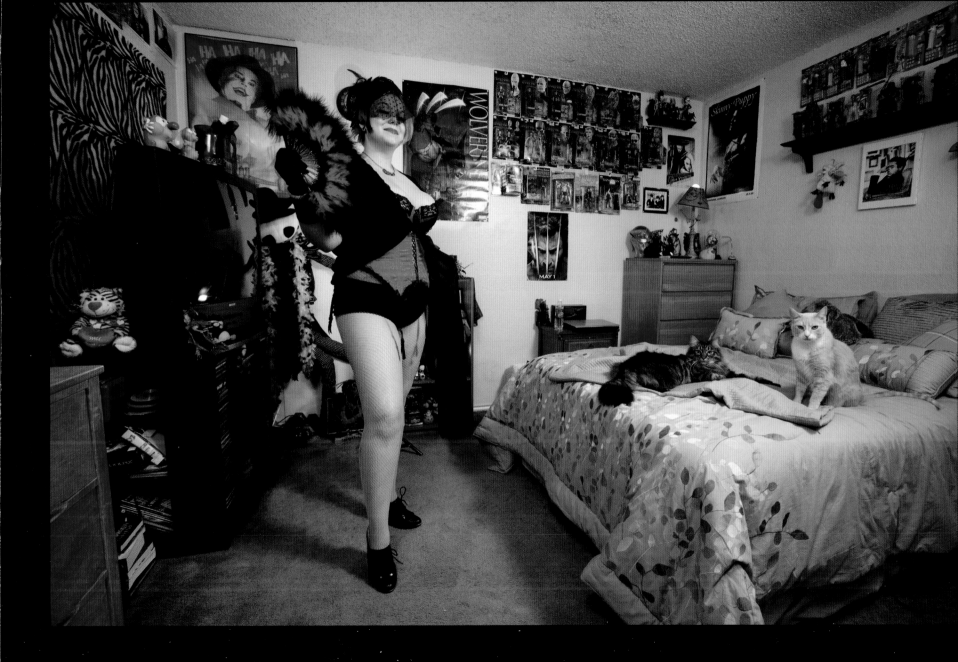

Violet Vogue
Burlesque Dancer
CHICAGO, ILLINOIS

I think to me burlesque means being someone else for a while, putting away your normal workday jeans and t-shirt, no makeup self, and putting on a lot of sparklies and feathers and being glamorous for a little while.

I think it's important to be telling a story to the audience. I feel like your costume and music and your concepts, your idea, should all work together to explain what your story is for your act.

I think you can really be inspired by anything. A lot of people I know get inspired by their song or a costume piece they found or just some random idea based on something they saw, but I think creativity is really the important part of it. That and putting a lot of effort into what you're doing. I feel like it's okay to start small as long as you don't start out lazy, without putting in a lot of work. I don't mean not spending a lot of money. I mean obviously everyone likes to save money, but putting in the work shows in the end, I think.

On the other side of it, what burlesque means is finding sequins in your refrigerator, and inhaling a lot of feathers while you're making your costume, and finding random rhinestones stuck to your sock. Materials for it look great but they shed and stick to you, and sometimes you find them at pretty random places and times. Once I was onstage for something else and I had regular pantyhose for it and I found a burlesque sequin in between my leg and my pantyhose while I was onstage. It was green. So, it didn't match. I thought it was hilarious.

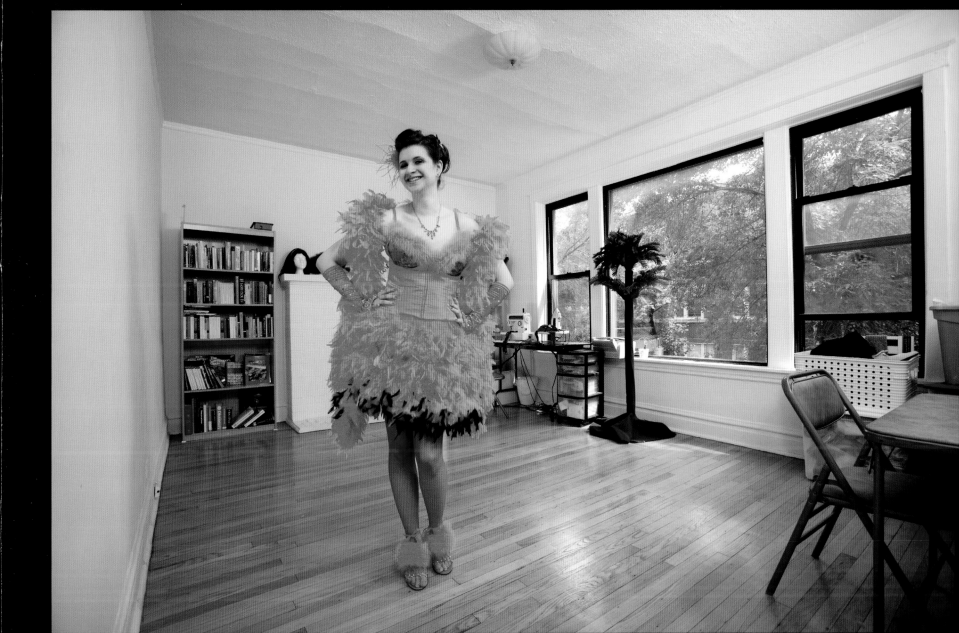

Nicolette Tesla
Burlesque Dancer
CHARLOTTE, NORTH CAROLINA

Well, burlesque to me, I think it's about empowering women and giving them control of how their sexuality is presented, how their bodies are presented, by use of music and costuming. What's really magical about burlesque and what makes it special is that the women or the performers are totally in control of their costuming, what they show, music, and everything. They're not forced to meet some sort of an expectation that society might place on them. That's really what it means to me. It's about empowering women and putting them in control of how they express their sexuality.

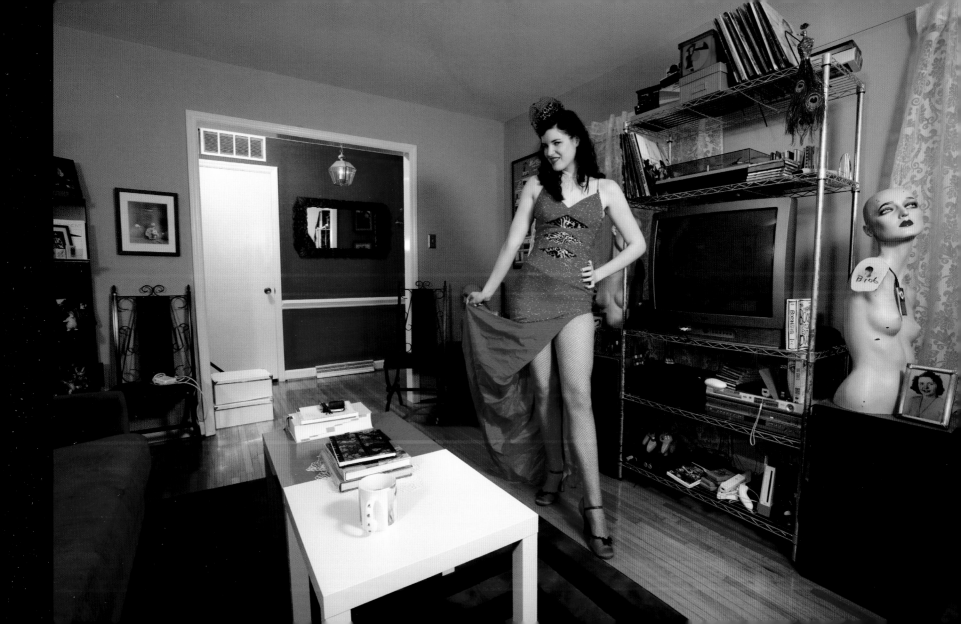

Titi Touché

Burlesque Dancer

CHICAGO, ILLINOIS

I guess that burlesque to me is some combination of the very traditional definition of burlesque as being parody and commentary with sort of the 1930s/1940s vaudeville type show where you have other performers including magicians and sideshow acts, as well as dancers. I think it's something that I felt was always missing from my life somewhere and I couldn't have ever put my finger on it, especially when I was much younger, but I was fascinated with sort of the 1940s glamour and being able to just put on that different persona and the clothing and the music and everything that went with it. Being able to express that in a consolidated art form is very exciting and refreshing.

I don't know how this fits into it exactly, but I think that, while my own interest is in the more classic traditional burlesque, I think it's so wonderful that the diversity exists within the genre and that it just seems to be getting stronger. And so you can go see a show that appeals to any taste. I like going to those other shows, even though I don't necessarily perform in those styles.

I think some of that traditional intent of burlesque that I was talking about before with the parody and everything else comes through a lot in some of the more modern interpretations of burlesque and that's very exciting for me to go and see. So you can go and watch hula-hoop dancers who are dancing like robots to the Flaming Lips and I love it, I think it's fantastic, but it's not what I do and it's not what our show does. But I love that it's out there and that I can go see it.

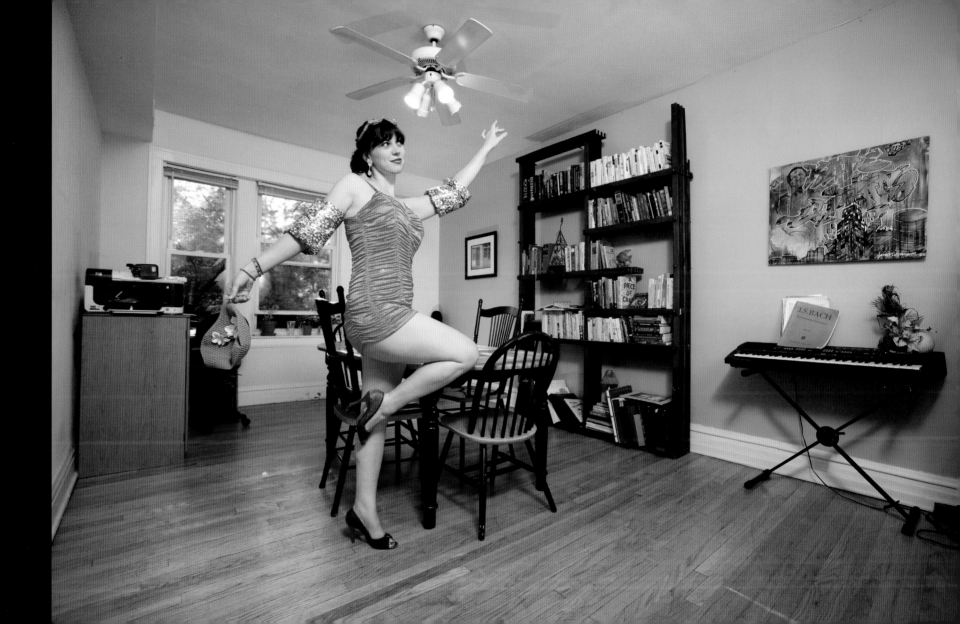

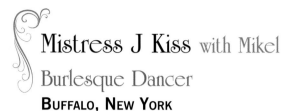

Mistress J Kiss with Mikel
Burlesque Dancer
BUFFALO, NEW YORK

Burlesque means to me that I have found my calling, and I know what I'm gonna do for the rest of my life. When I say I've found my calling, I mean I can't find any other outlet to express a certain part of my life and my visions and I wanna do so much and I wanna be so many different things. This liberating experience is what I get to live every week, every month, every year. I have people watch me and wanna be me. Not so much do me, but be me. That's the beauty of burlesque—I can still be pretty and beautiful, but respected, not only for being a cute little tart shakin' her thing onstage, but also somebody that took the time to do it in a clever way and to make that person feel comfortable with me, to say, "Hey, it's okay, I'm gonna take my clothes off but it really is just about the art. It's really about the entertainment." And, it's all I ever wanna do, just entertain, live my life to the fullest, and be everything that I can be.

I am going to be a stripteaser until I'm a "stripgeezer." I wanna take my clothes off up until the day I croak. I want to dangle my old, not so flashy body. I wanna have rhinestones and diamonds and rubies and feathers on an old, decrepit body. If that means I have to bedazzle my walker, so be it. But I will be performing for all of my friends in the old folks home because that's how we're gonna pass the time. We're gonna play Rummy, Parcheesi, Bingo, and burlesque.

I think burlesque is the most amazing experience of my life. I'm able to take clothes off, but shed all that brainwashing that I had to grow up with or that I know that other people still are bombarded with. Their thoughts are clouded with the way that they're supposed to be. I hope that I can be a messenger or an inspiration to anybody to say, "Look, you don't have to be a stripper, but you can live your life to the fullest. All we have is now. Have fun! Be silly, be beautiful, be anything you wanna be whenever you wanna be. It doesn't have to just be on the stage." Burlesque means that I finally have a chance to show others how I figured my life out.

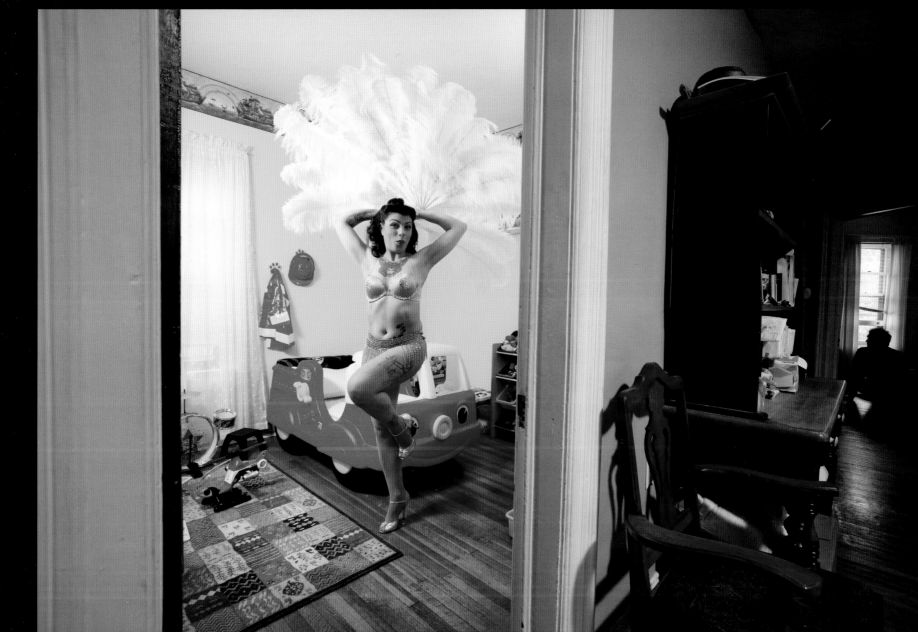

Satori Circus
Burlesque Performer
DETROIT, MICHIGAN

Burlesque in its classic sense means it has its ideas in the humor and the seduction, the mystery, and even some of the women who really took off and carved niches in it, like Lily St. Cyr and some of the others, like Gypsy Rose Lee. Those women added this spice to it that took it to a different level. I mean, otherwise, why would they end up in movies or Las Vegas or something like that? So, and there was all that humor aspect of it, the vagabond clown, so to speak. Emmett Kelly kind of characters who would always be there and they were kind of like the beauty and the goofball.

During the 1960s, it kind of got a little watered down and it started becoming something else and probably a little bit more profane to a lot of people and maybe dirty, so to speak.

It's freedom. It's freedom of expression. It's freedom to take what you are, Joe Smith or Debra Scott, and become Olive Jus, or Sinda Rella, or Sloan Easy. You create these alter egos that make you feel more comfortable because of what's inside of you, an alter ego that you can't normally express with the crowd that you might be a part of or during what you do as a day job. When you have that time to be you, really, really, really you, then that's when you can experiment and become this character that you create. It allows you to be freer. Maybe it's a good stress reliever. Instead of paying a shrink, you can just be a burlesque star or a clown or a vaudevillian or something, you know?

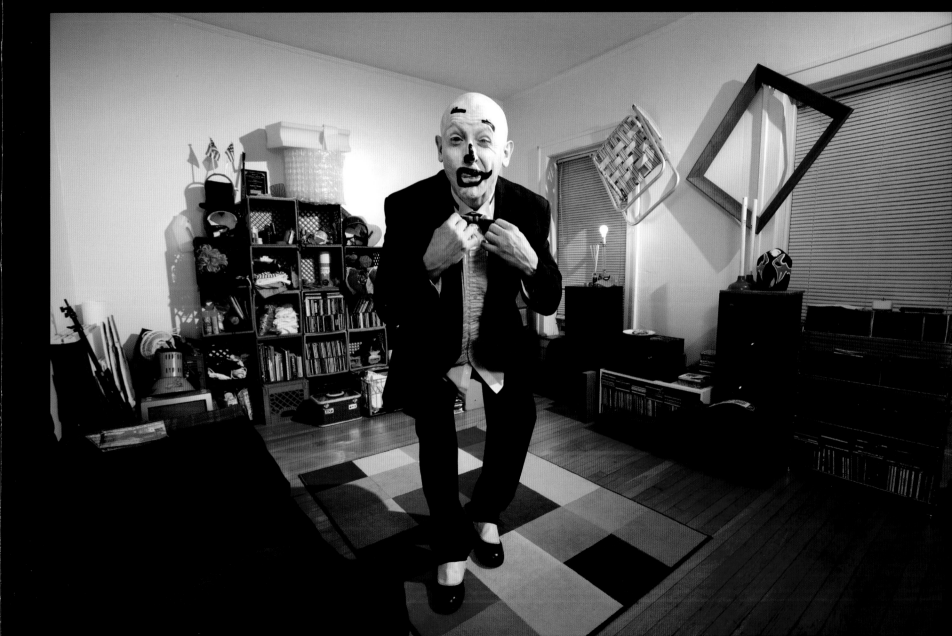

Foxy la Feelion
Burlesque Dancer
ST. LOUIS, MISSOURI

Burlesque, oh let's see. For me burlesque is fringe, it's corsets, it's gloves, it's extravagant, costumes, headpieces, finding feathers everywhere throughout your house. Finding sequins in between the crack of your boyfriend's ass. It's wads of glitter everywhere. To me it's being able to be really comfortable within your body and within yourself, even if you're a two hundred pound, five-foot, eighty-year-old woman, as long as your struttin', workin' it, and you're comfortable within yourself. It's the celebration of the female and male body. The empowerment of your body and how you use it and using all of the instruments that you have to express yourself. So, that's what burlesque is to me.

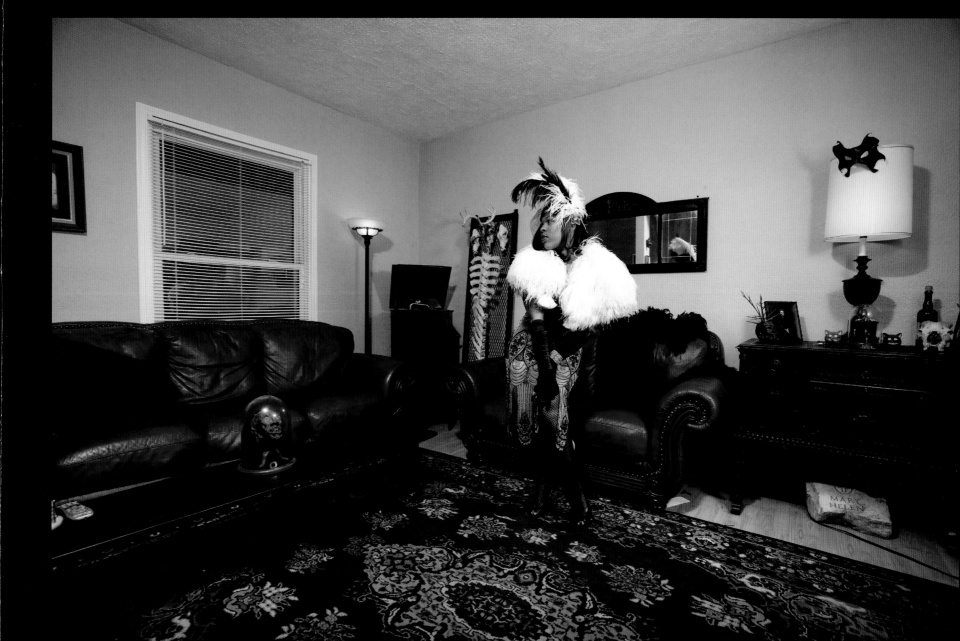

Raven Nevermore

Burlesque Dancer

MILWAUKEE, WISCONSIN

Burlesque to me is about female empowerment. When you get onstage, everything is in your control. You're the one picking the music. You're the one that's choreographing. You are the one that is designing your costumes. It's sensual, it's sexy, but it's not sleazy. It's classy and to me it embodies everything it means to be a woman.

I've always been fascinated with burlesque. I've always loved fishnets and lingerie and feather boas and glitter and the music and the makeup and the hairstyles. I've just always loved everything about it, but the things that really fascinated me most about it were the pasties and with the tassels and how they would twirl them. I always wanted to learn how to do that. I always thought it would be the coolest thing if I could make them go in one direction and the other and do an eggbeater. It fascinated me.

I guess the reason why burlesque is so meaningful to me is that when I started I had so many things going on in my life that I wasn't in control of. I had a job that I didn't like. I had a car that hardly worked. I just kind of felt like I was at everyone else's whim. But, when I was onstage it's the one thing I had control over. I had control over how much I took off. How much I revealed. If I wanted the crowd to get more in to it, it was up to me to make them do it. And, with everything in my life that was going on that was just crazy or not what I wanted, it was the one thing that went right.

It's made me overall a much happier person. I look forward to going out and meeting new people. I look forward to getting together with other girls and working on costumes and showing off the choreography that I've been working on. I look forward to being onstage and out in public. It's overall helped with my relationship with my husband because I am a much happier person.

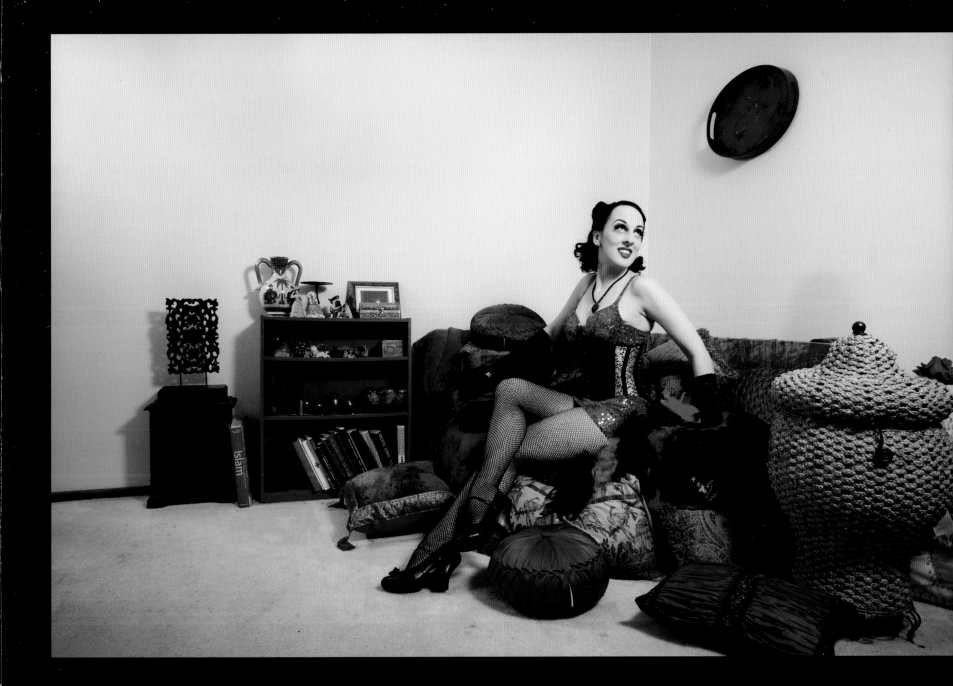

Bonny Babs
Burlesque Performer
CHICAGO, ILLINOIS

To me, burlesque means the ability to think up and imagine something grand and most often ridiculous and be able to act that out for an audience and have them appreciate it, and have them appreciate the time and effort I put into thinking of the concept and thinking of the costume and whatever else that might be involved.

I get a lot of inspiration from a lot of different things. I'd say that I probably kind of have a peculiar sense of humor. Most of the time when I think up routines I'm inspired by the thought of designing a particular costume or concept, and then I just run with it. For example, I have a recent routine with the title "The Sexiest Little Mermaid." I come out as a reverse mermaid with a giant fish head on the top and legs on the bottom. The thought of making that costume and walking around in this huge mascot suit was like so funny to me. I like laughed the entire time that I was sewing. So I don't know. Anything that makes the creative process enjoyable for me tends to be the thing that I run with when it comes to routines.

I have my real life job. I'm a seamstress. I'm a costume designer and creator and I've been doing it for many years. There's something still very enjoyable to creating costumes for me and something that I find especially fulfilling being able to do through burlesque. It's been a really good experience for me, being able to think of designs, how they will come off, and how they come off in an interesting way that's different than what other people have done before. So, I guess personally I am trying to approach burlesque by asking how can I be extra interesting? Hopefully. I don't know if there's anything else I want to say.

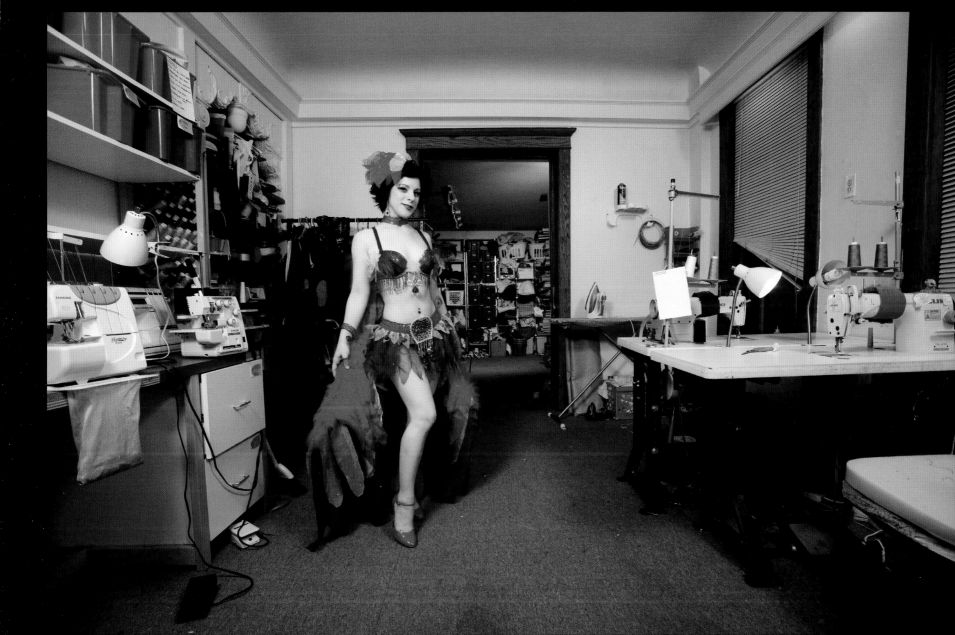

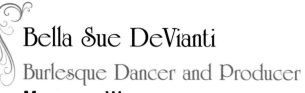

Bella Sue DeVianti

Burlesque Dancer and Producer

MILWAUKEE, WISCONSIN

What it means to me is girls being comfortable in their own skin. I really like the fact that girls that are moms and doctors and lawyers and big girls or little girls can get onstage and come up with these amazing performances and the crowd seems to just go crazy. They're classy performances, not trashy like just swinging around a stripper pole. Not that. I love girls that do that too, but the point I'm trying to make is it's just kind of a different class.

What else it means to me is making the costumes and there's nothing better than getting onstage in this amazing costume and the big pop of the song. You throw down a shoulder strap or reveal a little cleavage or a little bit of leg or a little bit of an arm and the feedback from the crowd, the yelling and the screaming, I love that. It's definitely somewhat of a rush.

One thing I love about burlesque is all of us girls getting together. It's like playing make-up or playing dress-up when you were little. Then we're traveling across the country and performing and doing shows and meeting new girls. Basically those are a lot of the main reasons that I love doing burlesque. I like the tease part about it. I like getting together with my friends from other states that are also burlesque performers and performing. I love the dressing up and the makeup and the glitter and the sequins and the boas and the feathers and the garters and the gloves. I've always been into the very retro, vintage style, so it just kinda fits. When I first started doing burlesque, I always really liked big band instrumental music and the very traditional burlesque numbers that girls did. I always really enjoyed music like that. I've always enjoyed dancing to that music. I've always just kind of felt that music and before I ever was a performer, the pops and the parts where you remove the gloves or just do something extra, those parts have always stood out to me. The very first time I ever saw burlesque I had stars in my eyes. I was like, "Oh my gosh, that is … that is so what I want to do."

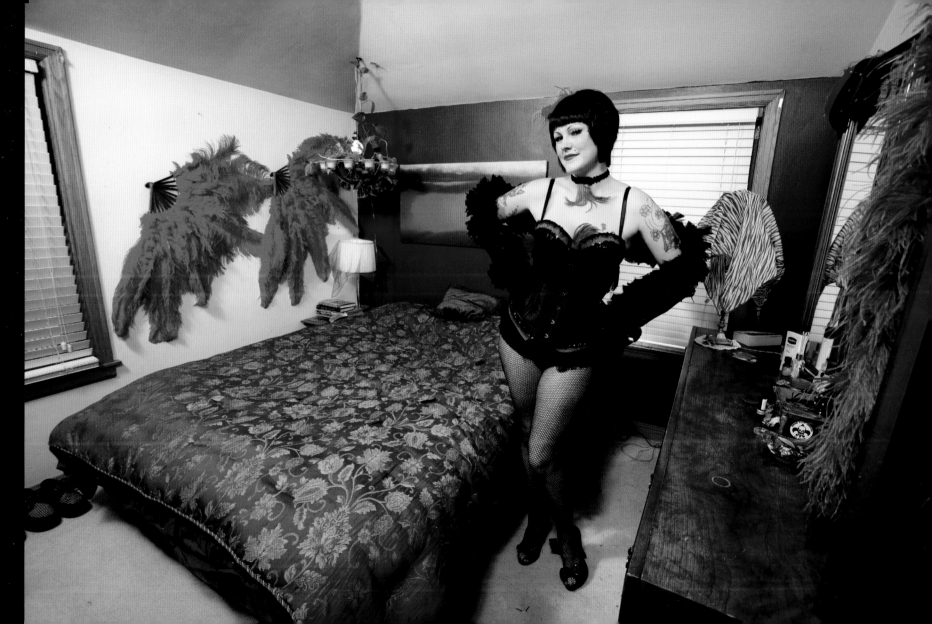

Rosy Roulette with Gracie and Addi
Burlesque Dancer and Choreographer
CHICAGO, ILLINOIS

Okay ... what does burlesque mean to me? That is a very huge question for me because burlesque is a huge part of my life. It started off as just a crazy fun thing to do to challenge myself and break outside of my box. It has become something that is so deep inside me, it's a way that I'm able to artistically express myself. It's extremely empowering for me to be able to express myself. I came from the dance world, which is a lot more stringent. The burlesque world allows me to choreograph things and dance things that I really shouldn't ... not *shouldn't*, but society says I shouldn't. So, it's been really fun to be able to do that.

Those aspects that society considers bad are women being sexual beings. People being sexual beings. People showing their bodies. It's very looked down upon, as is being proud of their bodies. It's looked down upon even when a girl wears a short skirt; that's considered slutty and not acceptable. But, really there's something wonderful and fantastic about the human form and seeing it move. It's also not acceptable to dabble in forms of sexuality, which you get to perform in burlesque such as S&M, knife play, being dark and angry. Being angry in general is not considered okay in our society and in burlesque you get to explore that and show how it can be really sexy. You get to show how even being funny and goofy is sexy. Society doesn't find the sexuality behind *that*.

What I love is when a burlesque performer goes out there and is funny. I love that! And I love that there are sides of burlesque performers that they show people. I've been opened up to so many different forms of sexuality that my definition of what is sexy has definitely been blown out the window. Really, with the right attitude and the right confidence, *anything* is sexy. And I think it's really neat to watch people express that and have everybody accept it, have the audience accept it and embrace it. The performers accept it and that's just really fantastic, really, really fantastic, so ... yeah. I think that's ... yeah.

It's also something that's extremely empowering because I've seen all body types, all types of genders, sexuality, and it's just all-encompassing embracing of that. It's embracing of who you are as a person, who you are in your sexuality, who you are as an artist. And burlesque is also a family for me. Really, because it's so embracing in that manner, and particularly The Flaming Dames. I'm part of The Flaming Dames and they are a group of women who get together and get to express who we are. We form these relationships and it's fun because we've

been able to perform with other burlesque performers, and they're just warm and kind people. I've met some of the neatest, unique people that I've ever met in my whole life. And I've been in the theater world for quite a while and it's just really neat to see a variety of people and a variety of personalities. They light up when they get on stage.

And on top of that, burlesque is for me a way to express my femininity, express my body, and be able to be accepting of it. And it's not only me being accepting of it, but everybody's accepting of it. Everybody's accepting of everything that you put out there, and it's really fantastic. One of the most wonderful experiences I've had is, I've had the opportunity to be empowering to other people. It's extremely empowering for me as a performer to go out there, because, obviously I'm able to break through my shell and lay out on the line everything that I am. What's really neat is when people come to you after the show and say thank you, because they don't feel sexy, but when they watch a show and they see people that are their same body type, or hair type, or personality type, and they see ... whether that be sexy, whether that be dark or funny ... they see somebody that is similar to them expressing that, it makes them feel sexy inside. And that is one of the most wonderful feelings I've ever had in my whole entire life, to be able to empower other people, too. So, burlesque means empowering and expressing yourself, to me, whether that be dancing, whether that be choreography, whether that be ... for some people it's their costumes ... they really lighten up with their costumes or their stories, and that is wonderful to me. So, that's what burlesque means to me, expressing yourself and being empowered by that.

The artistic creativity that comes out of these burlesque performers is phenomenal. I think that's because it is such a liberating form, that once you pass that level of liberation, people grow. That's one thing that I've seen that's really neat about burlesque, too, watching people grow. Burlesque really, really makes you grow, because you're pushing your boundaries; you're making yourself discover things about yourself that you didn't ever know.

When you push that, then you start to think about other ideas and you start to think about other ways to push the envelope. Not even necessarily push the envelope as far as trying to be shocking, just pushing your own envelope. It really helps you discover who you are and accept who you are, because you have to. You have to. You can't go up there if you're not accepting of yourself. I mean, you can ... but you're more successful if you accept who you are. It also helps you find ways to accept. When you see everybody else being accepting of you and your character, and who you are, then it kind of is really therapeutic and teaches you that. It's really phenomenal how I've seen it give so many women so much confidence. It's really, really phenomenal and I just love that. I love that it's an unconventional form of therapy, which is phenomenal.

Lushes LaMoan with Captain Poncho Gato
Burlesque Dancer and Producer
DETROIT, MICHIGAN

Burlesque to me is preserving a history. And it's makin' it modern to where it fits into our society, but restructures our society based on the history that we have. So, it's preserving it, making it a little bit more modern, but keeping it fun, keep it happy, keep it campy, keep it entertaining. It's supposed to be entertaining, not arousing. If you bring that arousal part into it, that's when it is no longer burlesque.

The history to preserve has class and elegance to it and there's a certain manner that you conduct yourself in, as well as group members. When you go to somebody and you meet them, you're polite with them. You represent yourself and your group in an elegant manner. You have care and dedication. Everything was made with care, charisma, how old garments were made. Everything that is vintage has an art to it. And nowadays not everything has an art to it. So, it's taking those wonderful elements from past times and making them modern.

I believe everybody's different, so everybody can get aroused, be seductive, in different ways. Two people are never alike, so, there may be people that will have that feeling come over, and it doesn't necessarily mean that the performer did it wrong. It could be taken out of context. There are many different contexts of what burlesque is. That's when the idea gets misconstrued. I've had people come to me that say, "I've seen a burlesque show in Amsterdam and there were women onstage with phallic devices doing inappropriate things." That's where the context is just totally wrong. That is completely wrong from what burlesque is. Burlesque is comedic, it's fun, it's lively. My mom comes out to shows and she has a great time. I'm sure that nobody's aroused her. And if they did, oh boy! I'd hate to see the aftermath of that. So, I mean, it can be taken out of context. But what I try to do is keep it that classic, cheesecake, happy feeling, and preserve what once was.

It's my life, it's my lifestyle, I love it.

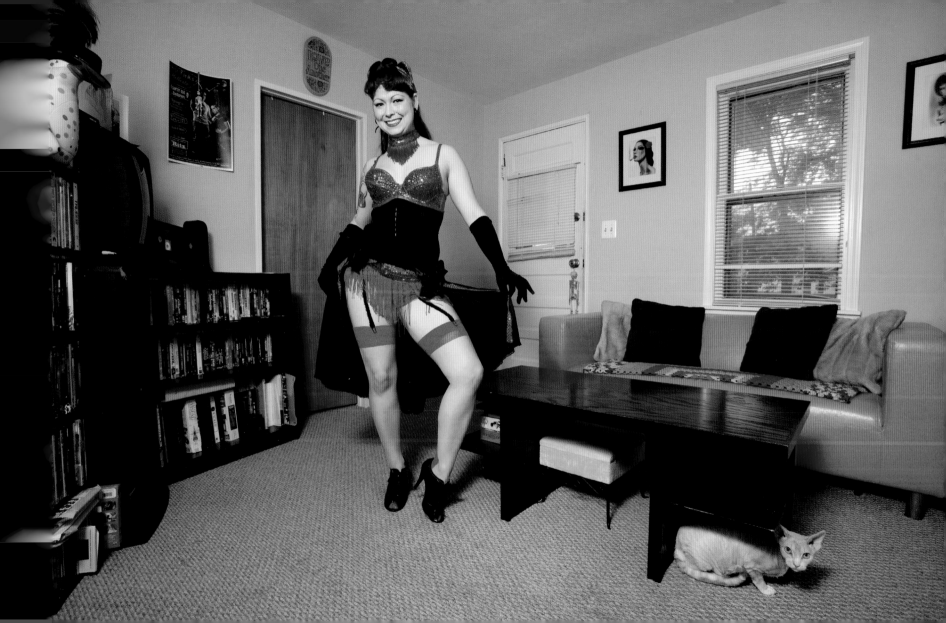

Roxy Red Rockets with Edvard Munch and Doug
Burlesque Dancer

ST. LOUIS, MISSOURI

I think that burlesque is basically the adult equivalent of the naked toddler running through the sprinkler. And that's sort of what I figured out for me. I think it's about fun to the nth degree where it's so much fun that all your clothing goes away, too. I think that there is sexuality to it and beauty to it but in the end it's really about being yourself but not being yourself at the same time. So having as much fun as you ever could either in your uber-persona or really showing what your true colors are. "It's fun," I think, is my true definition.

In my general background, and in art in general, I think that death and sex and such are the most interesting topics. So there is something very interesting in confronting sex as a topic in a silly and a really up front way.

To me there are two people. There is the person that I am in my normal life and there's who I get to be onstage. And so sexuality is a part of yourself that you have to censor when you're out and normal that you don't in burlesque. Sort of ... interesting in that way, that we don't reveal everything to everyone. Yet, on a stage in front of strangers you do reveal all these parts of yourself that you would normally hide. So, I think that's how I feel. It's a very interesting part of human life and I like to look at it in as many ways a possible.

I tried a lot of other performance and there was just something unique or original and fully myself in burlesque. So it wasn't even necessarily sexuality. It's just not being a different character on a stage while being a different character onstage.

I was raised, this is very divulgent, in a very conservative Christian environment, incredibly so, and I still feel a lot of that control in normal life where I want to be appropriate and such, but performing is performing. There are no rules. It sorta lets go of that because I can walk off the stage and I didn't give away anything that isn't me. I'm still myself when I walk away but it's a show. So you can do what you want.

I don't know if I just want to put it on the record, but I think there are tons of kinds of burlesque. I think it's interesting that each city has its own choices and I feel like our city is very, very silly, and I like that. There's lots of us silly girls and everything I do is spaced-themed and weird. But there is also such a refined grace to burlesque as well. I think both ends still have that same release of fun, somehow. It can be slow and gorgeous and sexy and somehow it just makes me want to giggle and clap. It's just great that, even though I call it fun and silly, you can still have fans and be gorgeous. It's still silly somehow, 'cause you're not really like that in real life, I guess. So, that's all. Just wanted to qualify.

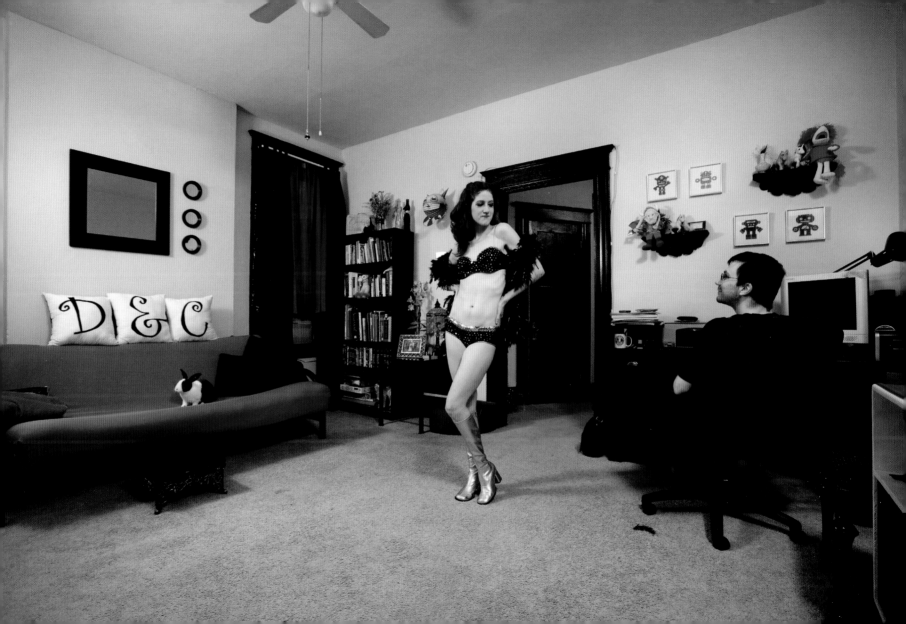

Devilyn Disguise with Munly and AJ

Burlesque Dancer

DETROIT, MICHIGAN

Burlesque to me is kind of a feminist statement in certain words, in certain actions. When I started doing burlesque, I kind of had body issues. And so, when I saw a lot of girls that would perform, I would just admire everything about how strong and how confident they all were. Burlesque is confidence. Burlesque is celebrating that you're a woman. Burlesque is finding the joy in performance and making costumes and really paying homage to a lost art form.

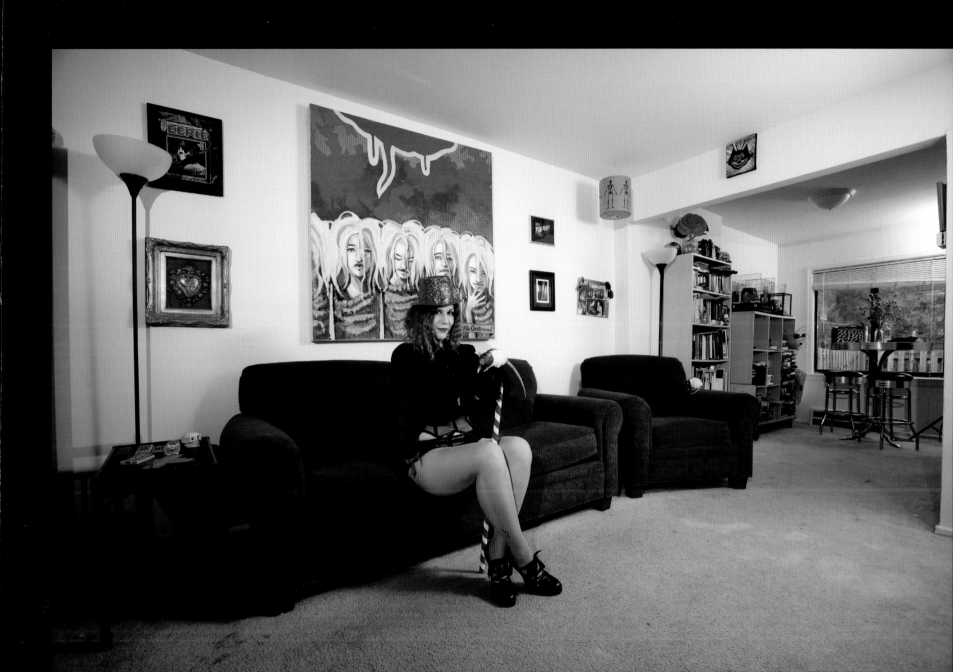

Jeez Loueez

Burlesque Dancer

CHICAGO, ILLINOIS

You know, I actually thought about this for a long time and the whole reason that I got into burlesque was because I love performing and I love dancing, obviously. And, I'm not gonna lie, I really love taking my top off. But more than that, I really enjoy creating characters and storylines. Burlesque to me is cheeky and it's funny and there's a lot of elements that I didn't know about when I first wanted to get into it that I am discovering. Like, the comedy of it, not just your costume and your music choice, but how all of it is going to come together and how the audience is going to take it in and what they are going to take away from it. That's something that's really important to me, not just, oh you did such a great job, you looked great. I really want to know how my performance has affected them and what they take away from my characters, 'cause I really enjoy creating characters onstage.

Burlesque is fun and awesome and I really enjoy it. It's making me very happy. I'm meeting a lot of really great people and having a great time and I just wanna see how far I could go with it and … that's it.

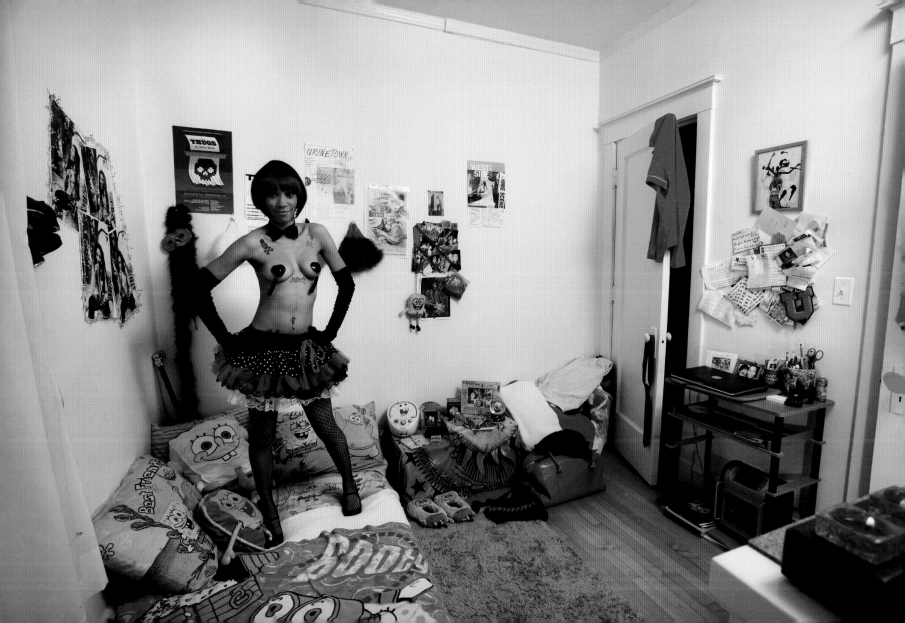

Ma Belle

Burlesque Mom

DETROIT, MICHIGAN

Burlesque means a really good time. It's a chance to be creative and to be sexy and silly all at once. And I love doing it. The creativity—because I am a painter and I do the choreography and I do a lot of the graphic design for our flyers and such—I get a chance to be very creative. And when I either perform or put together shows, I get a chance to either be silly and sexy myself, or make my girls do it. So that's a good time.

The funnest part about it is rehearsing in my living room with a box of wine and lots of chairs and feather boas flying everywhere, and just having a really good collaboration with girlfriends and feeling good about being a woman. Because women aren't so nice to each other, but they are in the burlesque world, so, I'm glad to be a part of it.

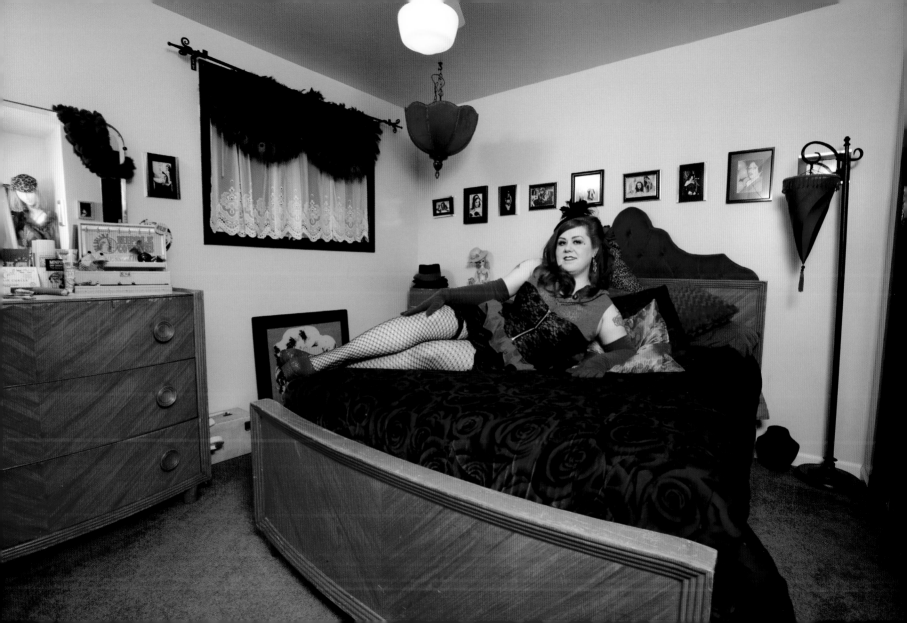

Wham Bam Pam

Burlesque Dancer

CHICAGO, ILLINOIS

What does burlesque mean to me? Well, burlesque to me is just another wonderful way that I've discovered for me to express myself and express my sexuality and my femininity. And the reason that I love it so much is that I found it to be a very empowering community. There are a lot of really great women that I've met here and everyone helps each other out. I've learned so much more than dance moves; I've learned a lot about female friendship, which is something that I've never really had; and a lot about sewing my own costumes, making nipple tassels, and bedazzling anything and everything that you could wear or hold in your hands.

The other thing that I really love about doing burlesque is that I get a chance to express a part of myself, mainly something that I think is sexy or that I think is intriguing that I want to show people. I have the opportunity to choose whatever it is that I want to do. I don't have to consign myself to someone else's definition of sexy or feminine. I could do anything that I want and I've found that the audiences really get into it, if you believe in what you're doing.

I'm also learning a lot about promoting events within social networks to get the audience members in; but also working with bar owners and other people in the industry. All those things have been so exciting and enlightening and fulfilling. That's why I keep doing burlesque, and that's what it means to me now.

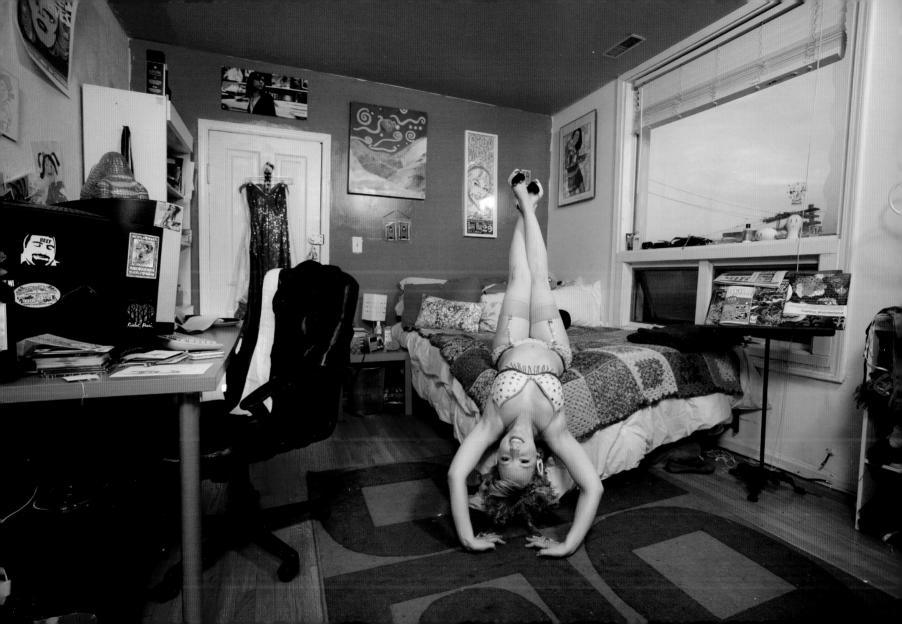

Katrina Dohl

Burlesque Dancer

St. Louis, Missouri

Burlesque means to me, well, I guess, it means a lot of things, but first and foremost it means that I can walk into anywhere with pins in my hair and a completely ridiculous face and not worry about it. Because I know that later on in the evening I'm going to be glamorous and onstage and appreciated. So I guess that means confidence. You know? I guess burlesque means confidence, because once you have a certain sense of yourself, you're able to do anything and if that means walking in with pins in your hair or your face half done or sweat pants and a bandana, you're still able to do it because you know that later on in the evening that there are gonna be people that are watching you. Does that sound conceited? 'Cause it's not, because pins in your hair is definitely inappropriate in most places.

You can't really define burlesque. Who is that person that they didn't know what pornography was? They couldn't define pornography but they knew it when they saw it? Well, I guess that's what burlesque is. You can't define it, but you know when you see it and that's such a douche bag kind of definition but it means something different to everyone. I don't think you can define it. It's funny and it's sexy and it's offensive and inoffensive and it's not lame. That's what it's not, is lame. I don't know what else to say.

I don't know. It's whatever you want it to be. You can't define it and I think that's what the beauty of it is, it is whatever anyone wants it to be and it's not just the performers. Because the performers make it what it is, obviously. But everyone has their own interpretation from the audience, too. They can appreciate it or they can be offended by it, but it's all interpretation. Every single part of it, it can be political or it can be non-political. It's nudity or the lack of nudity. You know? Anything. But it's not being vague either. I mean, doesn't that sound like a vague definition? But it's not. It's not. It's whatever anyone wants it to be.

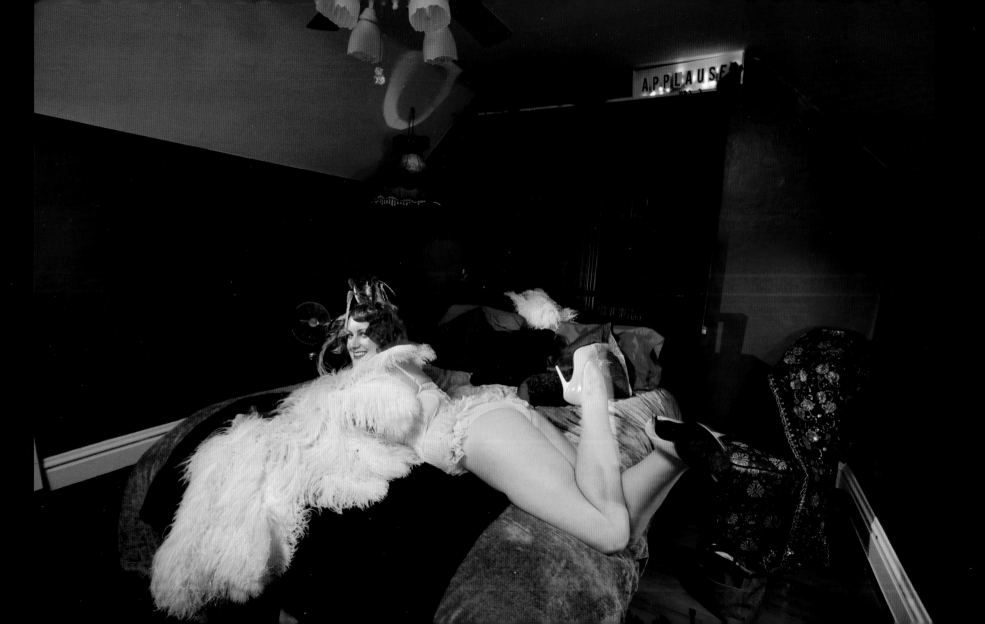

Appendix

For the latest news and information regarding *It's All That Glitters*, and to view a comprehensive list of Internet links pertaining to each of the performers featured in this book, visit http://ItsAllThatGlitters.com.

For the latest news and information regarding Brian C. Janes, visit http://briancjanes.com.

Index